height of fashion

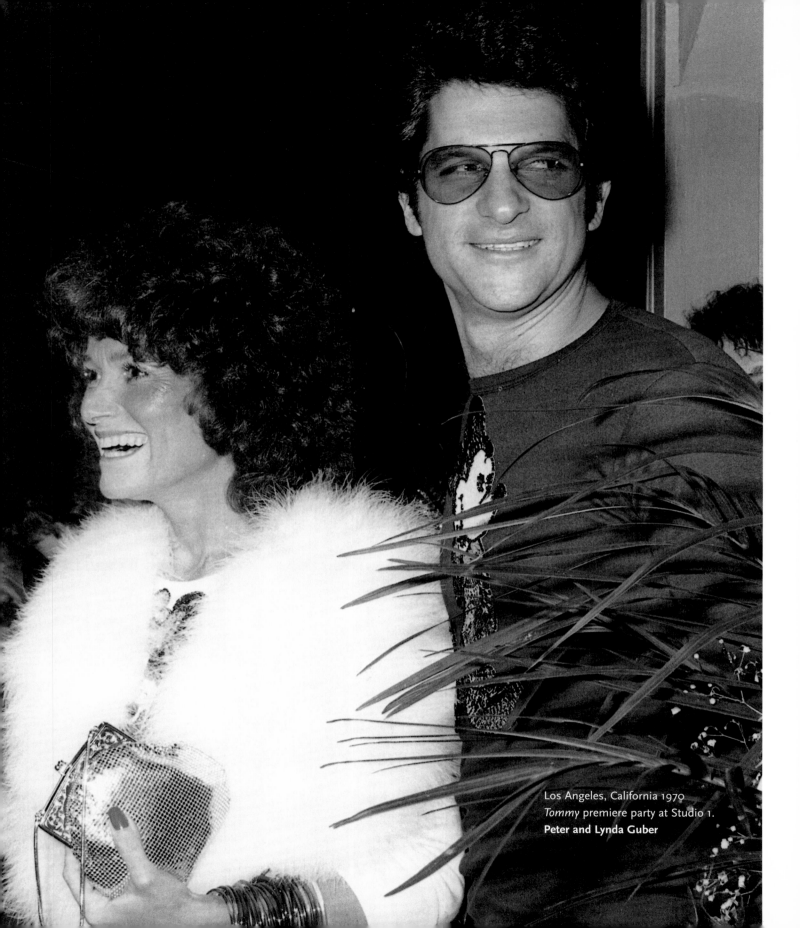

Los Angeles, California 1970
Tommy premiere party at Studio 1.
Peter and Lynda Guber

height of fashion

edited by
LISA EISNER *and* ROMÁN ALONSO

introduction by
AMY M. SPINDLER

designed by
LORRAINE WILD

GREYBULL PRESS

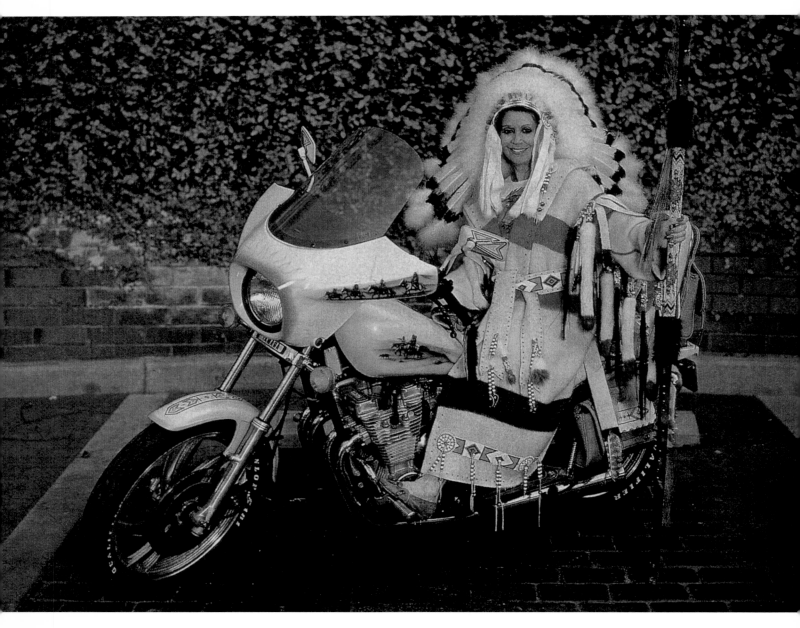

Los Angeles, California 1994
Shirley Barris

GREYBULL PRESS

July 1, 1999

Mrs. Shirley Barris
Riverside Drive
N. Hollywood, CA 91602

Dear Shirley

Congratulations stylish one! You have been carefully selected from a cast of thousands to participate in the ultimate tribute to personal style - our new book, Height of Fashion.

Height of fashion, you ask? It's that one time when you felt as if nothing and no one could stand in your way because you looked so darned incredible. You were glamorous, you were enticing, you were the one who made all the heads turn. Maybe it was the perfect accessory or the right shade of blue or maybe it was the genius foresight to combine stripes with plaids. You had it just right and everyone knew it. Your neck got longer, your back got straighter and your hair got better. No doubt it was your Height of Fashion.

So, here is what we need, it's so easy. Just send us a head to toe photo or one from your waist up. The photo should capture that exact moment, at any point in your life, when you knew you were the most magical person in the room. If you've been that person more than once, don't worry. If you've got them, we'll take them. Feel free to send as many photos as you like.

Please, please don't worry about your photos. We understand that they may be all that's left of your crowning moment and that they are precious. Filling out the attached information form and release ensures their safety and return. We will, however, need to hold on to them until Fall.

Please submit the photos and form in the enclosed self-addressed, stamped envelope by September 1, 1999 and please call us if you have any questions.

We do hope you'll want to be part of Height of Fashion. We think you measure up and, Shirley , you won't want to be left out.

Your adoring fans,

Lisa Eisner

Roman Alonso

Stand this book on its spine. Let it drop open to any page. Check out the photo that comes up. Strike the pose on the page. Is there confidence in your stance? Poise? Is there an implicit toss of your head, a straightening of your spine? Is your chin tilted up, a challenge to the camera? No matter what you're wearing, if someone photographed you now, you could be experiencing your 'height of fashion.'

The 221 photos in this book define precisely what the 'height of fashion' is. It can be a snowsuit or a ballgown. It can be inspired by Duran Duran or Davey Jones. It can wear a bandanna or a blow-dried coiffure, or an Afro or a Flock of Seagulls haircut. It can be naked except for a military cap, a jockstrap and a birthday cake. It can be naked except for a grapefruit, an orange, a dead animal head, and aviator glasses. It can be naked except for a white horse between the legs. It sometimes wears a necktie. Sometimes it even wears a necktie around the neck. It doesn't discriminate by class or age or race or riches or region. It can be accessorized by a car or a camel or a chicken or a plaster poodle.

"Everyone in the world, whether they're interested in fashion or not, has had a 'height of fashion' moment," says Lisa Eisner, who edited this volume with co-publisher of Greybull Press, Román Alonso. "We are interested in individuality and the courage it takes to truly be yourself," says Román. "This is what our company is based on, originality, subcultures and people who are doing their own thing."

What binds *Height of Fashion* together is not rabid individuality alone. Sometimes feeling at the 'height of fashion' comes from the power of dressing to be part of a family. Sometimes it's the power of dressing as a couple. Sometimes it's the power of dressing to mirror a best friend. Most of the time however, it does come from the power of being an individual.

Designer clothes, the symbols that today unify those who wear them into one secure socio-economic pack, play a surprisingly small role in the heights chronicled here. As much as designers' advertisements promise hipness, and a sense of belonging, and an aura of wealth, no one submitted images of themselves in obvious examples of Prada, or Gucci, or Calvin Klein. Instead the moments chosen were when they looked like one of Charlie's Angels, or Janis Joplin, or David Hemmings in *Blow Up*. The anonymity of the fashion is what makes the photographs so clearly about something else entirely. The clothes didn't make the occasion memorable; the occasion made the clothes wonderful.

"A lot of these pictures are from Bar Mitzvahs, or birthdays, or proms because that's when you go through the whole ceremony of getting ready. You take the time, you make an effort," says Lisa. "It's the Greek ritual of bathing and preparing for something special in life."

Clearly, the 'height of fashion' can come from the setting: the beach, the Ball, Barbados or Karl Lagerfeld's home. It can be from the celebrity nearby, like Roy Gerber's proximity to four Beatles. (It's obviously the Beatles, and not the plaid sportsjacket, that made him feel at his height.) Sometimes the height comes from not being yourself but from slipping into another skin, whether it's your mother's shoes or someone else's identity entirely.

Sometimes it's the lack of clothes that gives the moment its import. My favorite photo (and like all good collections, everyone will find a favorite here) is Cherry Vanilla, naked

on a horse. "Clothes meant nothing, spirit was all," she writes. "I was hot and I was cool." If I were to pick one thing all these photos have in common, it's that. The subject is hot, and cool. And the power of that moment, the second that the camera flashes and all eyes are indeed on the subject, transcends fashion itself.

There's barely a look in the following pages that would be worn with confidence today by any of the people in the photos. But the fact that hindsight has made the clothes seem silly doesn't change the swell of pride that the memory inspires. We may never wear that outfit again, or be twelve again, but we can still thrill at the way we felt on that special day.

It's amazing how few moments we face in our lives dressed purely for ourselves. As babies, we're dressed for our mothers. As teenagers, we dress for our peers. As adults, we dress for a lover, or a boss. Or for our mothers.

My instinct is that many of the moments submitted were those rare occasions when the individual did dress only for themselves, for their fantasy of who they really were. When they were on a vacation where no one knew them, or in a magic moment of childhood where an obsession with pink, or paisley, or ruffles could be completely indulged.

Which is perhaps the other special thing about the photos collected here. In most cases, the person taking the photo loved their subject. It was a friend of the family, or a parent, or a lover who felt the pride of self so strongly that they documented the moment. And then saved the photo for years. Until the photo replaced memory of the moment itself.

"It's a certain kind of 'wait, where's my camera' photography by adoring friends and adoring family who want to capture the moment because they know you look good and feel good," Lisa says. "A lot of them have a sense of humor and an intimacy that I love. Most of these pictures are the ones that they have next to their beds, where their most cherished memories are kept."

In a world that can be so divisive about style, so judgmental about clothes, the photos in *Height of Fashion* represent passages we've all experienced. In a society where a high school shooting like Columbine can happen because some people wear trench coats and some people don't, and some people wear Abercrombie & Fitch and some people don't, the individuality in the photos isn't just charming; it's essential to our ability to be human beings.

In times of war, uniforms turn men into killing machines. In prisons, uniforms are intended to dampen spirits. If there is a place which is the polar end of the earth from those abuses of clothes and identity, that is where *Height of Fashion* resides. It is clothes as a celebration of life, and individuality, and freedom to change who we are every time we put on our trousers (one leg at a time) and pull a shirt over our heads. And it's the freedom to like ourselves. As far removed as most are today from the person in the image they submitted, they still like who they were in the photo. They still like the subversive intent of their Danceteria outfit, the sexiness of their white vinyl boots, and the innocence of their white silk pumps.

"'It's a beautiful insight into people's lives. It's about fashion and style and growing into who you are," says Lisa. "*Height of Fashion* is a wave of intoxication that wipes away all the inhibitions that imprison us. It's self-expression." **Amy M. Spindler**

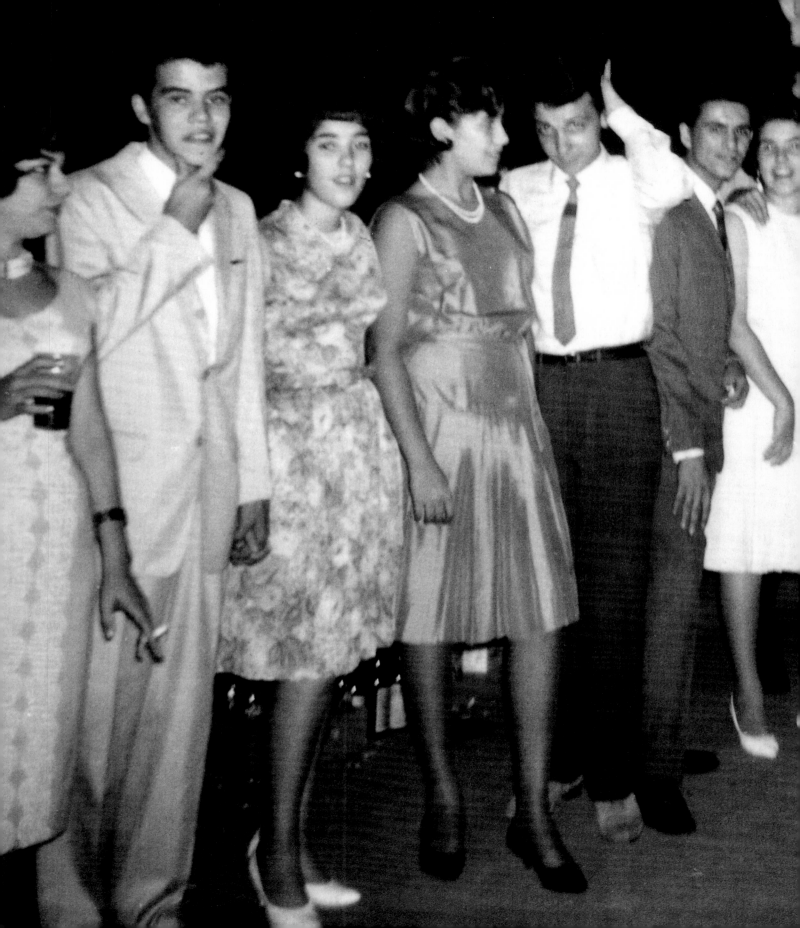

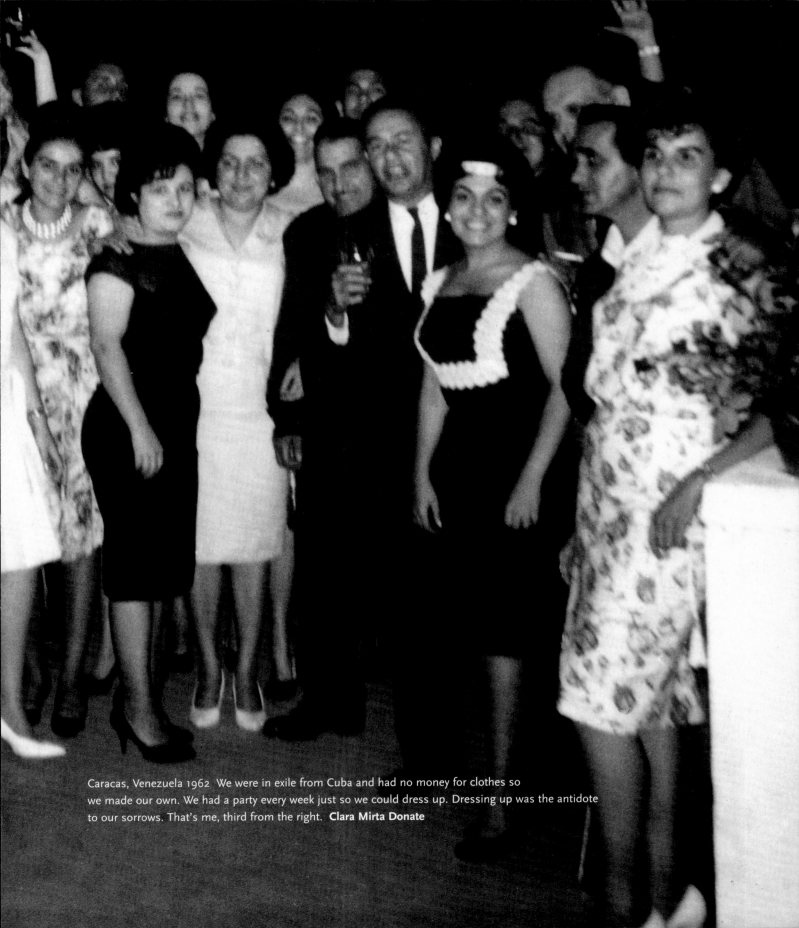

Caracas, Venezuela 1962 We were in exile from Cuba and had no money for clothes so
we made our own. We had a party every week just so we could dress up. Dressing up was the antidote
to our sorrows. That's me, third from the right. **Clara Mirta Donate**

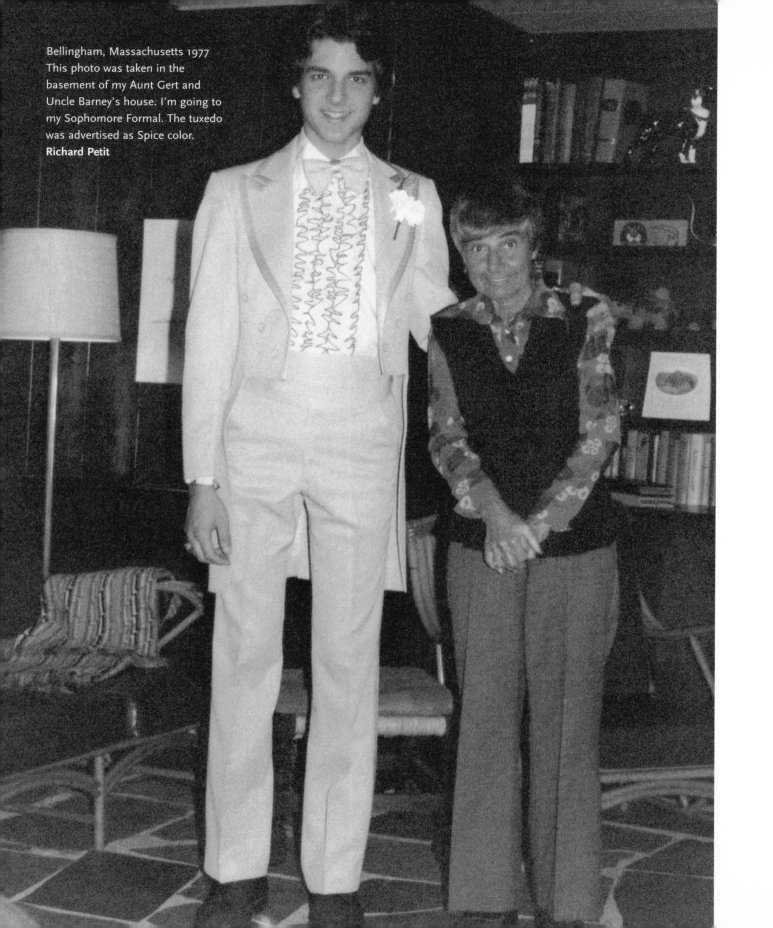

Bellingham, Massachusetts 1977
This photo was taken in the
basement of my Aunt Gert and
Uncle Barney's house. I'm going to
my Sophomore Formal. The tuxedo
was advertised as Spice color.
Richard Petit

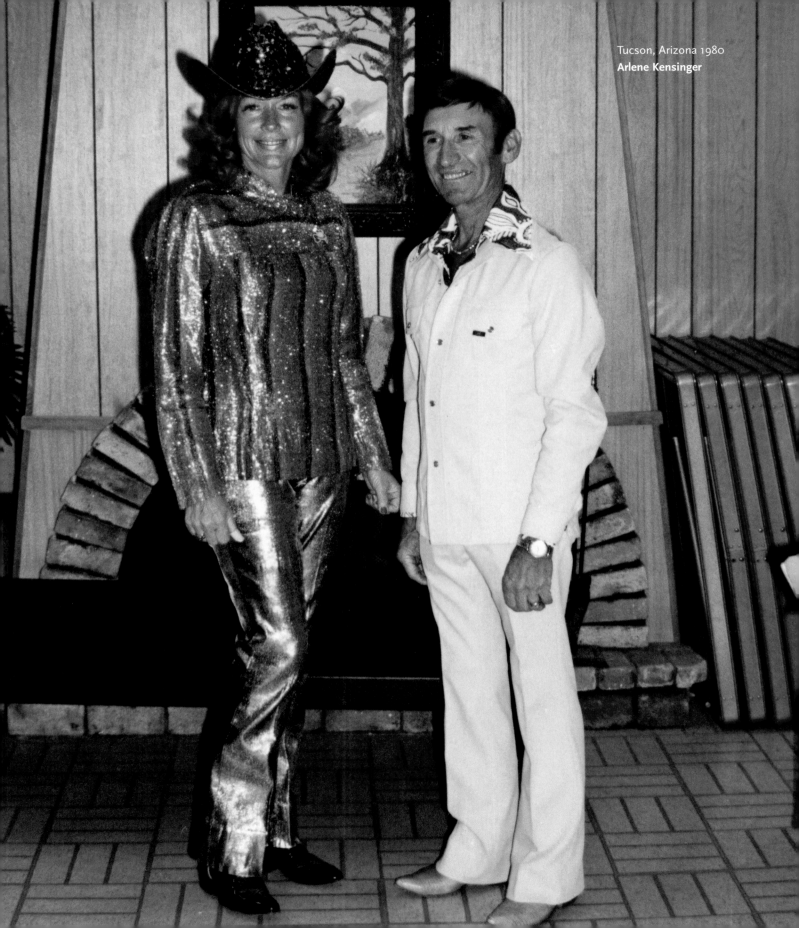

Tucson, Arizona 1980
Arlene Kensinger

Yonkers, New York 1971
My body was thinner and my
hair was fatter than any other
moment in my entire life.
Joe Freilich

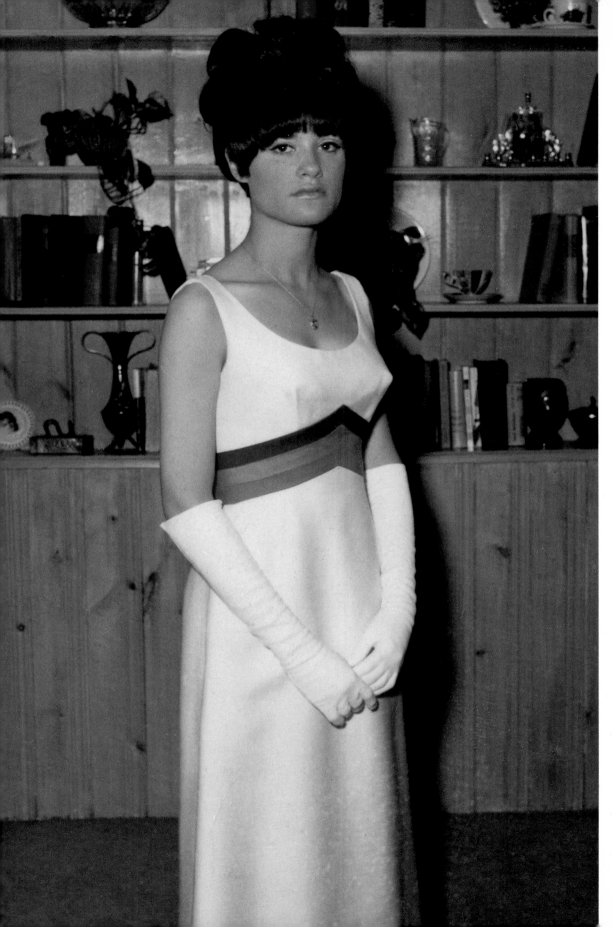

Yonkers, New York 1966
This is me right before my
Senior Prom. There are some
amazing things about this
photograph. The first is that
I was even asked to the Senior
Prom. The second is by whom—
a very cool, good looking,
popular boy. The third is the
dress. I got it at Loehmann's.
I thought it was very elegant
and it gave me cleavage.
I knew what I was doing. I read
Glamour and *Mademoiselle*
with Talmudic intensity. Adolph
of Tanglewood constructed a
Spray Net pyramid on top of
my personally created Peggy
Moffitt-head. This photograph
was taken by my father,
Herman Freilich, and he
thought I looked beautiful.
Barbara Benedek

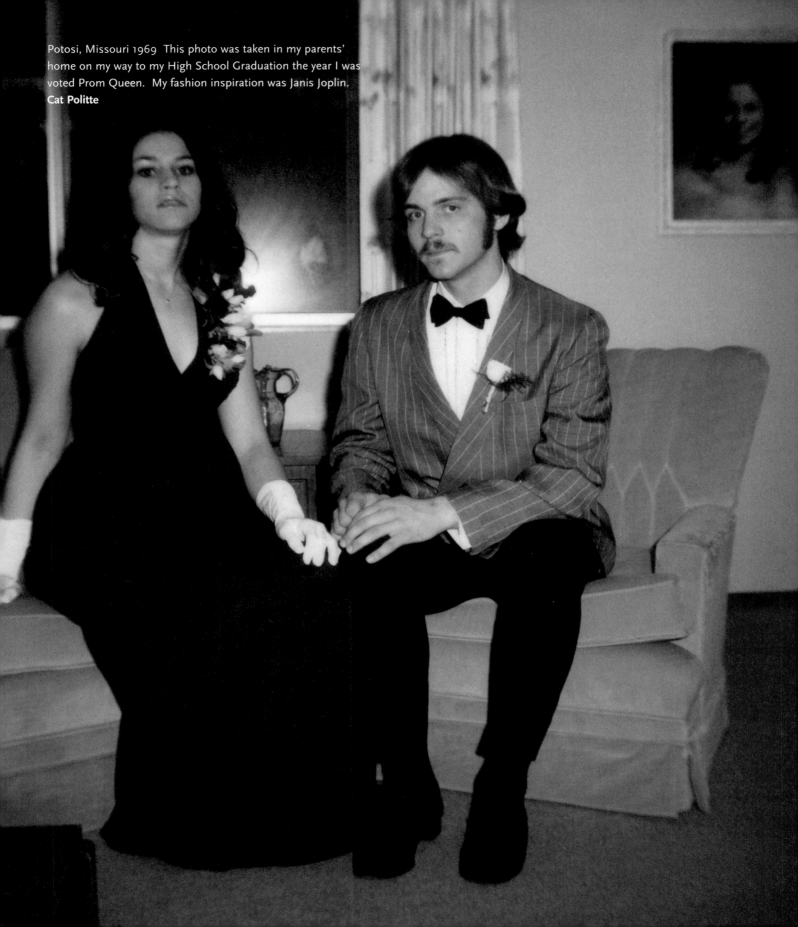

Potosi, Missouri 1969 This photo was taken in my parents'
home on my way to my High School Graduation the year I was
voted Prom Queen. My fashion inspiration was Janis Joplin.
Cat Politte

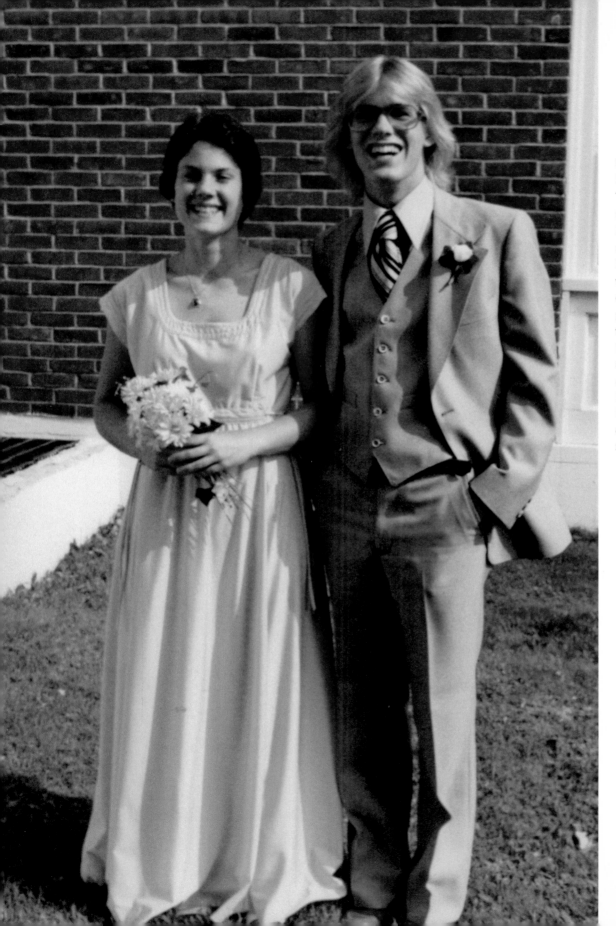

Syracuse, New York 1977
Everything came together.
The suit, the hair. I loved that
suit. It was from Anderson
Little. Everything felt
appropriate for the moment.
Except for my date. That
was the first time she'd
ever worn a dress. We were
going to a wedding. She
was the Maid of Honor.
I thought I was fine. I had
a little tan, the right haircut,
and everything matched.
I thought that was important.
I'm pretty sure she's a
dog groomer now.
Steven Johanknecht

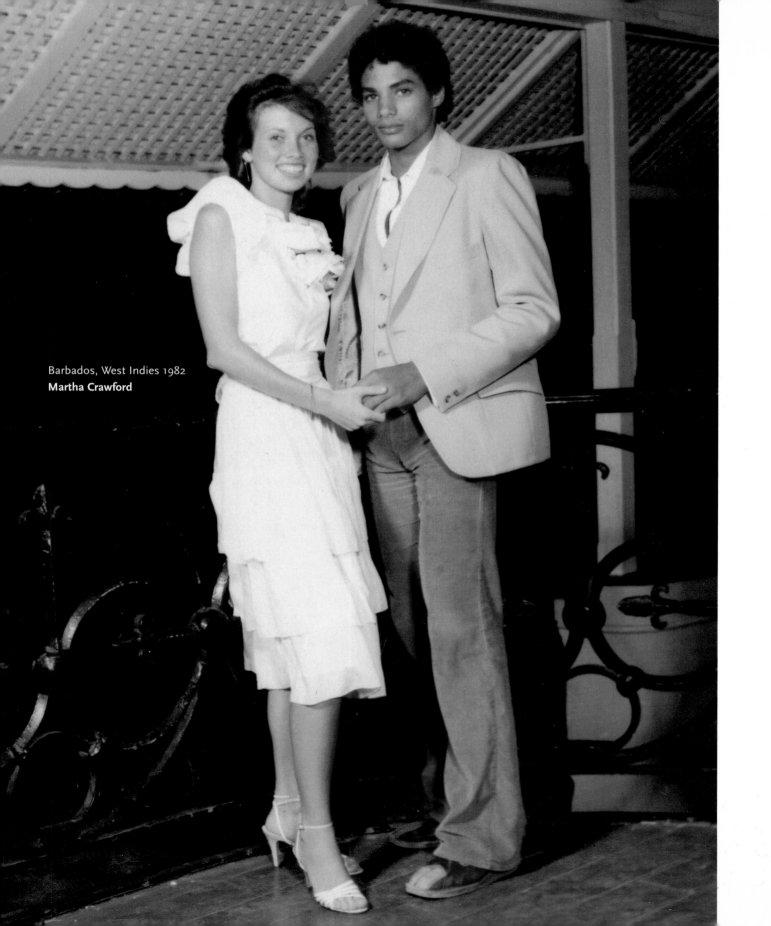

Barbados, West Indies 1982
Martha Crawford

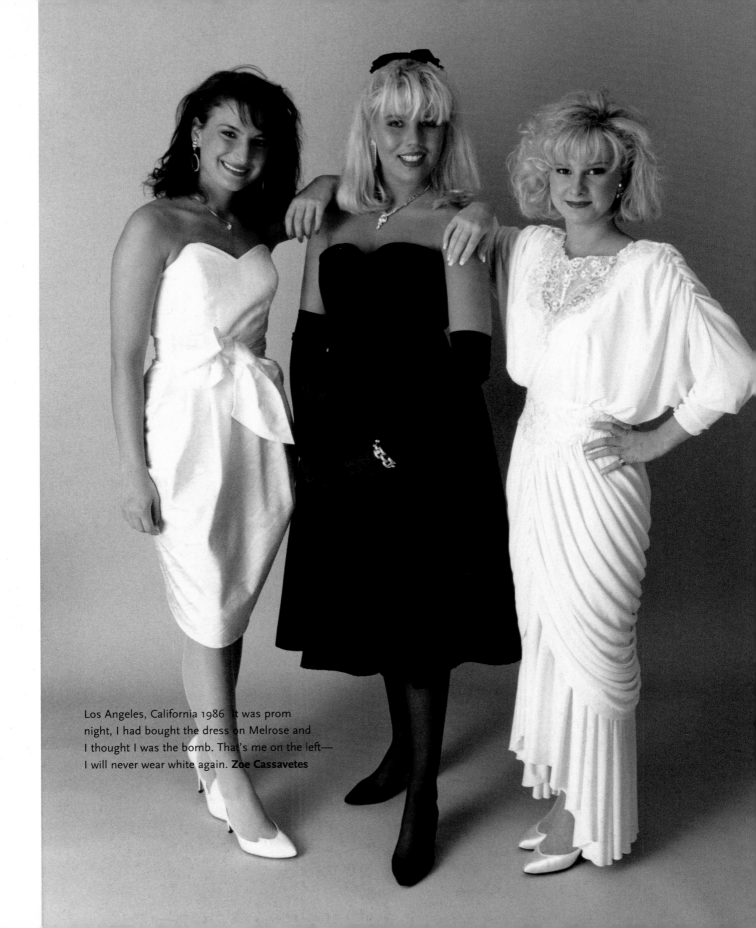

Los Angeles, California 1986 It was prom
night, I had bought the dress on Melrose and
I thought I was the bomb. That's me on the left—
I will never wear white again. **Zoe Cassavetes**

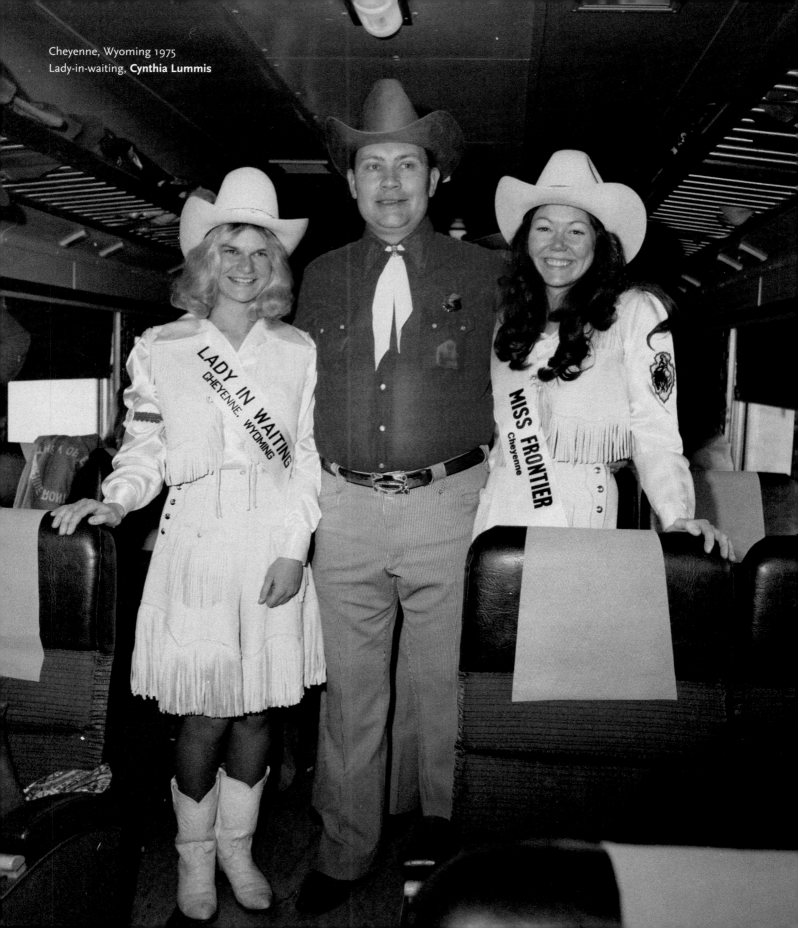

Cheyenne, Wyoming 1975
Lady-in-waiting, **Cynthia Lummis**

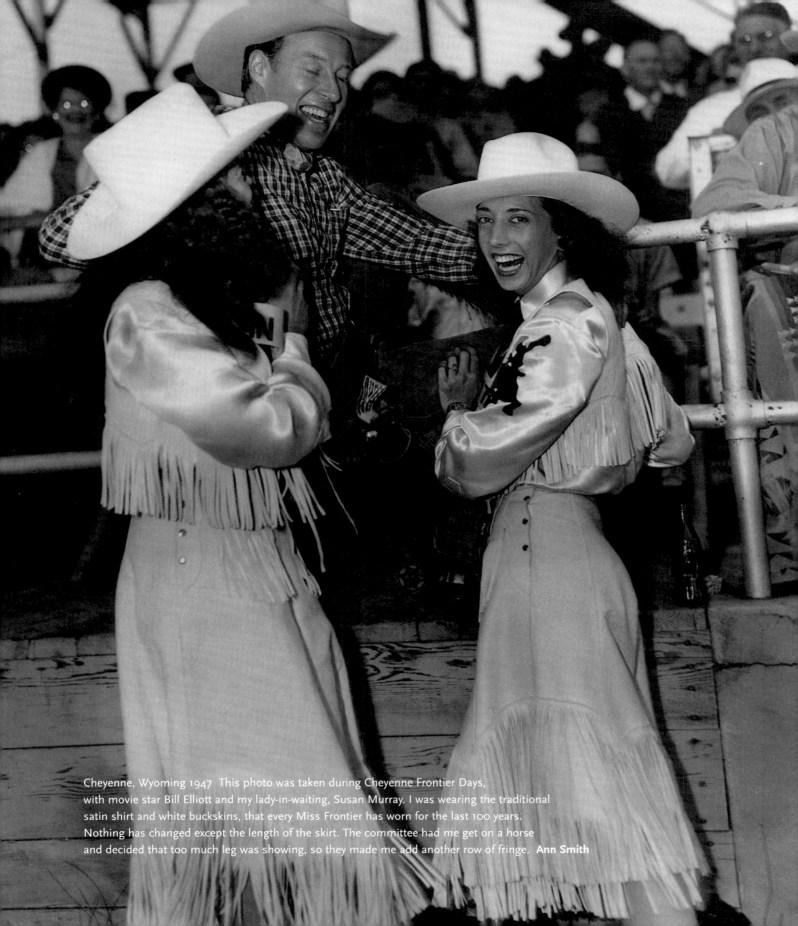

Cheyenne, Wyoming 1947 This photo was taken during Cheyenne Frontier Days,
with movie star Bill Elliott and my lady-in-waiting, Susan Murray. I was wearing the traditional
satin shirt and white buckskins, that every Miss Frontier has worn for the last 100 years.
Nothing has changed except the length of the skirt. The committee had me get on a horse
and decided that too much leg was showing, so they made me add another row of fringe. Ann Smith

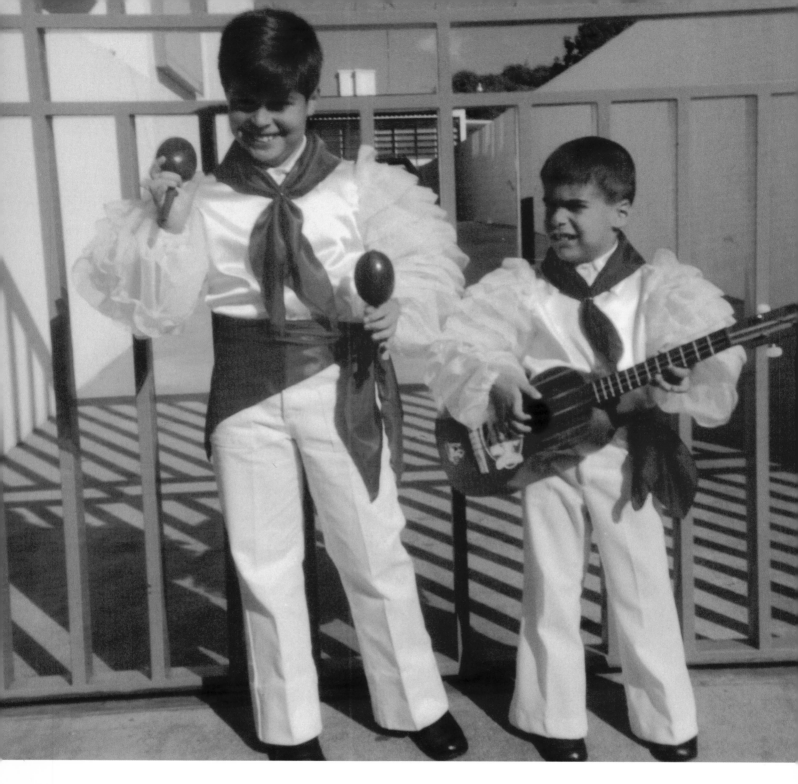

Caracas, Venezuela 1972 It was Carnival, and every year our costumes were a major production.
This year we were "lucky" enough to be *rumberos*. I played *maracas* and my brother the *cuatro*.
I was never again as clean and put together as I was during this period of my life. My mother was
a maniac. Note that there is not a crease or hair out of place. We were not allowed to sit down
until the pictures were taken. **Román Alonso**

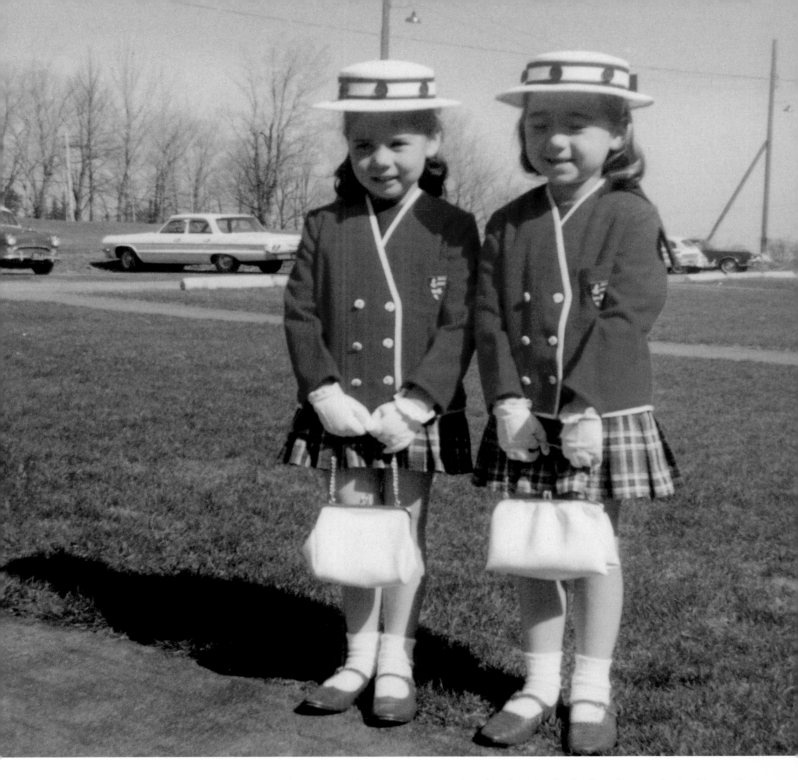

Potsdam, New York 1968 It's Easter (why, other than the death of our Saviour, the Lord Jesus Christ would anyone wear such finery?). My sister, Christine (on the right) and I are not twins, but my mother insisted on dressing us as if we were. Each and every day of our lives. Man, oh man. I loved that purse! The shiny white patent leather was so very, very ladylike. Later I adorned it with an American flag sticker which would have looked nice with the whole Vaudeville thing we had going on. **Cat Doran**

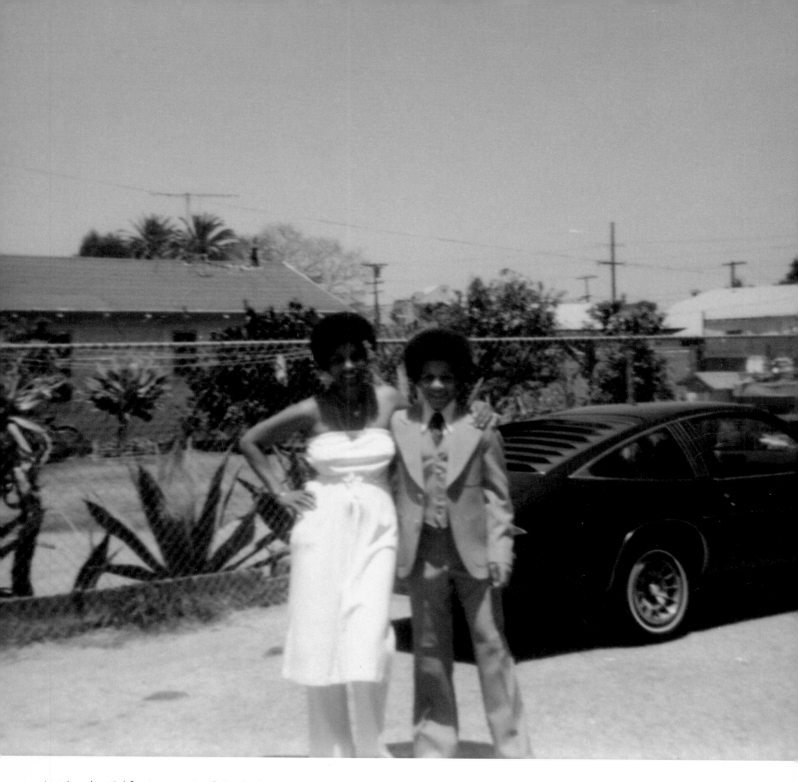

Los Angeles, California 1970 **Frank Carrington**

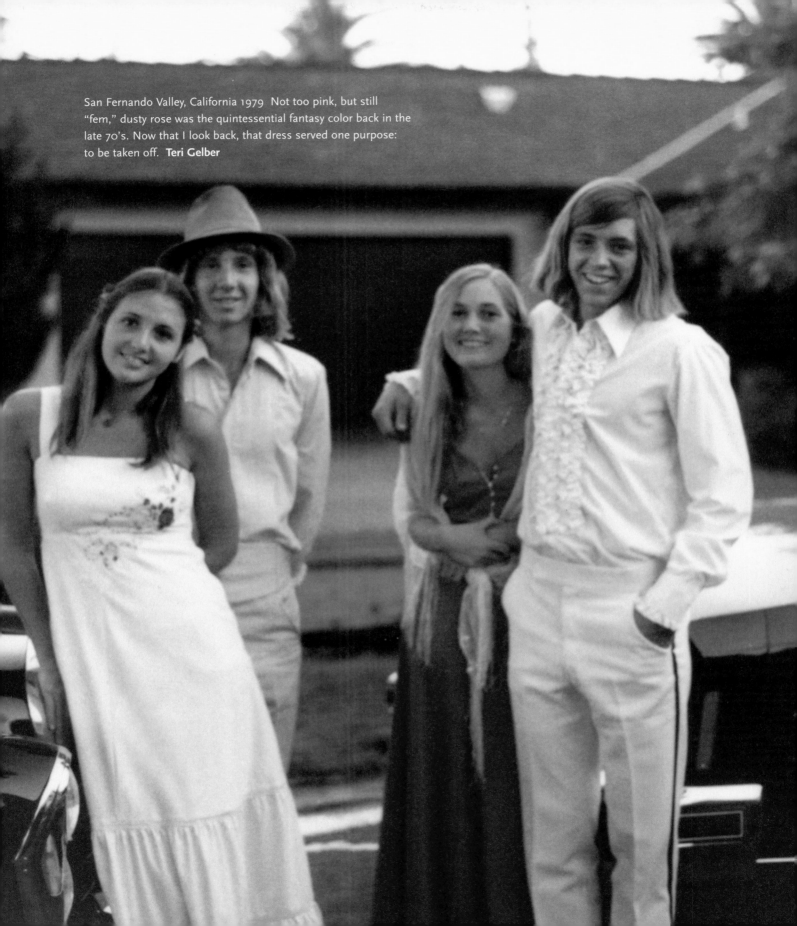

San Fernando Valley, California 1979 Not too pink, but still
"fem," dusty rose was the quintessential fantasy color back in the
late 70's. Now that I look back, that dress served one purpose:
to be taken off. **Teri Gelber**

Englewood, New Jersey 1959 I was 9 years old and was
supposed to present flowers to my hero—Eleanor Roosevelt.
I was nervous about remembering my speech and about
whether or not my braids would stay in place. They did.
And I did, too. **Lucy Fisher**

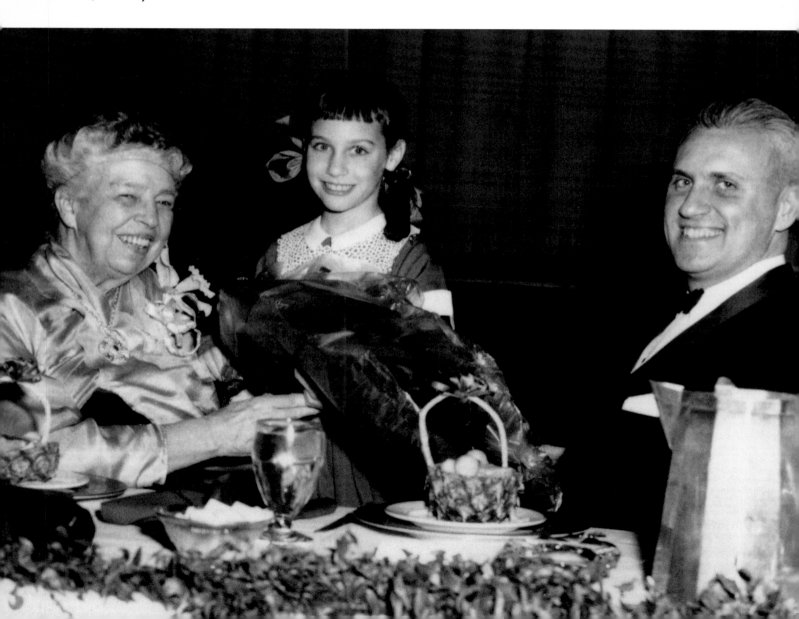

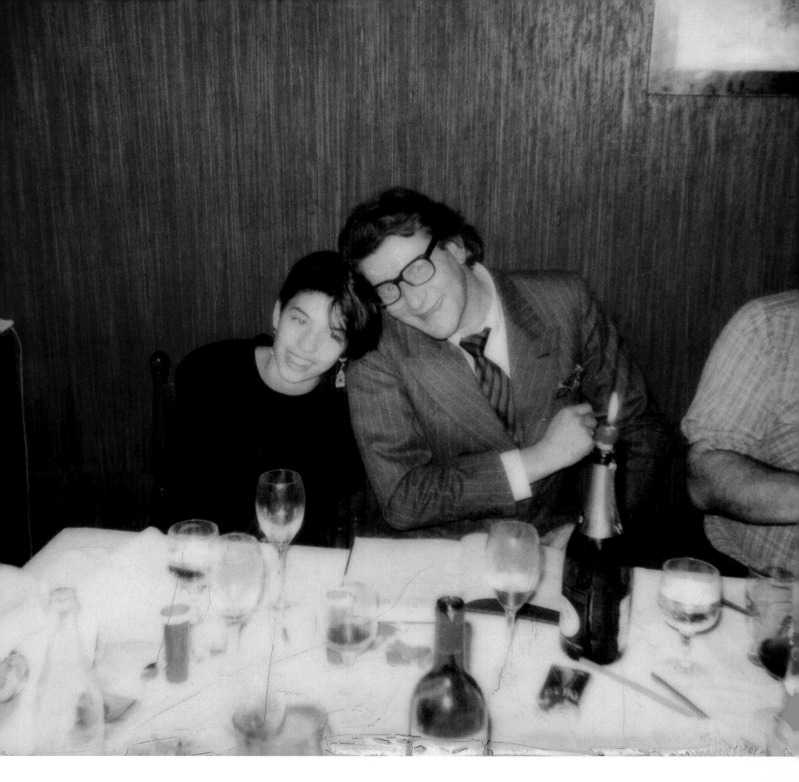

Paris, France 1984 My height of fashion? Snuggling up
with Yves Saint Laurent at Dave's. **Sofia Coppola**

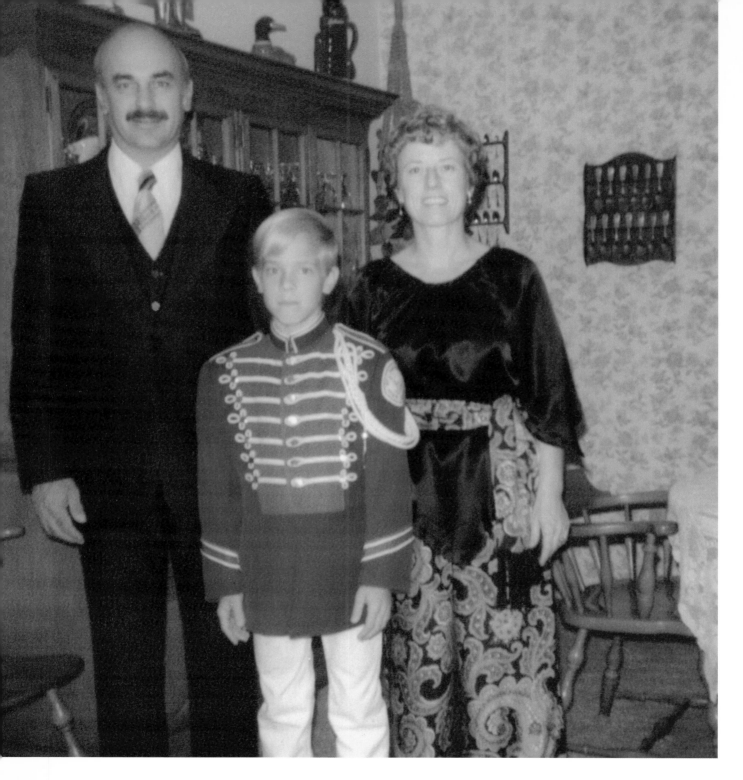

Yuma, Arizona 1979 I'm in Junior High and I'm in band. I loved my uniform. I just thought I was the shit. The jacket's too big and we had to wear white jeans because the school couldn't afford pants. It was so nerdy to be in band, but I really loved that uniform. I must be going to a concert and my parents were coming to see me because they're all dressed up. I played the clarinet. I was desperate to play the saxophone, but they said you had to start on the clarinet. I quit band when I got to High School. I still have my clarinet. Sometimes I feel bad about what could have been. **Bruce Pask**

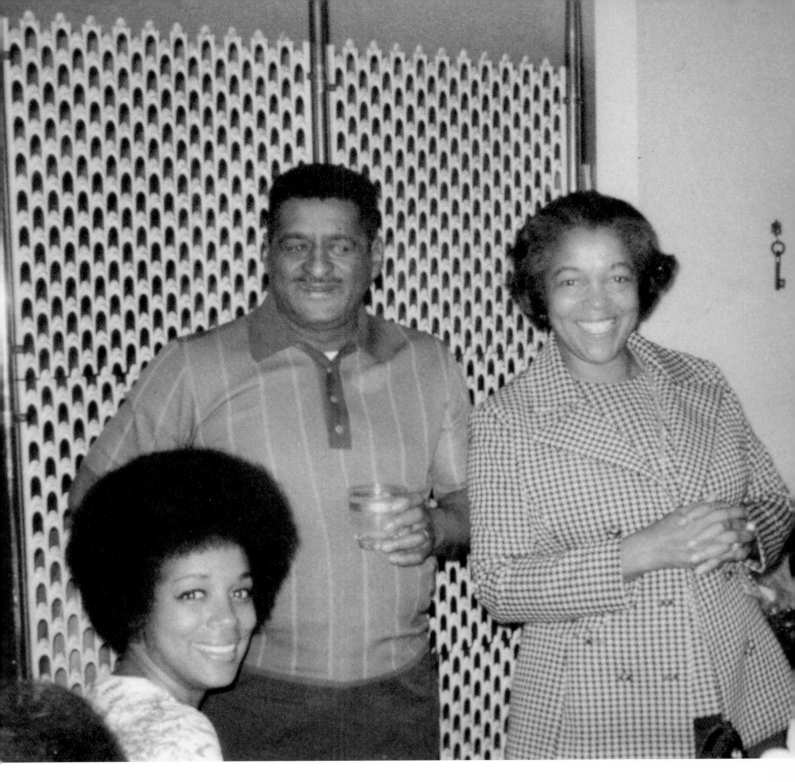

Los Angeles, California 1969
Lillian Baugh

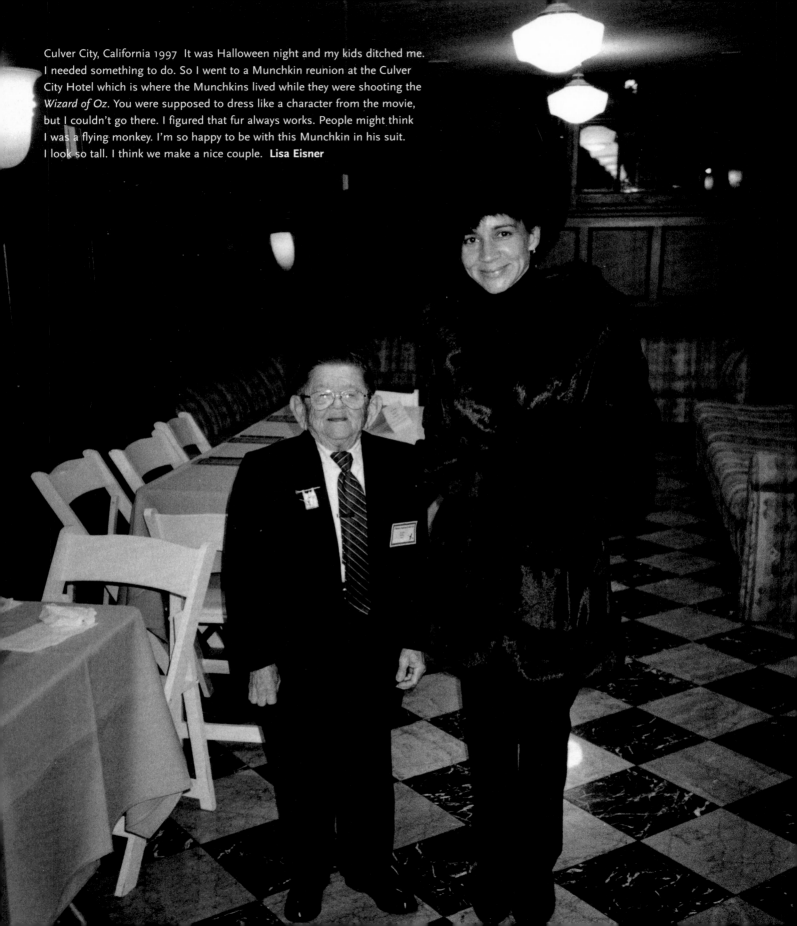

Culver City, California 1997 It was Halloween night and my kids ditched me.
I needed something to do. So I went to a Munchkin reunion at the Culver
City Hotel which is where the Munchkins lived while they were shooting the
Wizard of Oz. You were supposed to dress like a character from the movie,
but I couldn't go there. I figured that fur always works. People might think
I was a flying monkey. I'm so happy to be with this Munchkin in his suit.
I look so tall. I think we make a nice couple. **Lisa Eisner**

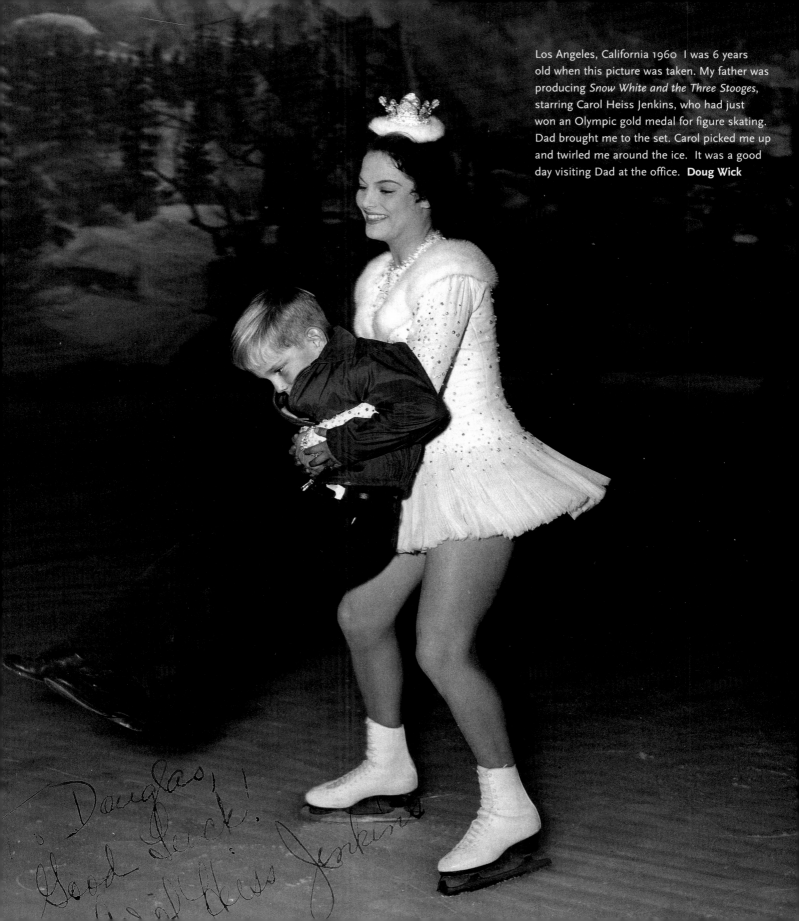

Los Angeles, California 1960 I was 6 years old when this picture was taken. My father was producing *Snow White and the Three Stooges*, starring Carol Heiss Jenkins, who had just won an Olympic gold medal for figure skating. Dad brought me to the set. Carol picked me up and twirled me around the ice. It was a good day visiting Dad at the office. **Doug Wick**

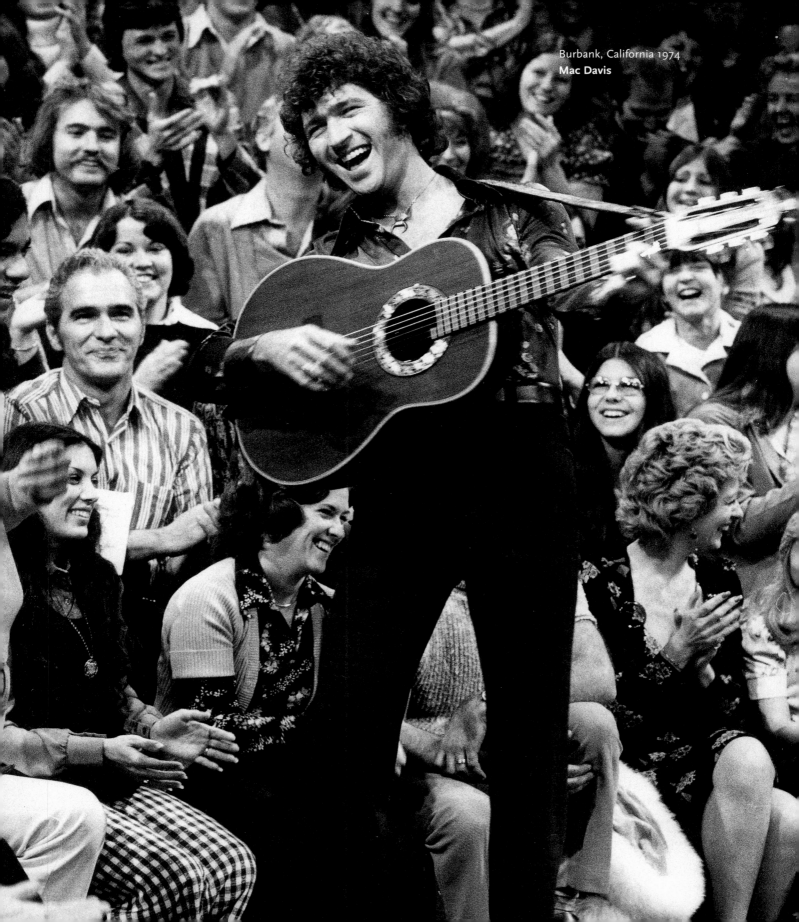

Burbank, California 1974
Mac Davis

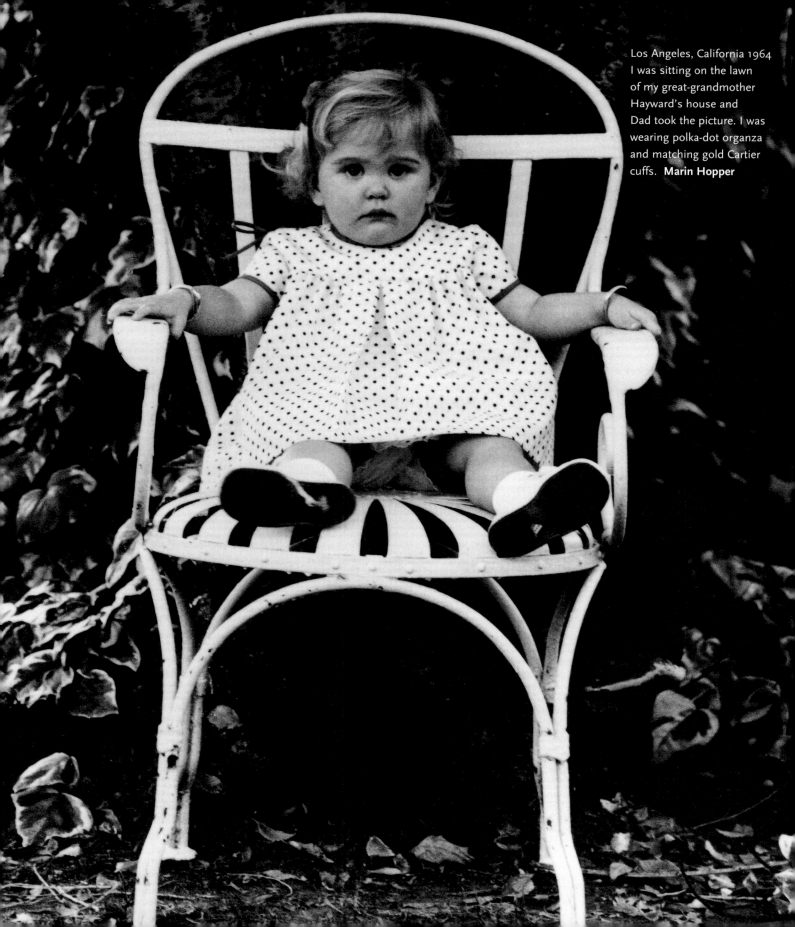

Los Angeles, California 1964
I was sitting on the lawn
of my great-grandmother
Hayward's house and
Dad took the picture. I was
wearing polka-dot organza
and matching gold Cartier
cuffs. **Marin Hopper**

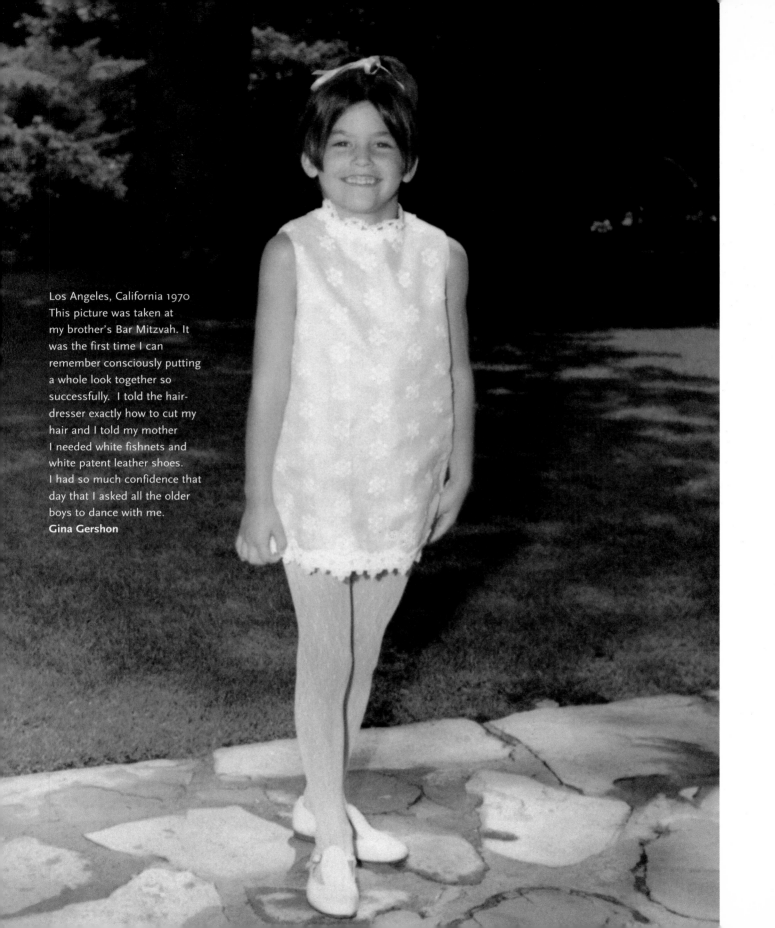

Los Angeles, California 1970
This picture was taken at
my brother's Bar Mitzvah. It
was the first time I can
remember consciously putting
a whole look together so
successfully. I told the hair-
dresser exactly how to cut my
hair and I told my mother
I needed white fishnets and
white patent leather shoes.
I had so much confidence that
day that I asked all the older
boys to dance with me.
Gina Gershon

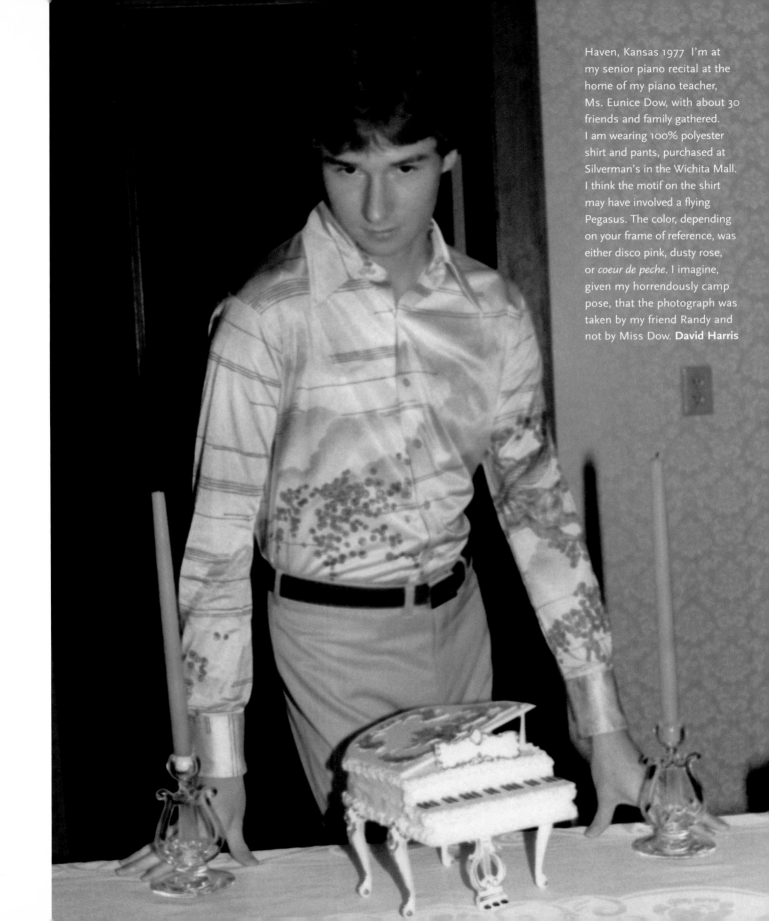

Haven, Kansas 1977 I'm at my senior piano recital at the home of my piano teacher, Ms. Eunice Dow, with about 30 friends and family gathered. I am wearing 100% polyester shirt and pants, purchased at Silverman's in the Wichita Mall. I think the motif on the shirt may have involved a flying Pegasus. The color, depending on your frame of reference, was either disco pink, dusty rose, or *coeur de peche*. I imagine, given my horrendously camp pose, that the photograph was taken by my friend Randy and not by Miss Dow. **David Harris**

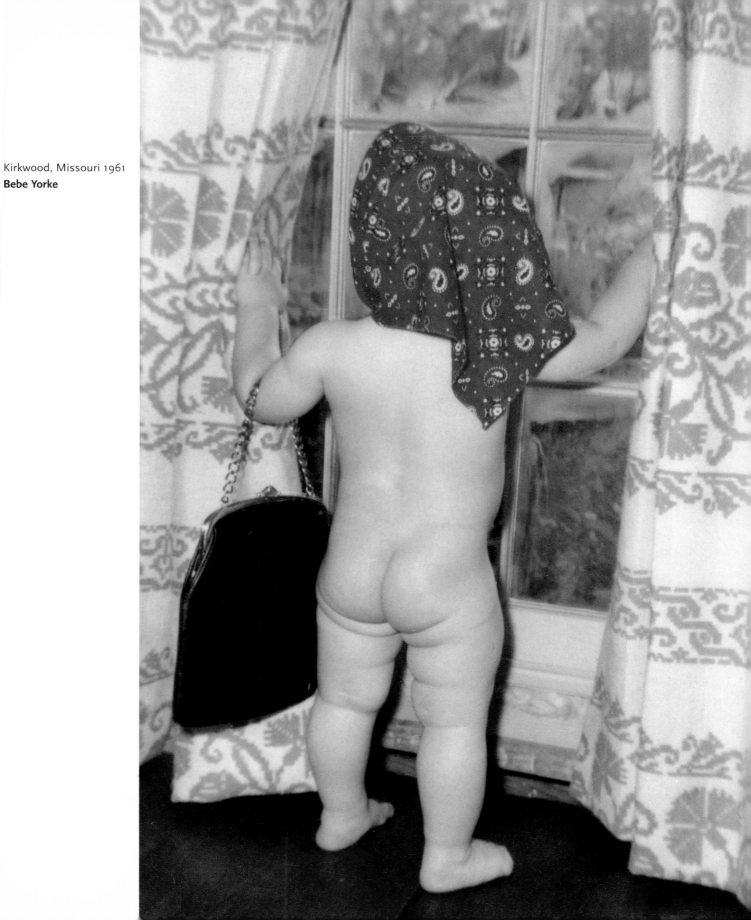

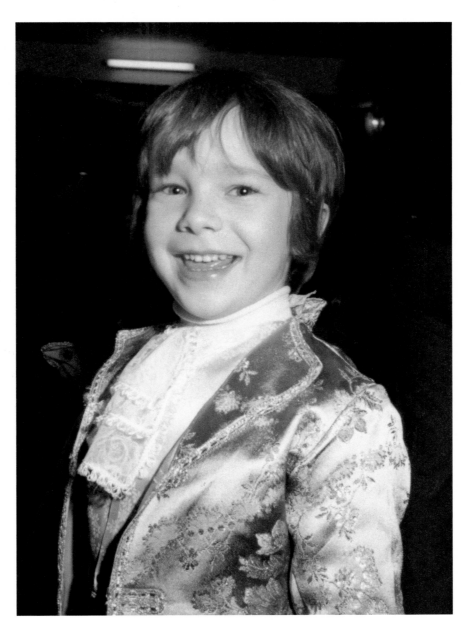

Cortina, Italy 1973 I was at a carnival party for children.
I am wearing a jacket designed by Pierre Cardin.
I had just taken off a white wig and beauty mark—they itched.
Domiziano Arcangeli

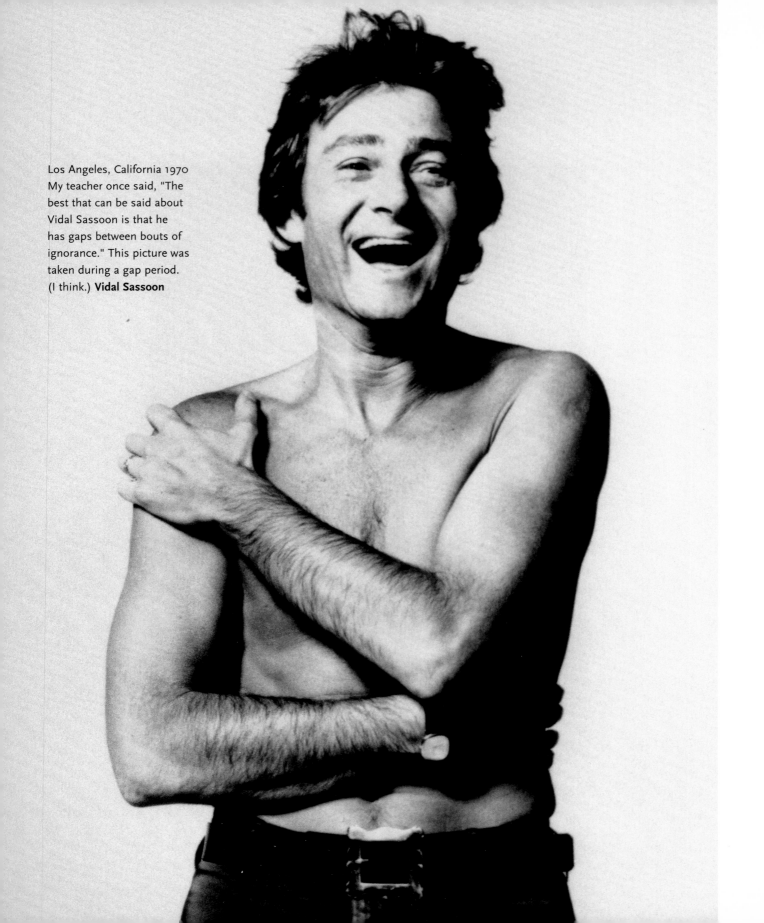

Los Angeles, California 1970
My teacher once said, "The best that can be said about Vidal Sassoon is that he has gaps between bouts of ignorance." This picture was taken during a gap period. (I think.) **Vidal Sassoon**

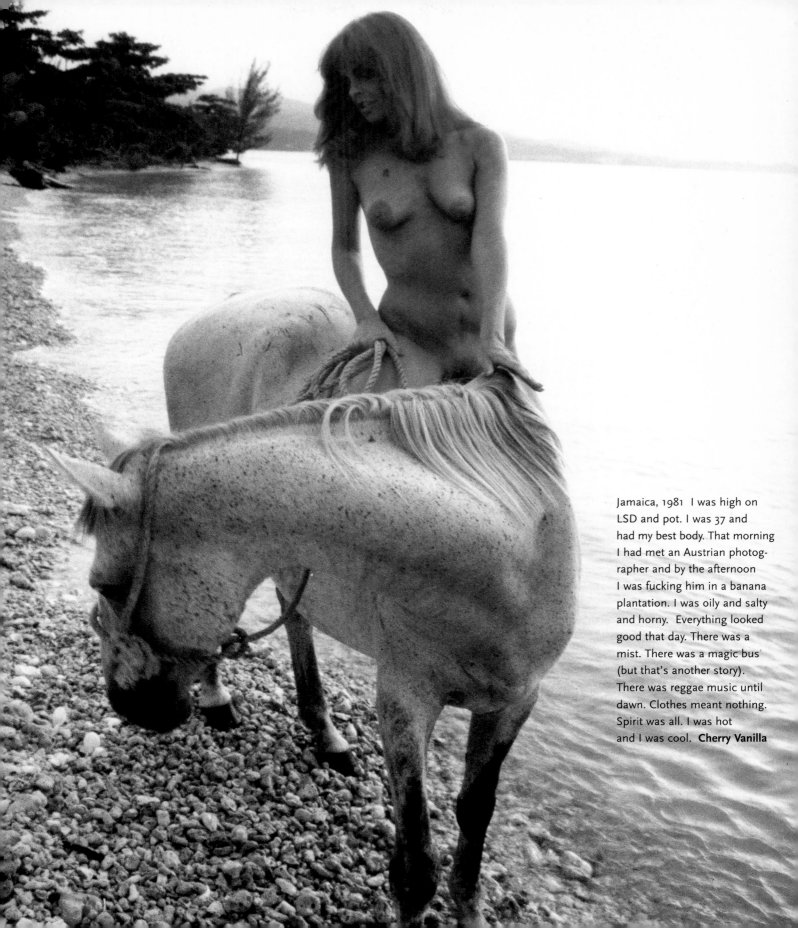

Jamaica, 1981 I was high on LSD and pot. I was 37 and had my best body. That morning I had met an Austrian photographer and by the afternoon I was fucking him in a banana plantation. I was oily and salty and horny. Everything looked good that day. There was a mist. There was a magic bus (but that's another story). There was reggae music until dawn. Clothes meant nothing. Spirit was all. I was hot and I was cool. **Cherry Vanilla**

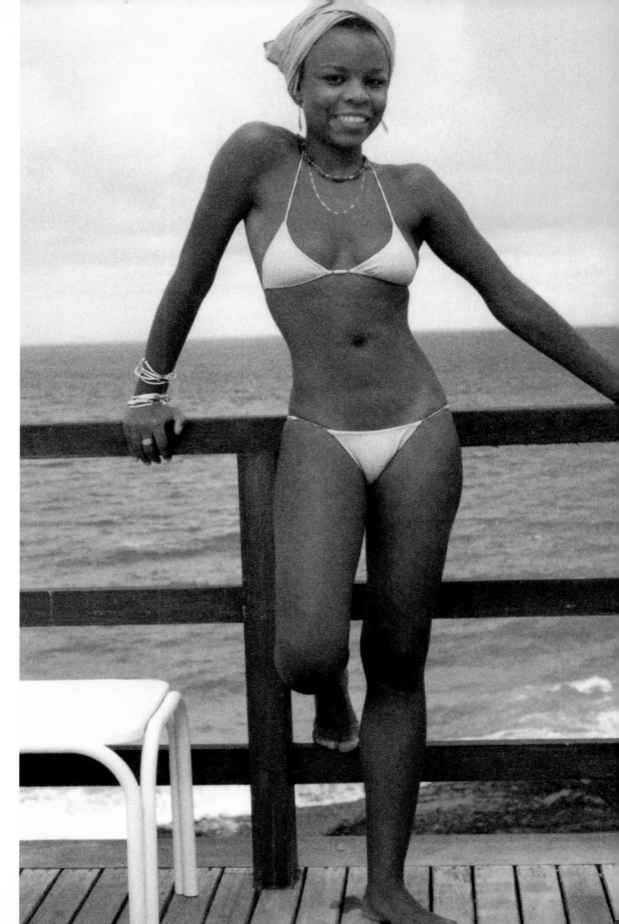

Salvador Bahia, Brasil 1979
I am reluctant to use this
photo yet I love it because
I am in my prime.
Teri Agins

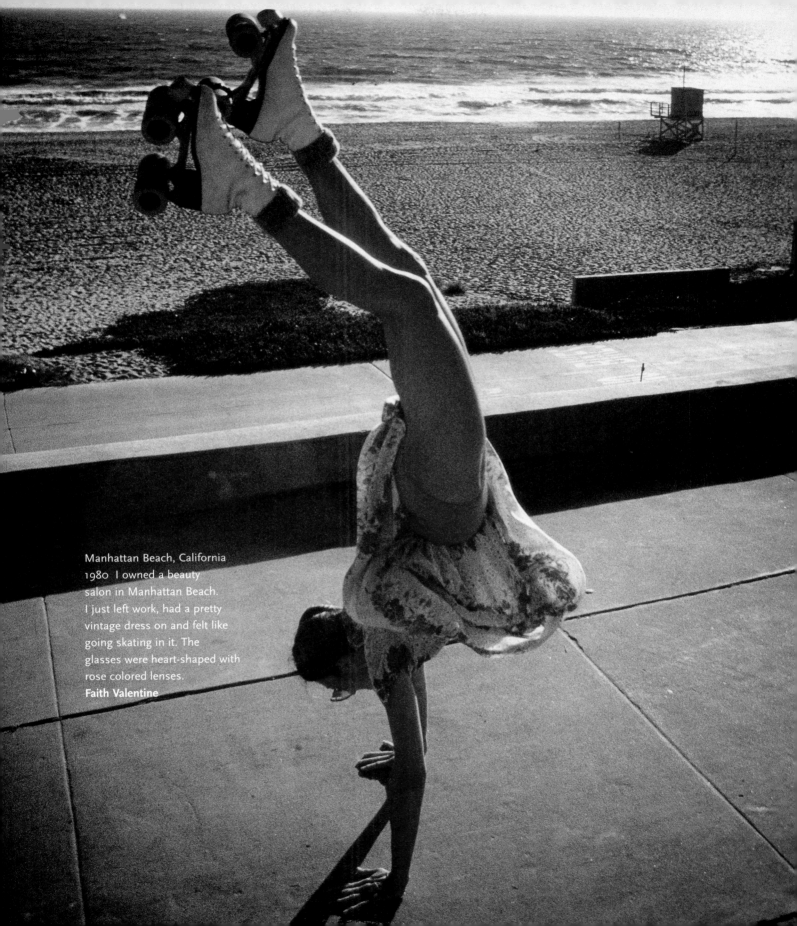

Manhattan Beach, California
1980 I owned a beauty
salon in Manhattan Beach.
I just left work, had a pretty
vintage dress on and felt like
going skating in it. The
glasses were heart-shaped with
rose colored lenses.
Faith Valentine

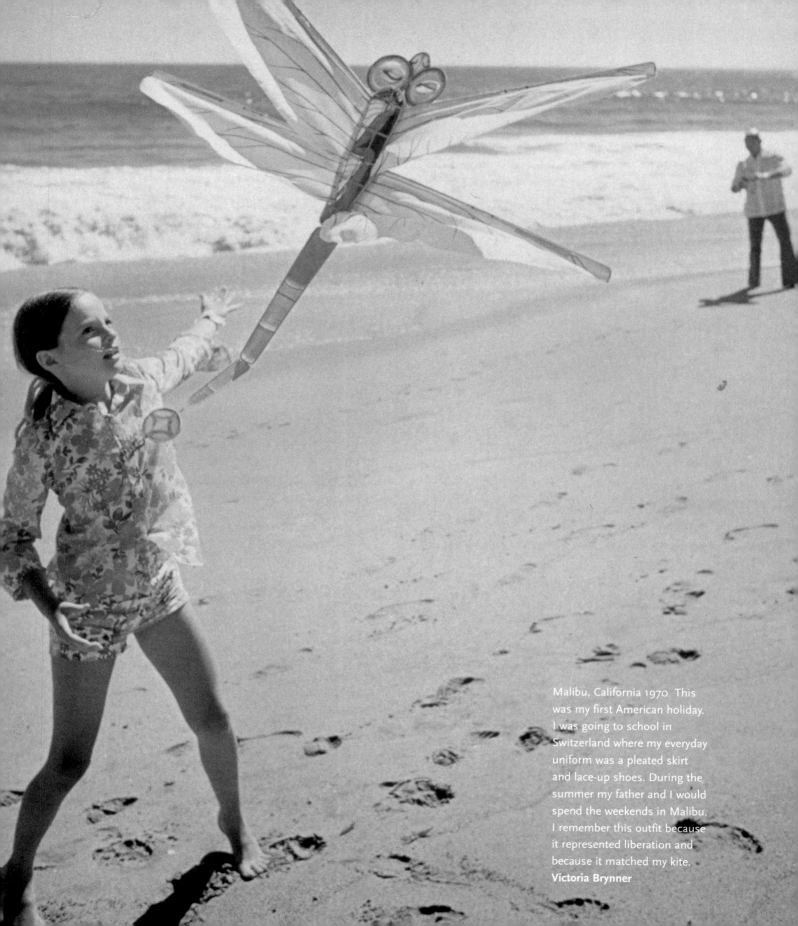

Malibu, California 1970 This
was my first American holiday.
I was going to school in
Switzerland where my everyday
uniform was a pleated skirt
and lace-up shoes. During the
summer my father and I would
spend the weekends in Malibu.
I remember this outfit because
it represented liberation and
because it matched my kite.
Victoria Brynner

Los Angeles, California 1975 First day of school, which always means new clothes. My jeans were creased and very starched. Starch was in. **Cecily Carrington**

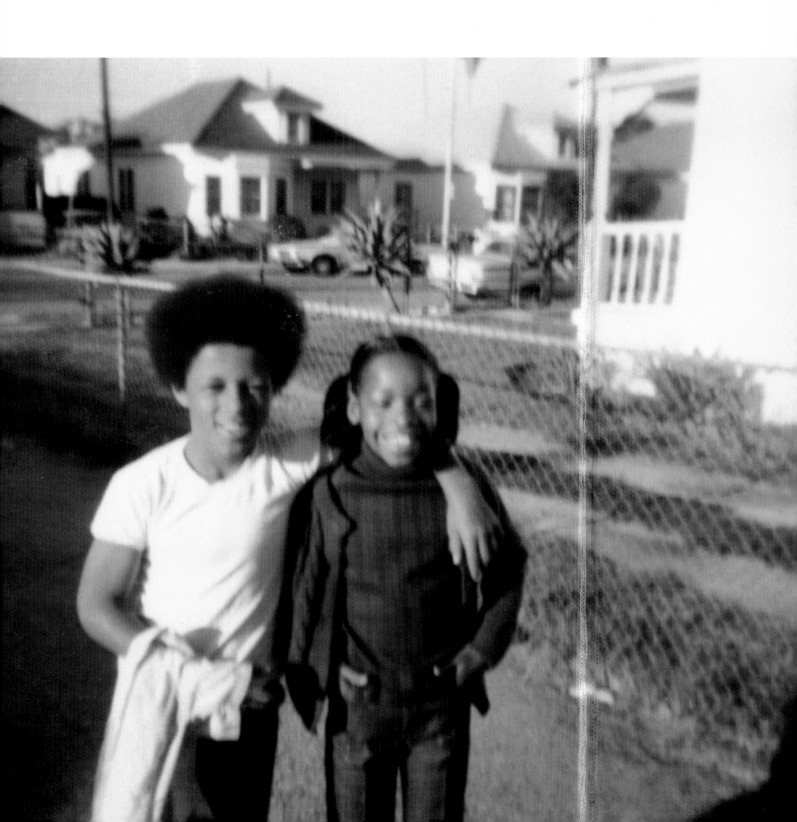

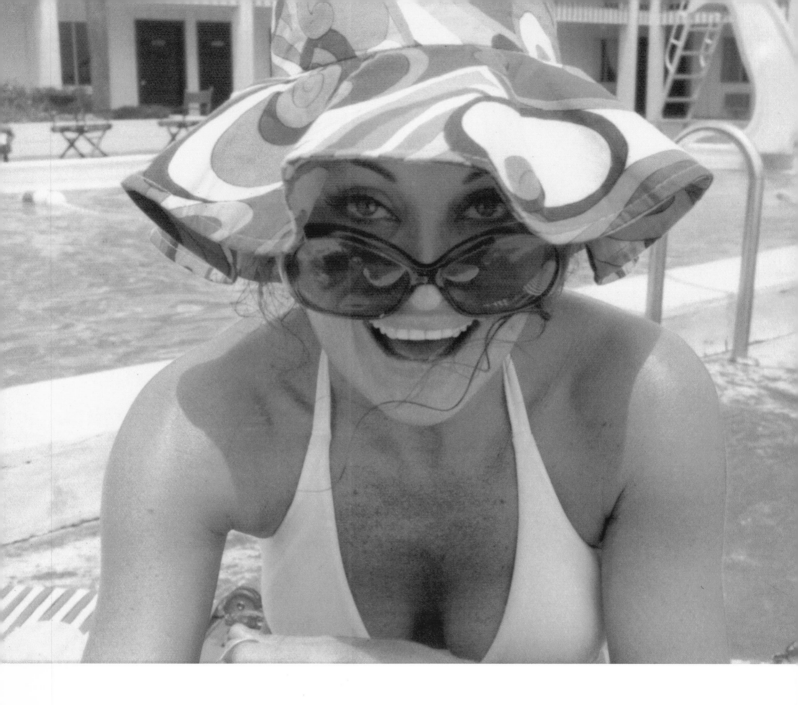

Destin, Florida 1972
Linda Tanana

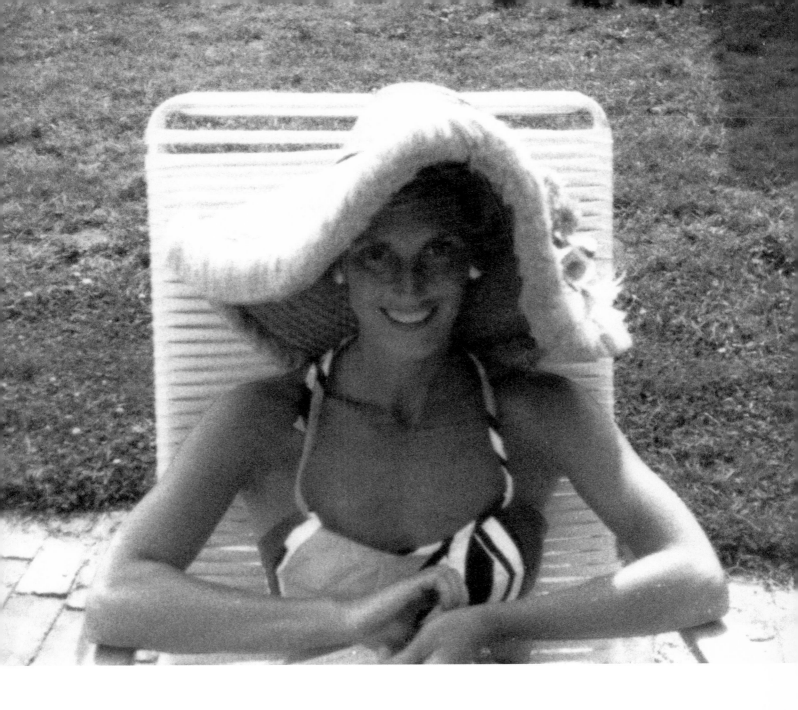

East Hampton, New York 1961
Jean Clarke

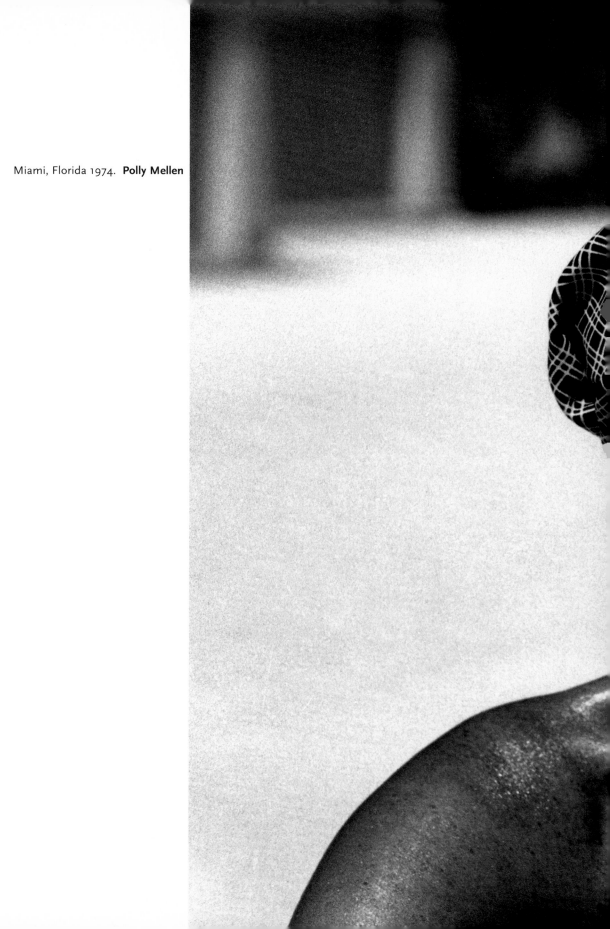

Miami, Florida 1974. **Polly Mellen**

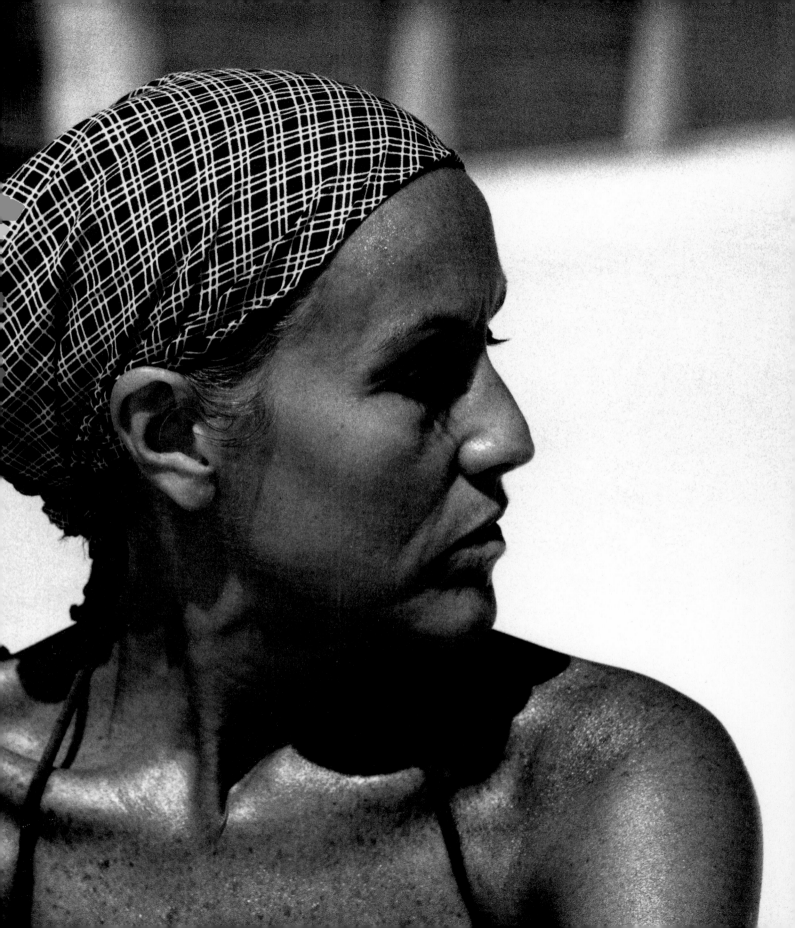

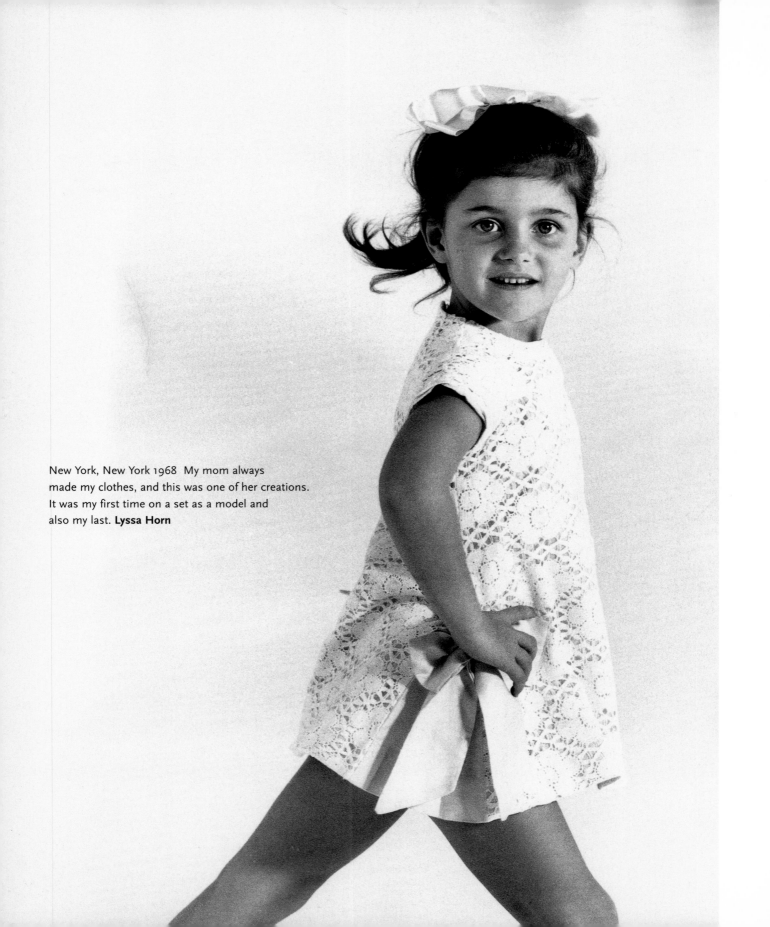

New York, New York 1968 My mom always
made my clothes, and this was one of her creations.
It was my first time on a set as a model and
also my last. **Lyssa Horn**

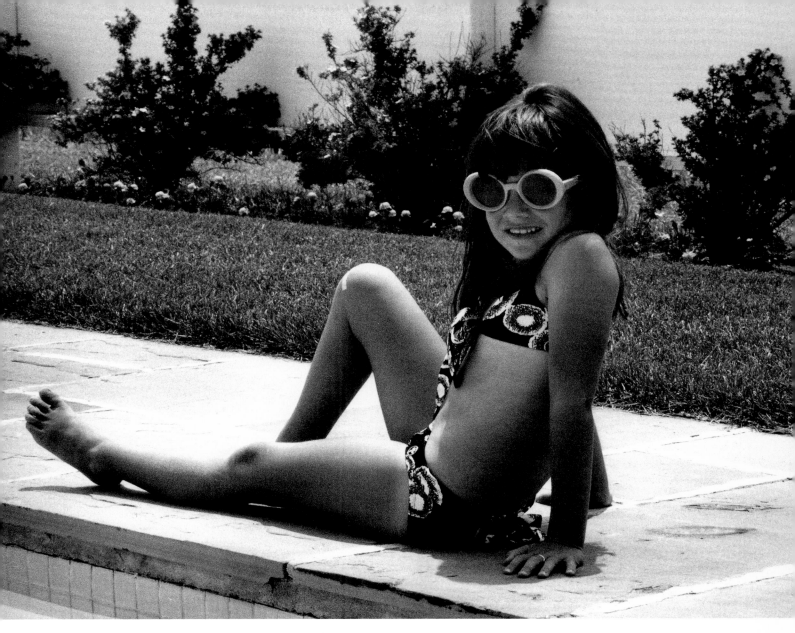

Long Island, New York 1970 This picture was taken at my family home in East Hampton.
I was 5, and this was my first grown-up swimsuit by Fiorucci. The sunglasses were my Mom's.
I wanted to be just like her. She was the original Mrs. Robinson. All my other girlfriends
were going topless, but I insisted on wearing the whole suit. I think I was waiting for the lawnboy,
who was 14, to come over. I remember running home from daycamp to wait for him.
Elizabeth Saltzman

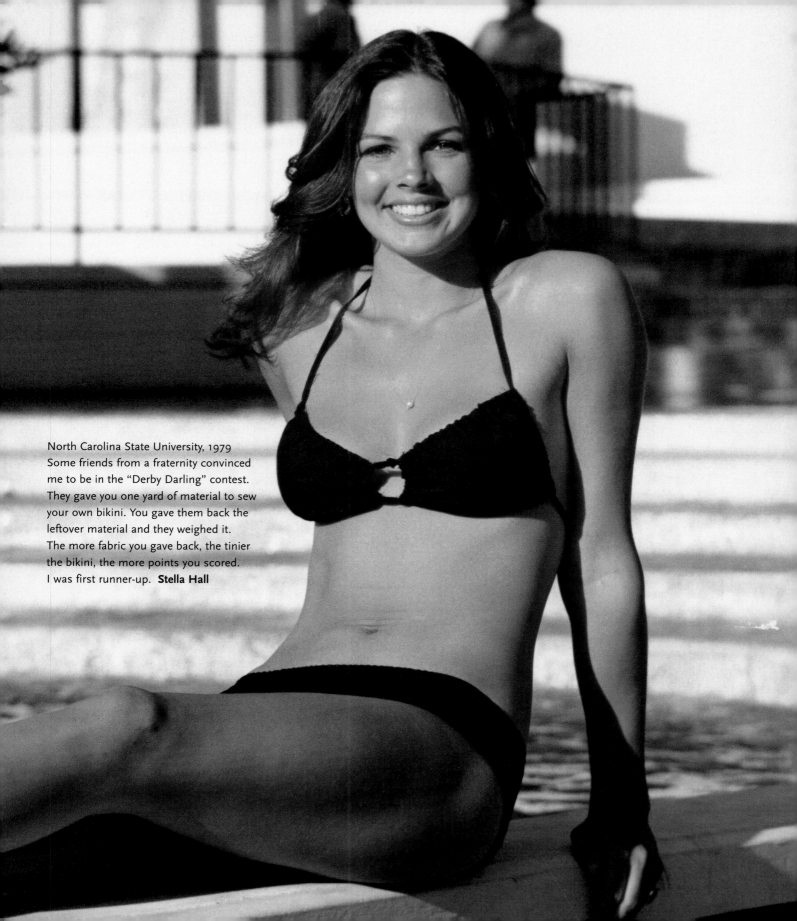

North Carolina State University, 1979
Some friends from a fraternity convinced
me to be in the "Derby Darling" contest.
They gave you one yard of material to sew
your own bikini. You gave them back the
leftover material and they weighed it.
The more fabric you gave back, the tinier
the bikini, the more points you scored.
I was first runner-up. **Stella Hall**

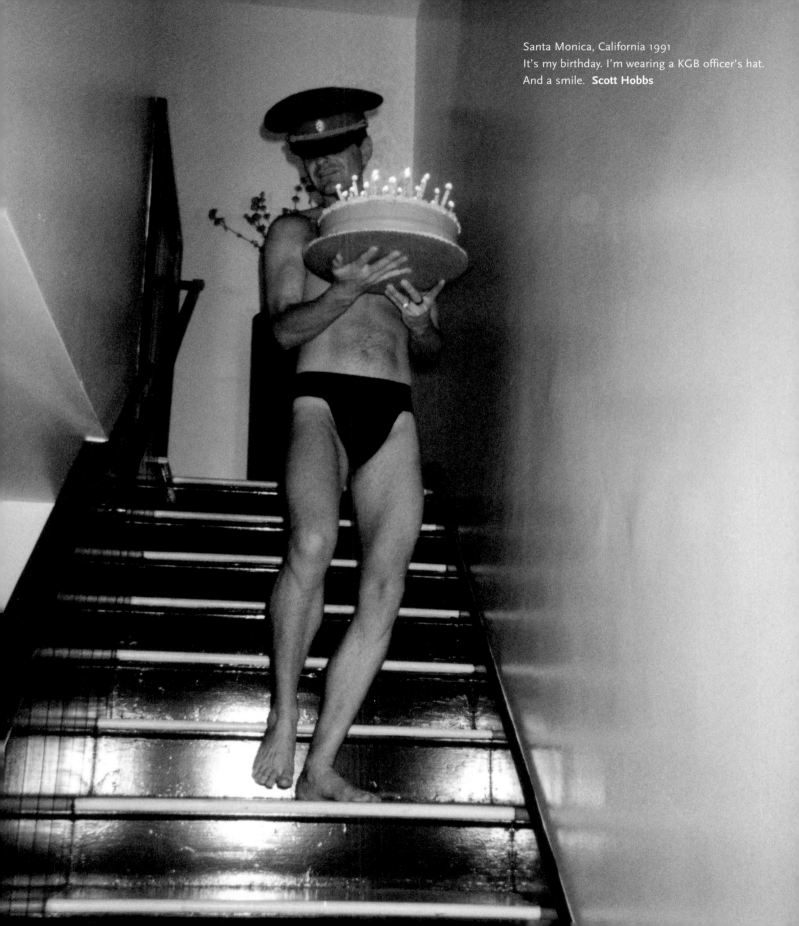

Santa Monica, California 1991
It's my birthday. I'm wearing a KGB officer's hat.
And a smile. **Scott Hobbs**

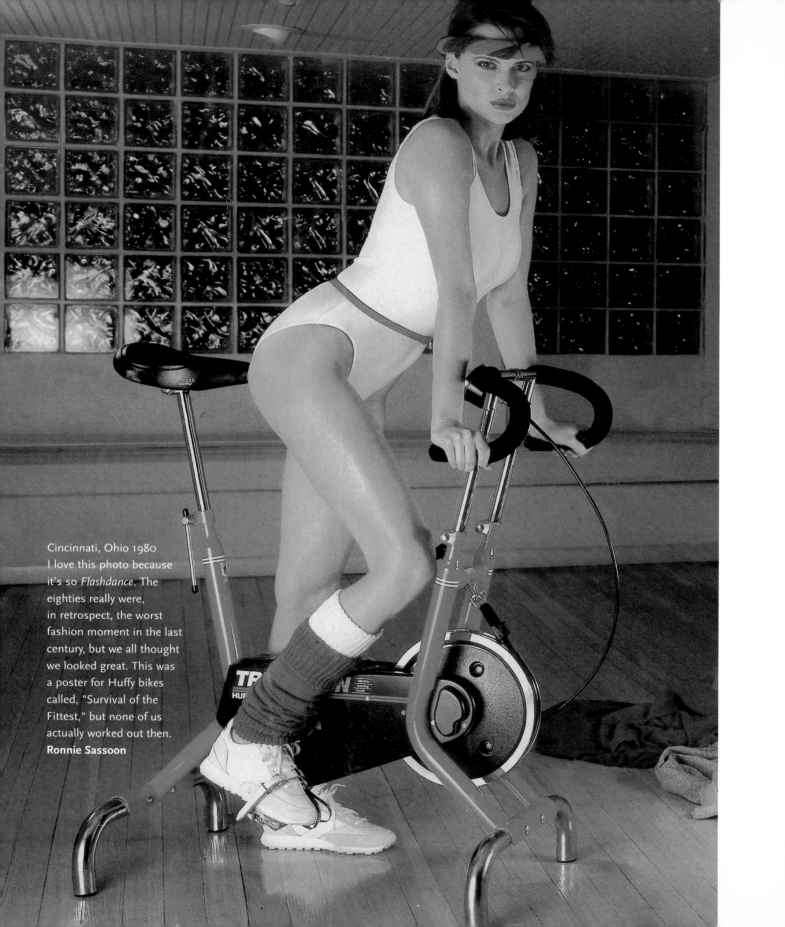

Cincinnati, Ohio 1980
I love this photo because
it's so *Flashdance*. The
eighties really were,
in retrospect, the worst
fashion moment in the last
century, but we all thought
we looked great. This was
a poster for Huffy bikes
called, "Survival of the
Fittest," but none of us
actually worked out then.
Ronnie Sassoon

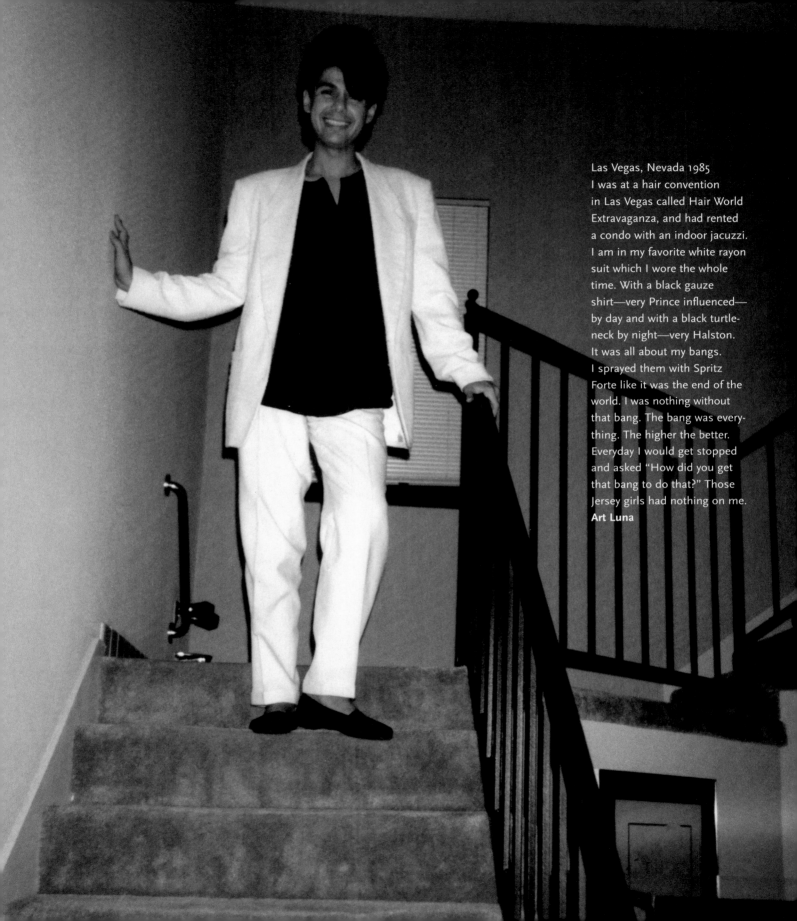

Las Vegas, Nevada 1985
I was at a hair convention in Las Vegas called Hair World Extravaganza, and had rented a condo with an indoor jacuzzi. I am in my favorite white rayon suit which I wore the whole time. With a black gauze shirt—very Prince influenced—by day and with a black turtle-neck by night—very Halston. It was all about my bangs. I sprayed them with Spritz Forte like it was the end of the world. I was nothing without that bang. The bang was every-thing. The higher the better. Everyday I would get stopped and asked "How did you get that bang to do that?" Those Jersey girls had nothing on me.
Art Luna

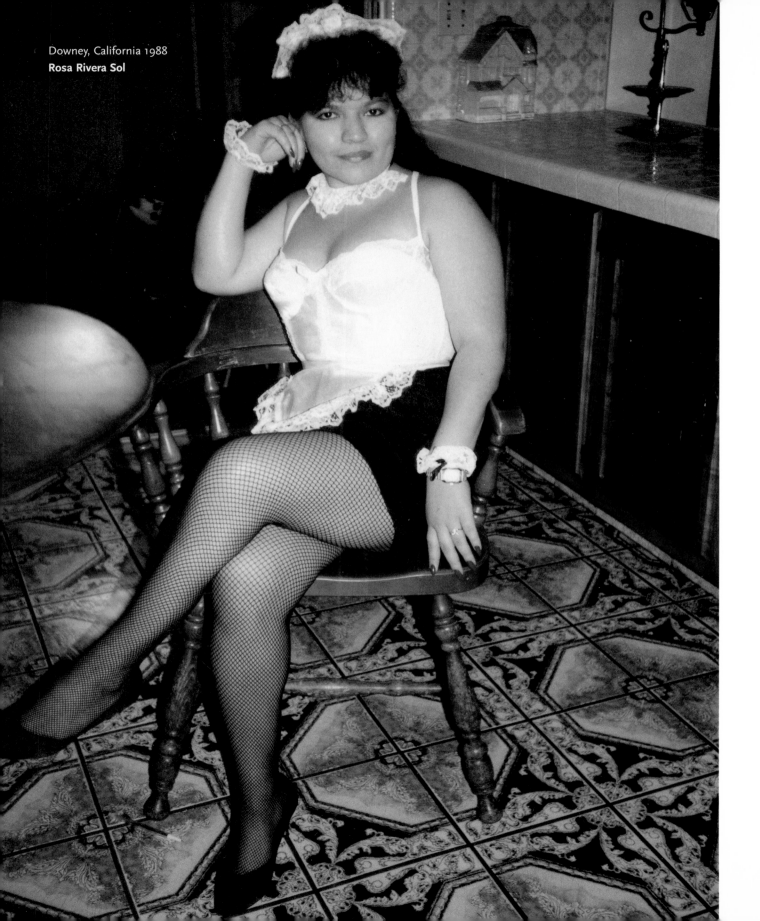

Downey, California 1988
Rosa Rivera Sol

THE "MISS SKYWAY" AWARD

New York, New York 1956
Muffett Bowie

Tuscaloosa, Alabama 1972
I was in the Inga School
of Dance. The costume
was hand-made for a
recital. I loved it. I wore
it all the time. I even
dressed my life-size doll
in it. I still have it, actually,
but it's pretty nasty.
I think I peed in it.
Jamie Tisch

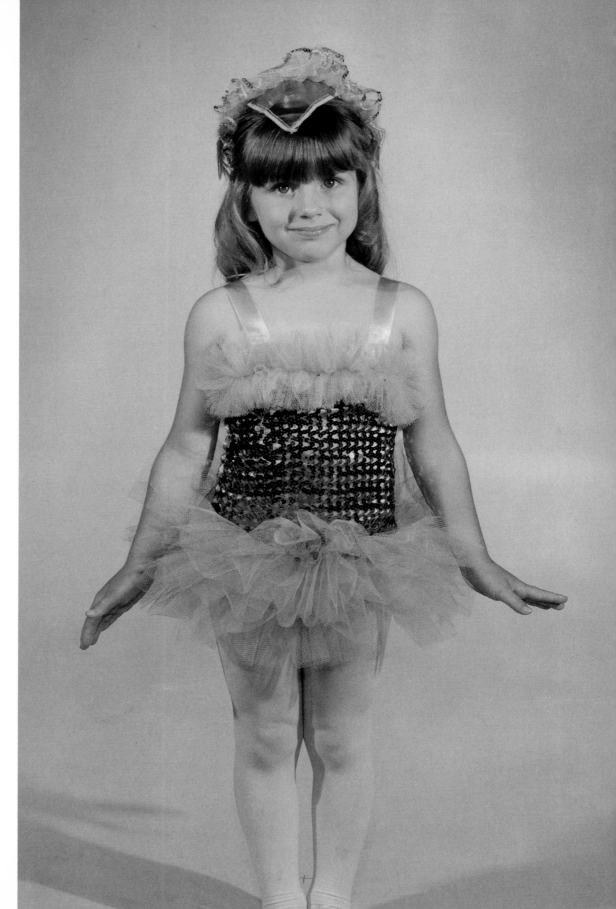

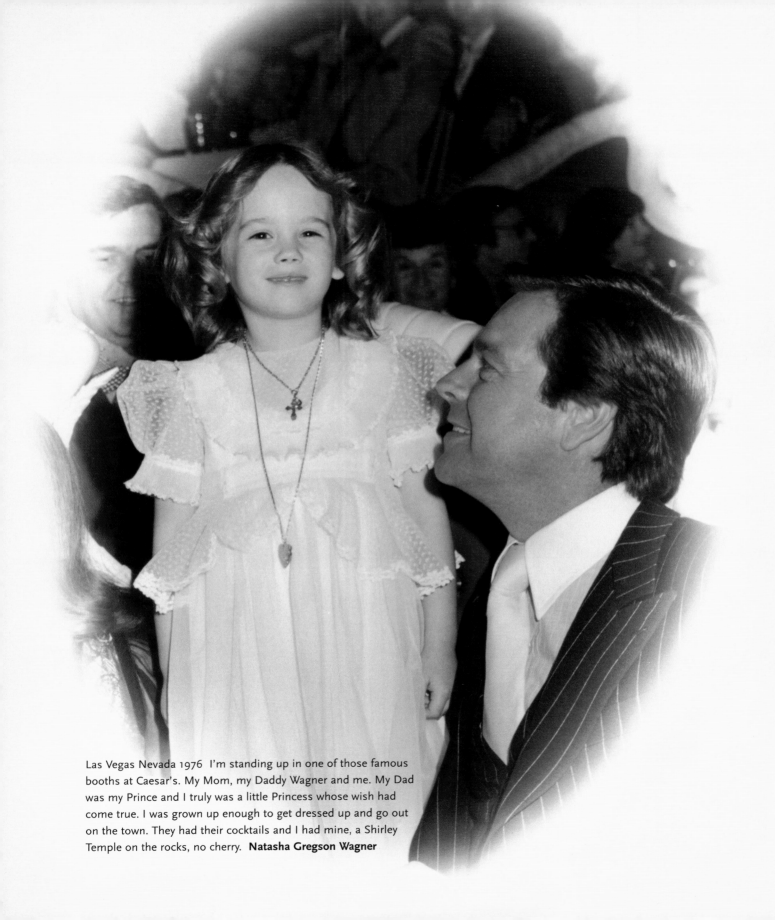

Las Vegas Nevada 1976 I'm standing up in one of those famous booths at Caesar's. My Mom, my Daddy Wagner and me. My Dad was my Prince and I truly was a little Princess whose wish had come true. I was grown up enough to get dressed up and go out on the town. They had their cocktails and I had mine, a Shirley Temple on the rocks, no cherry. **Natasha Gregson Wagner**

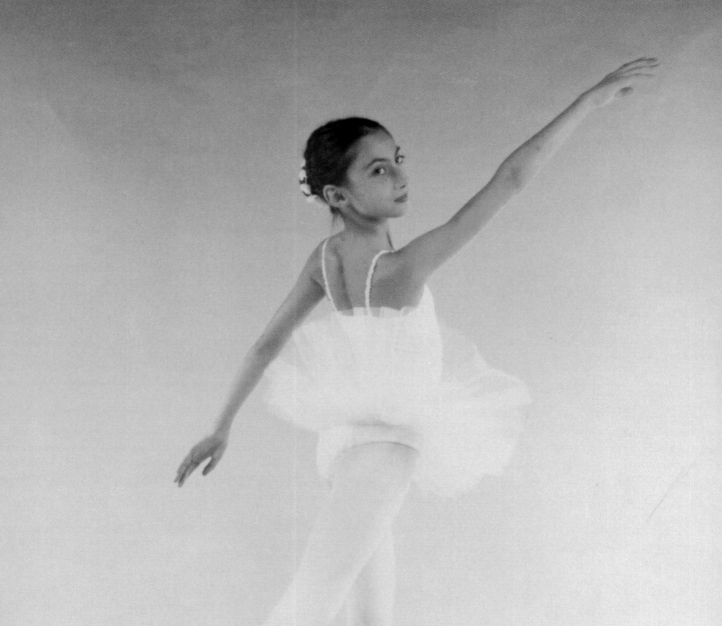

Paris, France 1974
Anh Duong

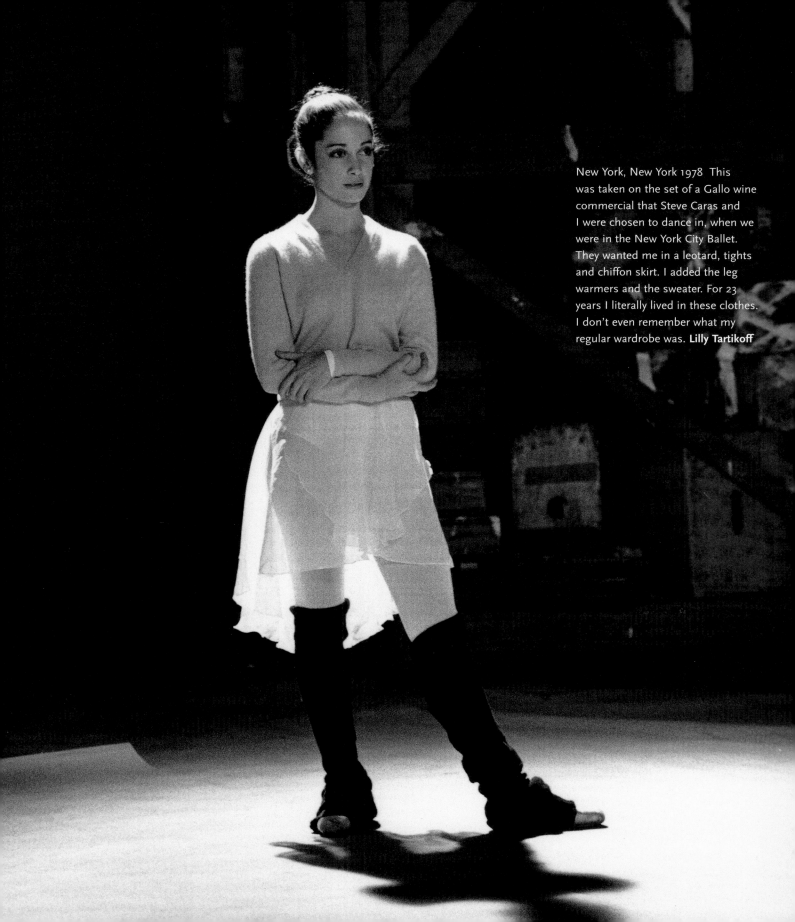

New York, New York 1978 This
was taken on the set of a Gallo wine
commercial that Steve Caras and
I were chosen to dance in, when we
were in the New York City Ballet.
They wanted me in a leotard, tights
and chiffon skirt. I added the leg
warmers and the sweater. For 23
years I literally lived in these clothes.
I don't even remember what my
regular wardrobe was. **Lilly Tartikoff**

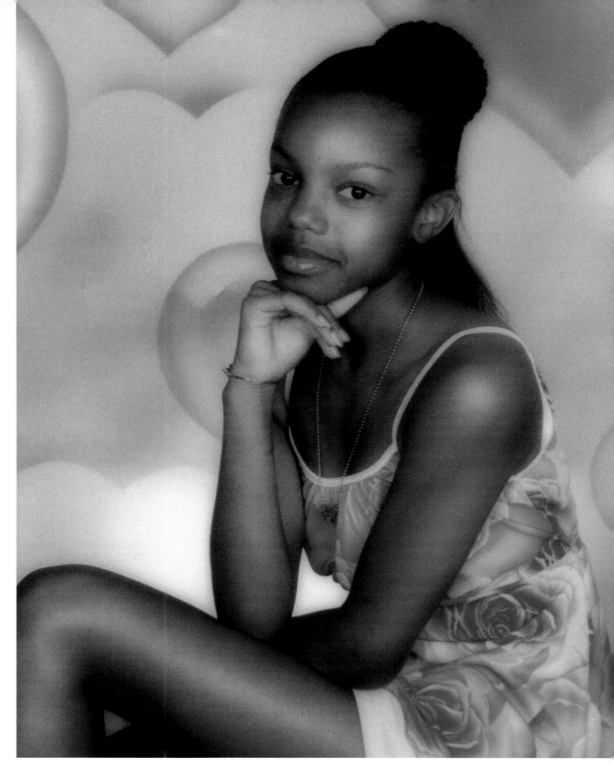

Carson, California 1999
Mieke Jackson

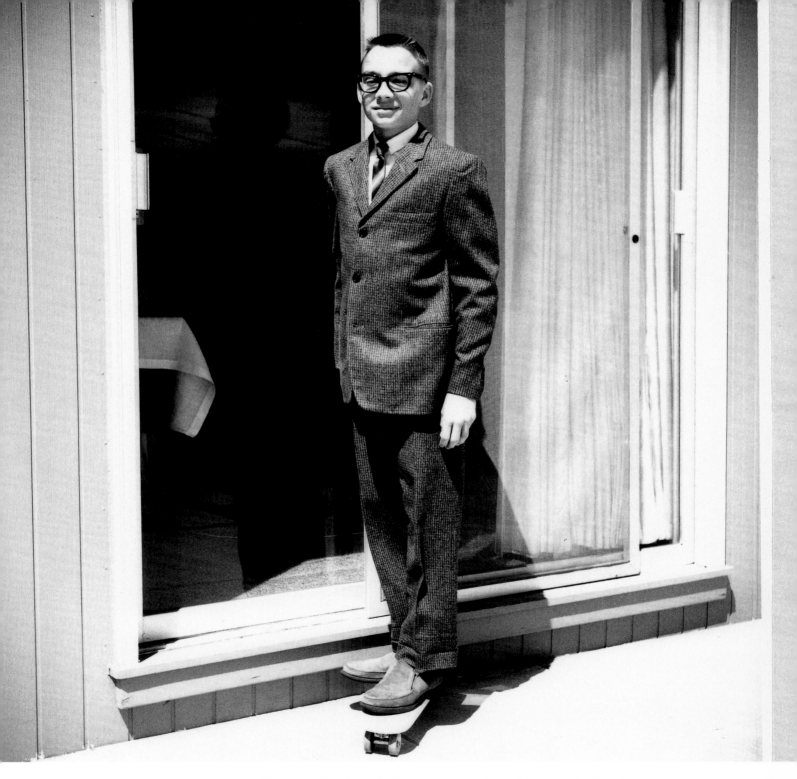

Cheyenne, Wyoming 1964 I never went anywhere without my skateboard.
The shoes: Hushpuppies. The crewcut: everyone had one. The white
socks: of course. The new suit jacket: a little too big. And last year's pants:
a little too short. The tie: my Dad's. I didn't own one. **Buck Norris**

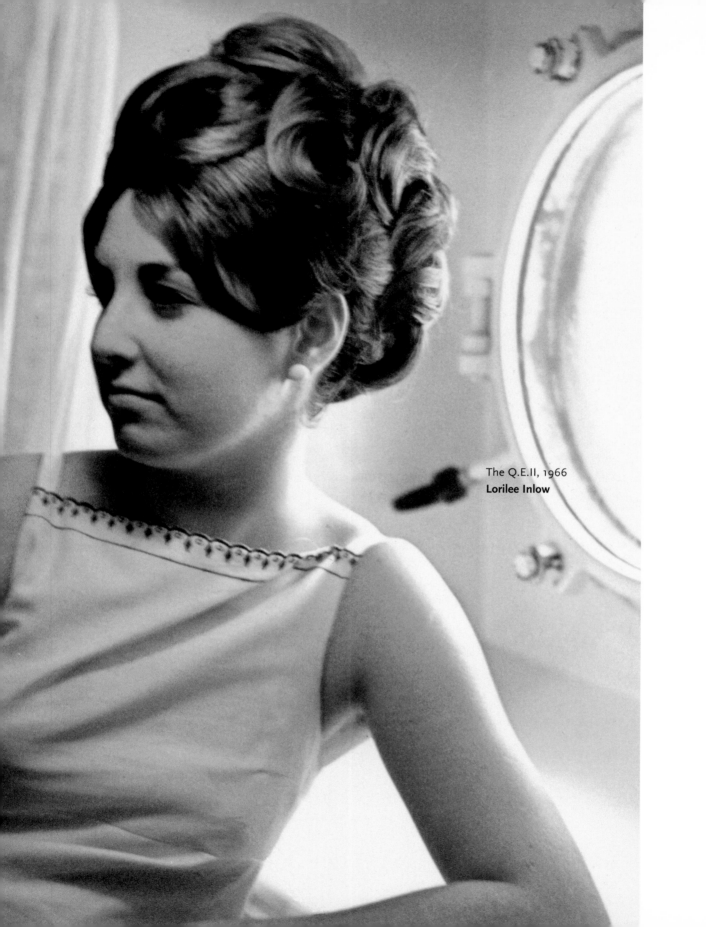

The Q.E.II, 1966
Lorilee Inlow

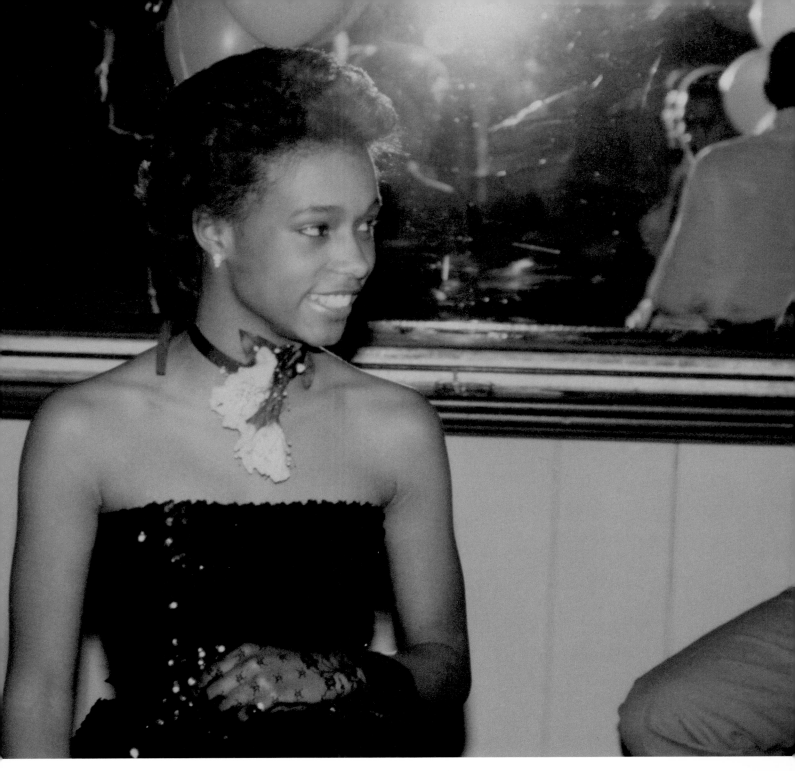

Morristown, New Jersey 1985 At my "sweet 16" birthday party. My Mother absolutely did not like this outfit! To her, I looked like a Playboy Bunny. To me, it was my ode to Madonna, the material girl! A Norma Kamali velvet skirt, a sequined top, and black lace gloves. Mom tried to soften the "hardness" with the stupid gardenias. I couldn't tell her she had just made me look *more* like a Playboy Bunny! **Sydne Bolden**

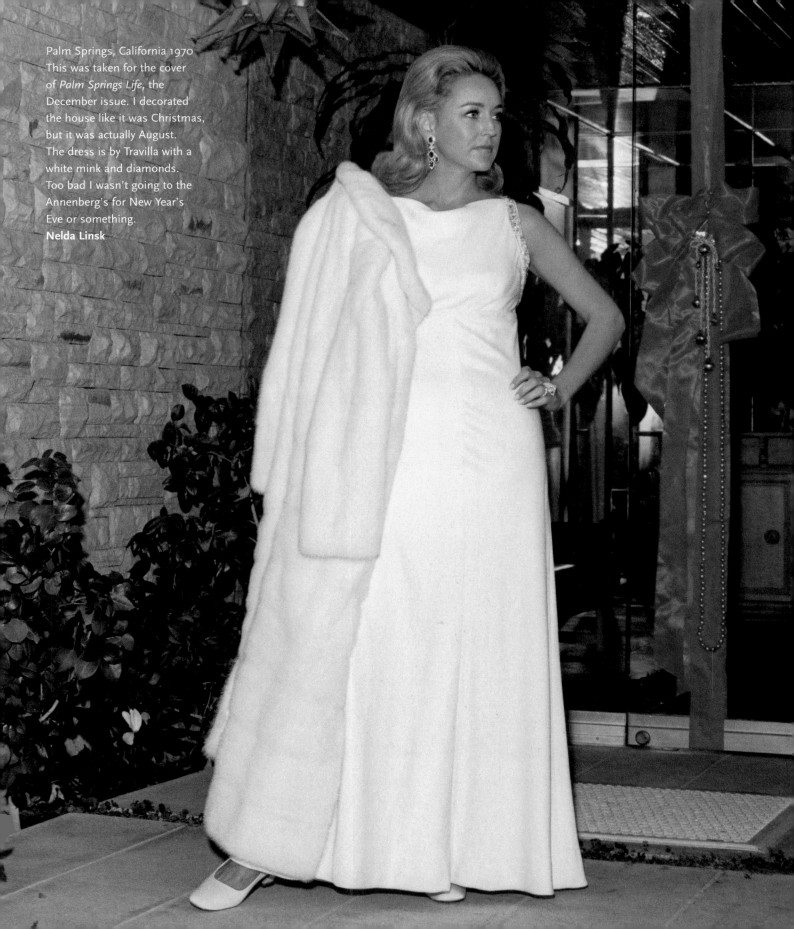

Palm Springs, California 1970
This was taken for the cover
of *Palm Springs Life*, the
December issue. I decorated
the house like it was Christmas,
but it was actually August.
The dress is by Travilla with a
white mink and diamonds.
Too bad I wasn't going to the
Annenberg's for New Year's
Eve or something.
Nelda Linsk

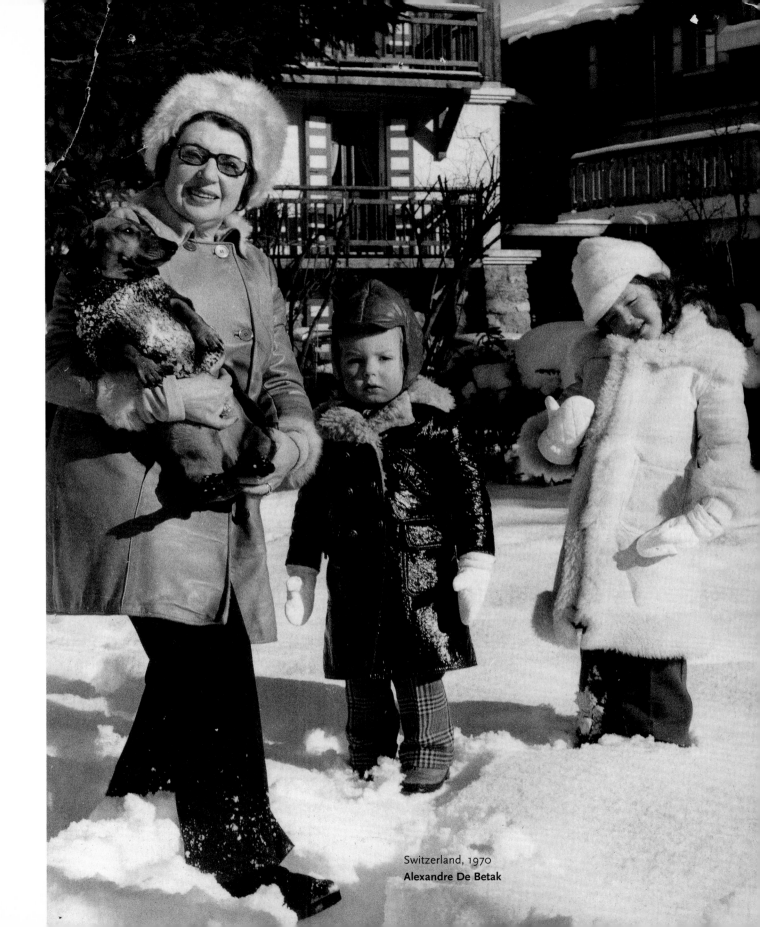

Switzerland, 1970
Alexandre De Betak

Montreal, Canada 1960 I went to see Santa in my white angora.
I thought a white angora muff was the ultimate. Until I couldn't get
it out of my eyes. **Linda Genereux**

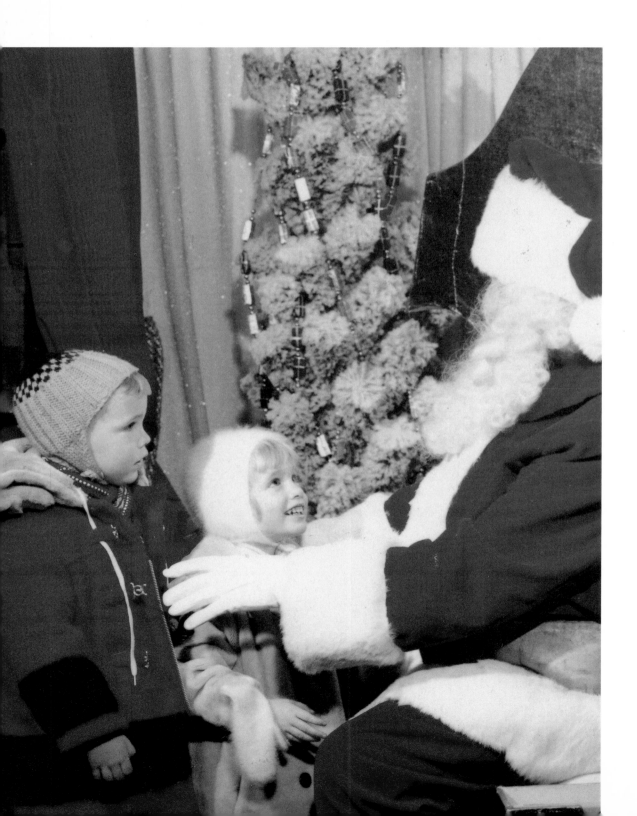

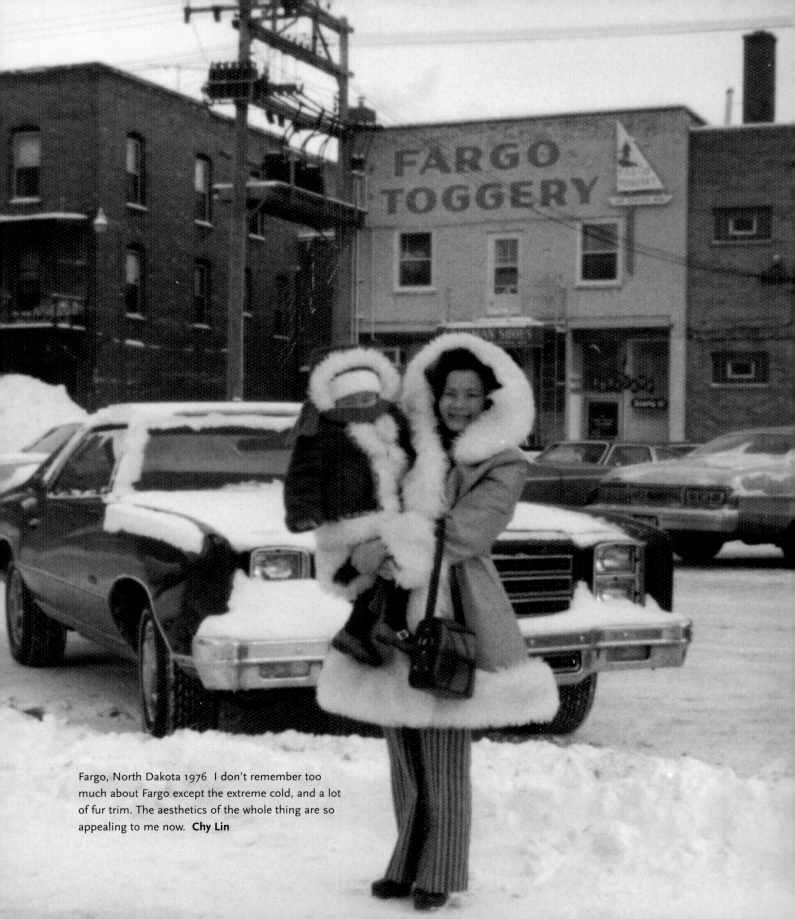

Fargo, North Dakota 1976 I don't remember too
much about Fargo except the extreme cold, and a lot
of fur trim. The aesthetics of the whole thing are so
appealing to me now. **Chy Lin**

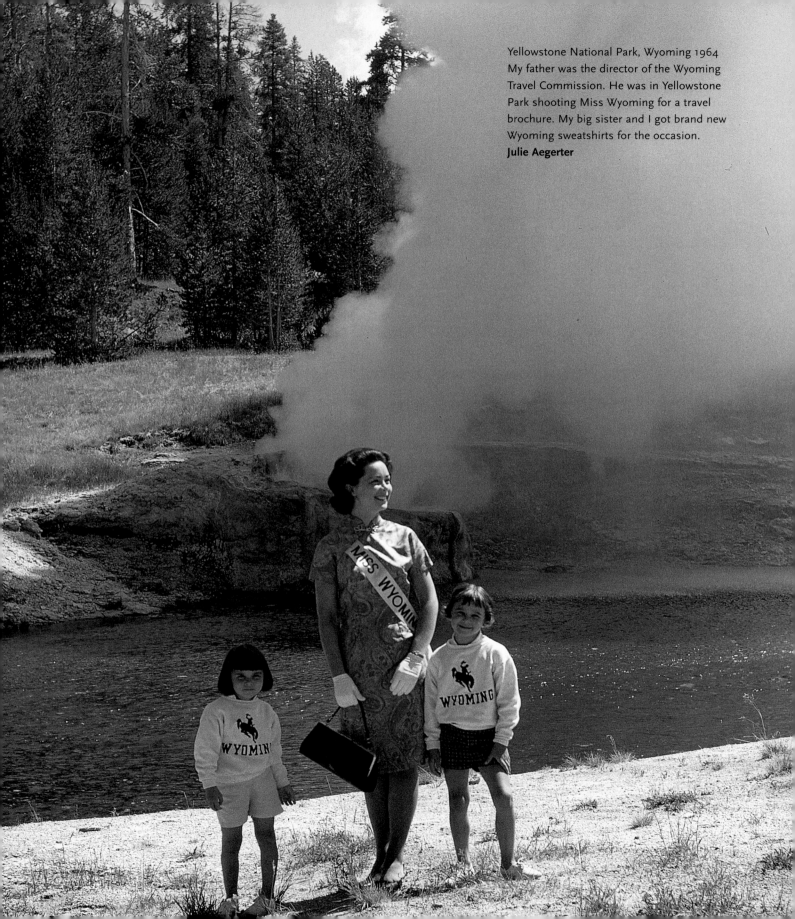

Yellowstone National Park, Wyoming 1964
My father was the director of the Wyoming
Travel Commission. He was in Yellowstone
Park shooting Miss Wyoming for a travel
brochure. My big sister and I got brand new
Wyoming sweatshirts for the occasion.
Julie Aegerter

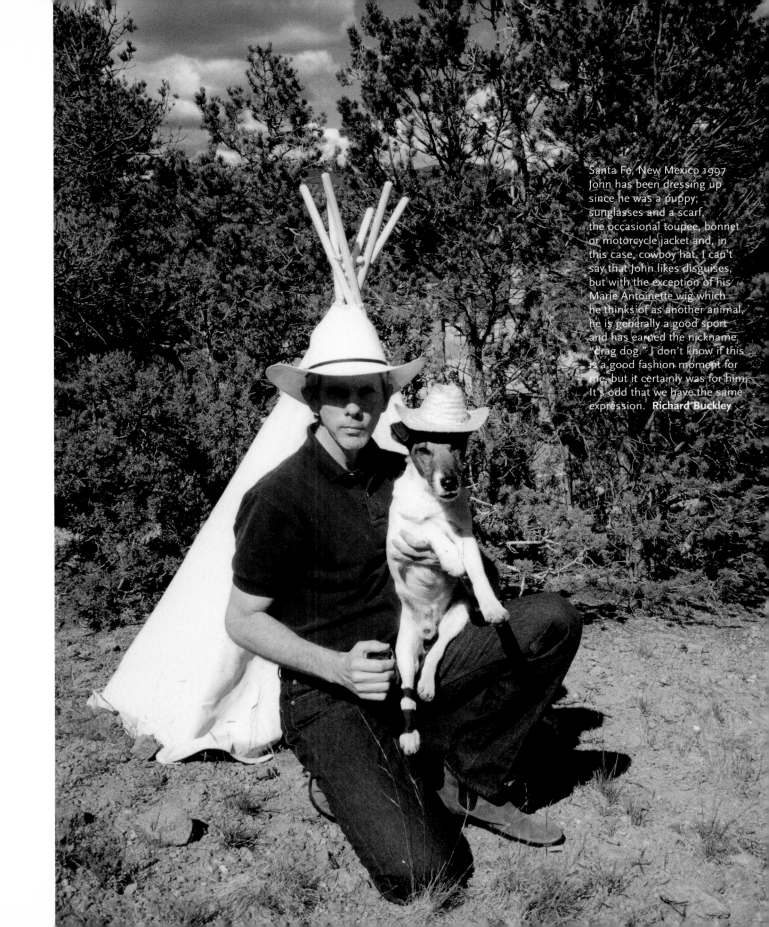

Santa Fe, New Mexico 1997
John has been dressing up
since he was a puppy;
sunglasses and a scarf,
the occasional toupee, bonnet
or motorcycle jacket and, in
this case, cowboy hat. I can't
say that John likes disguises,
but with the exception of his
Marie Antoinette wig which
he thinks of as another animal,
he is generally a good sport
and has earned the nickname,
"drag dog." I don't know if this
is a good fashion moment for
me, but it certainly was for him.
It's odd that we have the same
expression. **Richard Buckley**

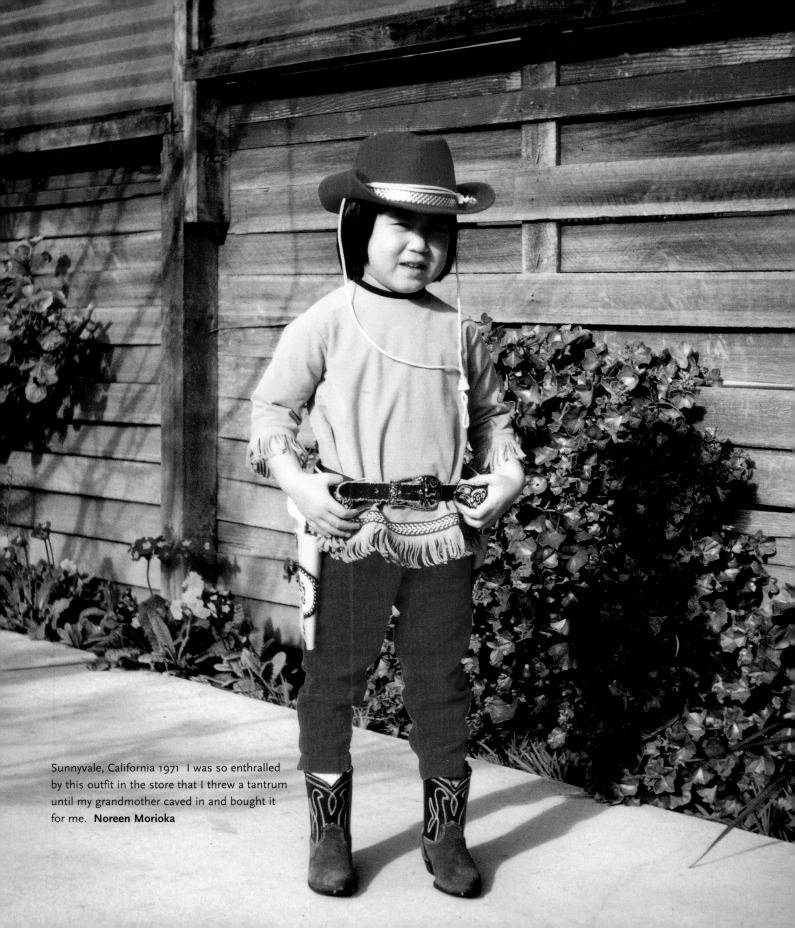

Sunnyvale, California 1971 I was so enthralled by this outfit in the store that I threw a tantrum until my grandmother caved in and bought it for me. **Noreen Morioka**

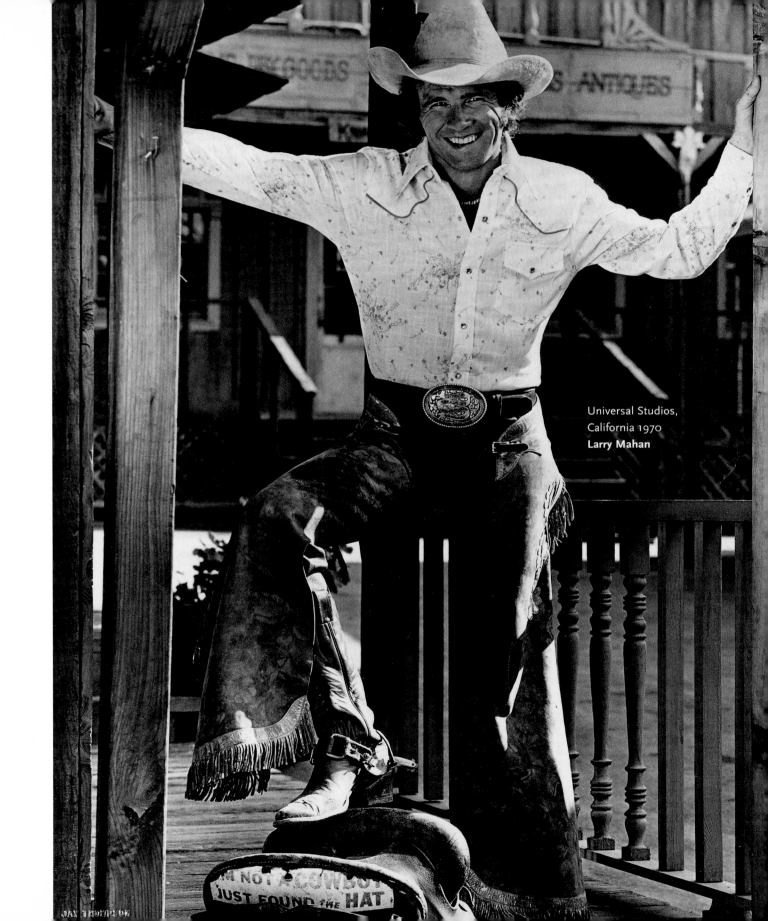

Universal Studios,
California 1970
Larry Mahan

Lynwood, California 1976 This was my horsey period. I'm at my grandfather's stable with my horse Guinevere. I thought the bandanna was the mark of a horsewoman. My grandmother made the sweatshirt and stitched the horse head on it. I was really skinny—my mom calls this "The Karen Carpenter Picture."
Courtney Small

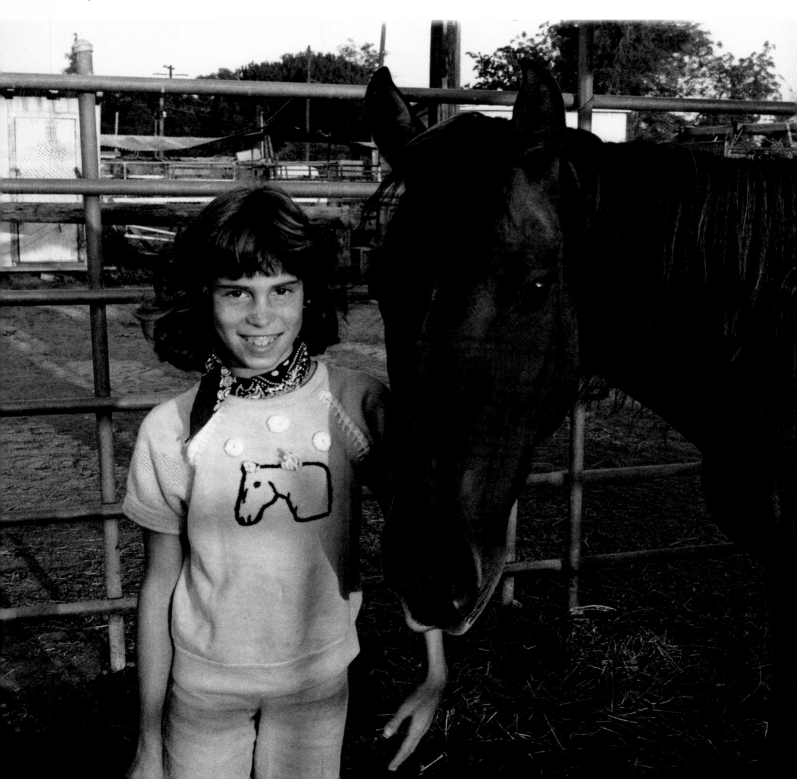

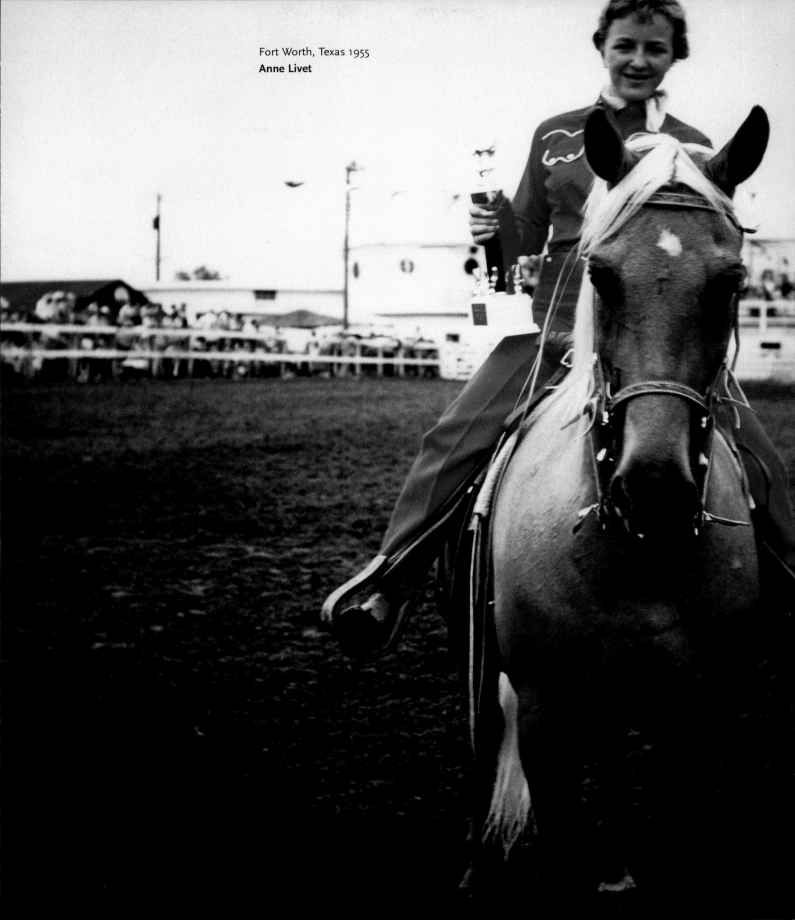

Fort Worth, Texas 1955
Anne Livet

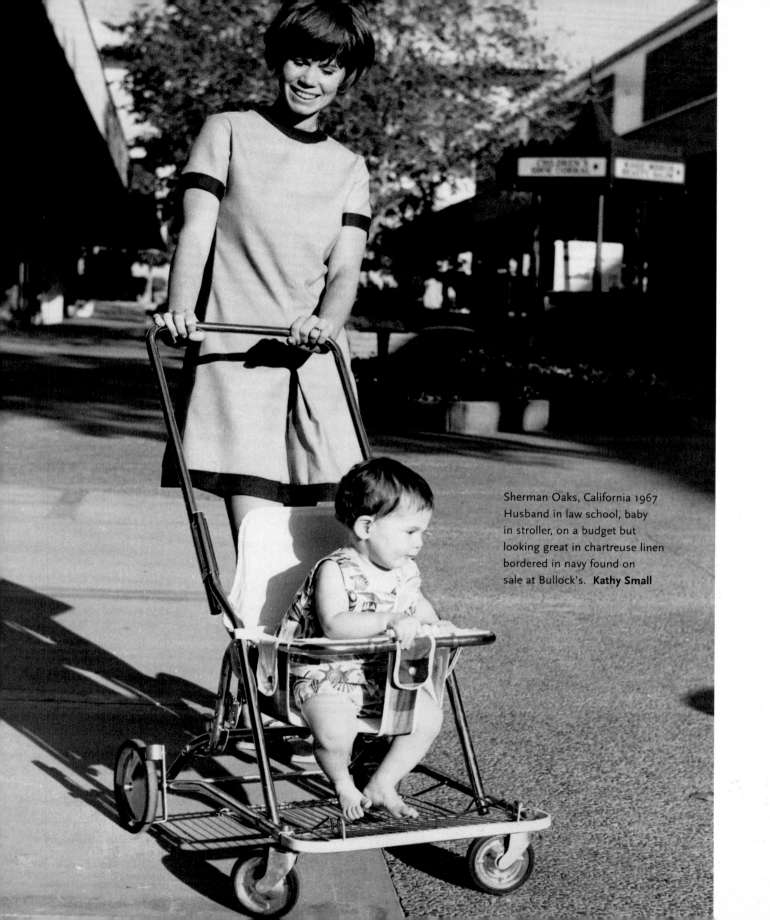

Sherman Oaks, California 1967
Husband in law school, baby
in stroller, on a budget but
looking great in chartreuse linen
bordered in navy found on
sale at Bullock's. **Kathy Small**

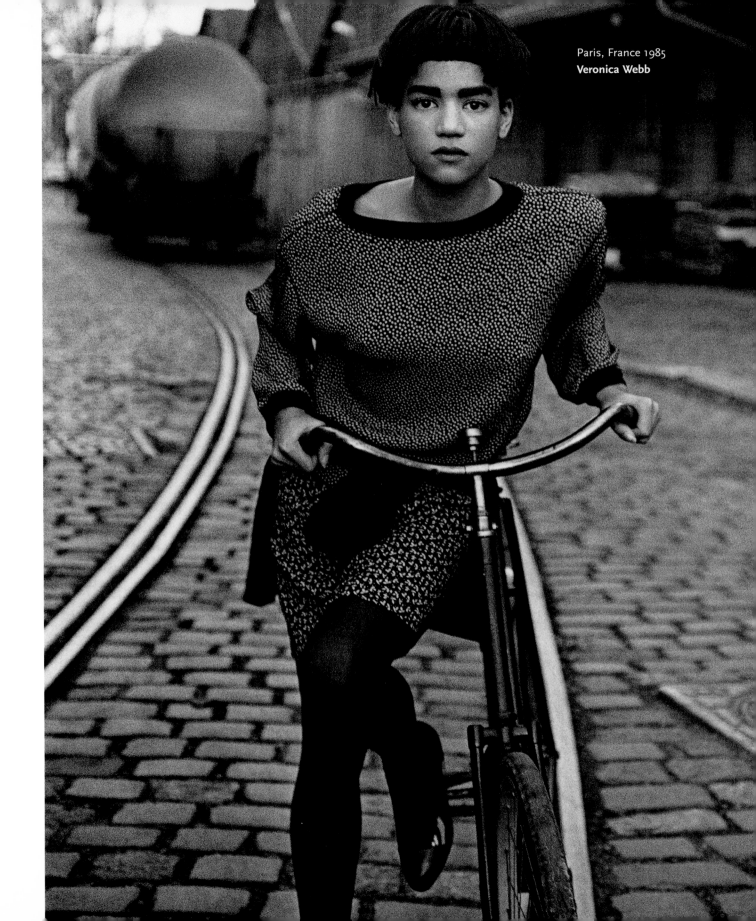

Paris, France 1985
Veronica Webb

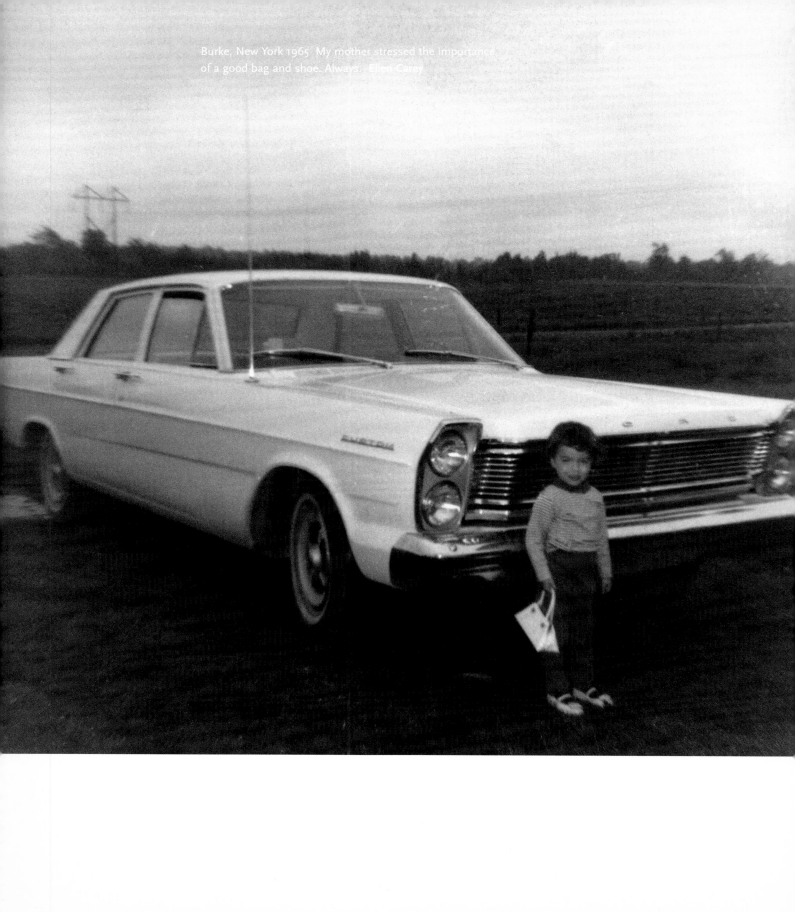

Burke, New York 1965 My mother stressed the importance
of a good bag and shoe. Always. Ellen Carey

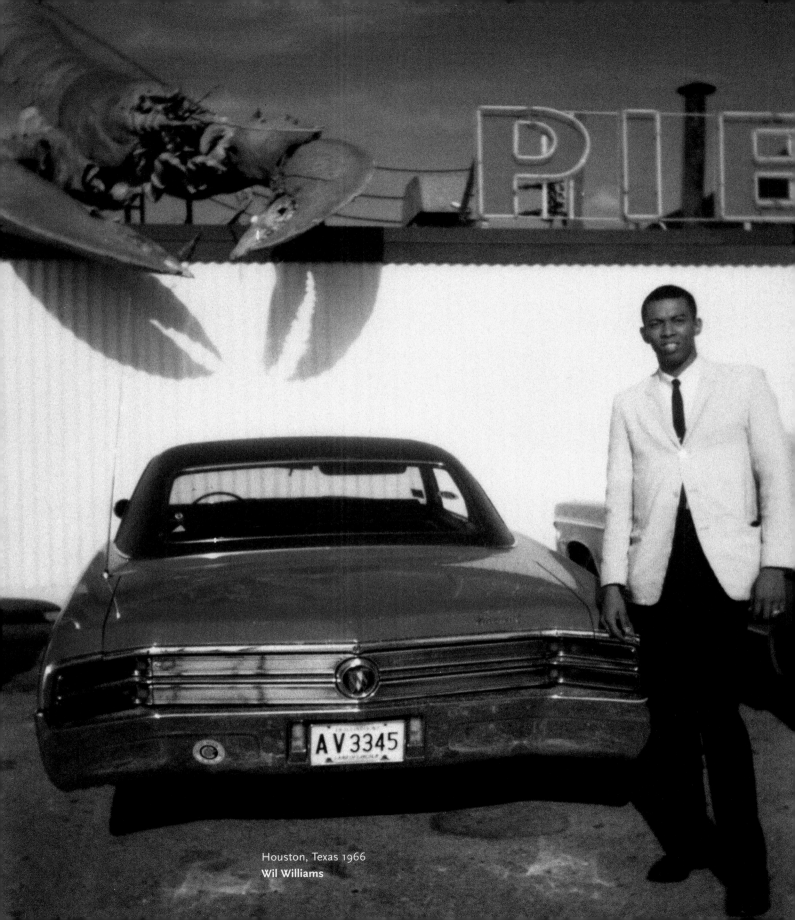

Houston, Texas 1966
Wil Williams

Northern Italy, 1970
Life was great. *Bonnie and Clyde*
had just been released. I was
shooting a movie with Marcello
Mastroianni. Douglas Kirkland
took the photo while driving
very fast on a road between
Venice and Treviso on my way
to meet Marcello.
Faye Dunaway

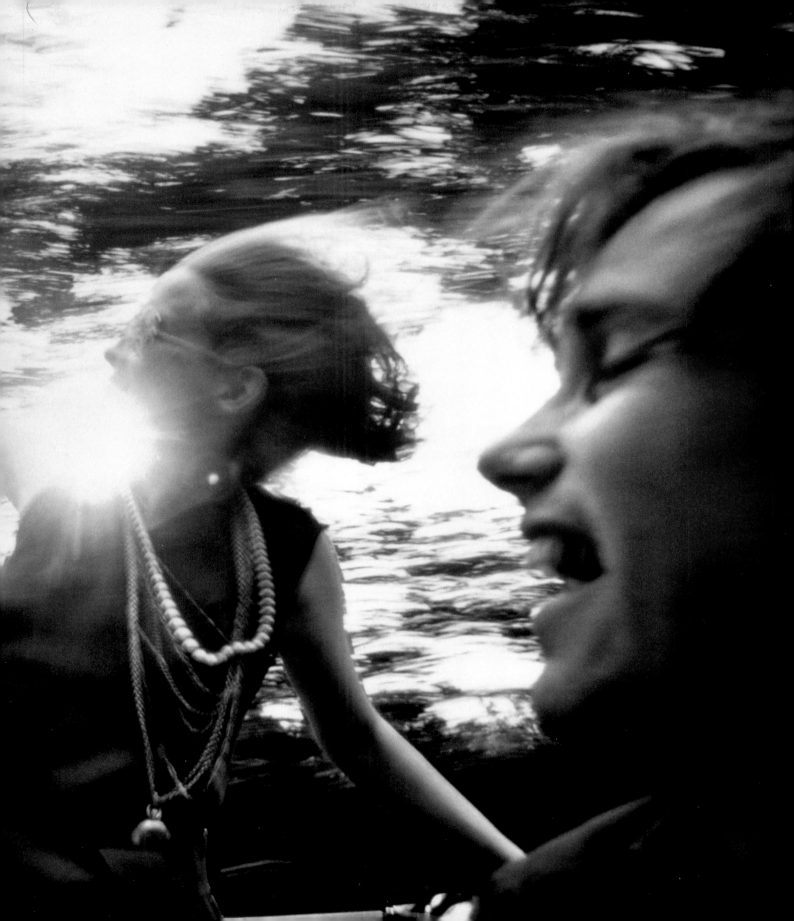

Encino, California; Salt Lake City, Utah; Vail, Colorado 1969–70
This was the beginning of my "sex, drugs, and rock and roll" period.
It was about Ziedler and Ziedler see-through shirts, a George
Harrison-inspired mustache, downhill racing, muscle cars, a tie-dyed
dorm room and LSD suppositories. **Bobby Heller**

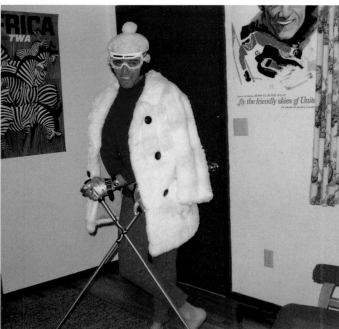

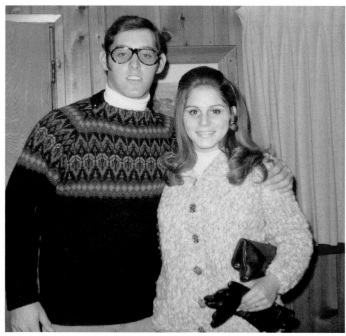

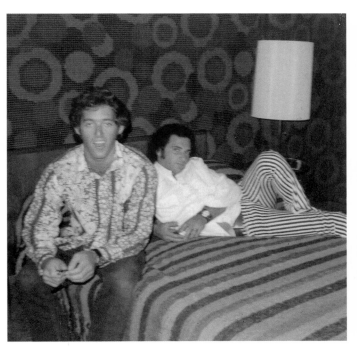
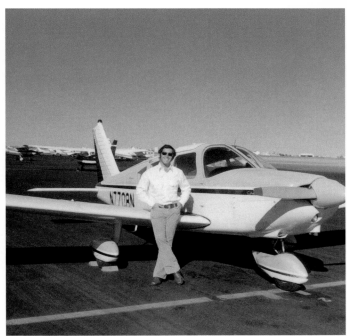
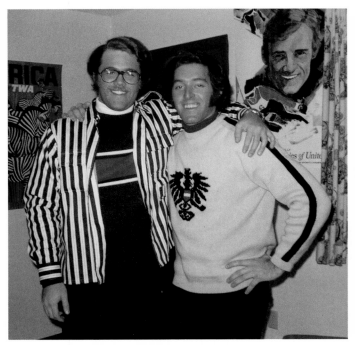
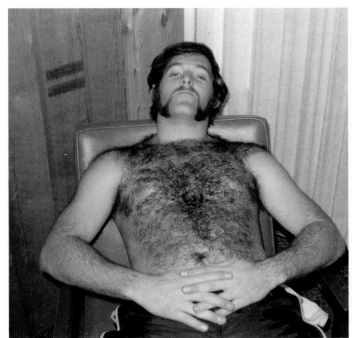

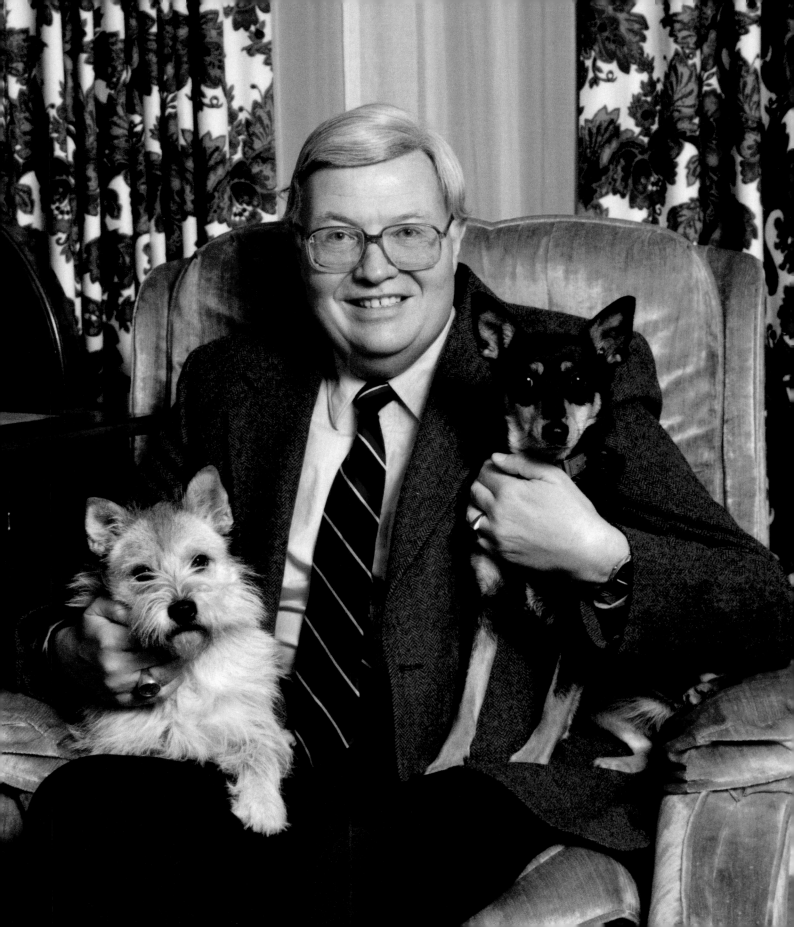

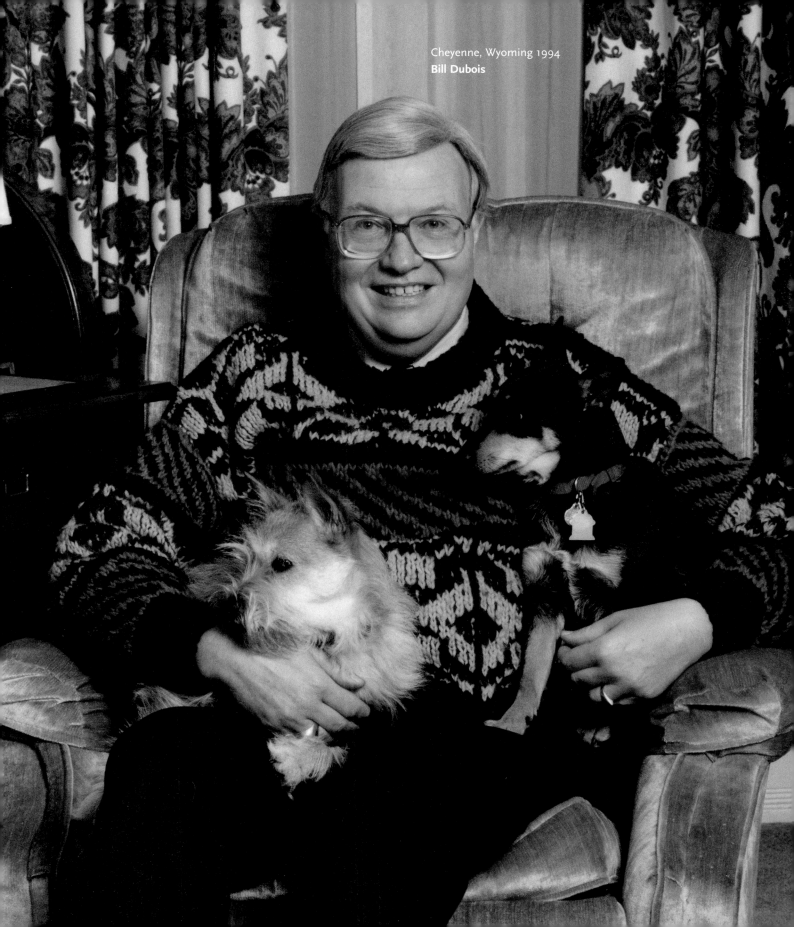

Cheyenne, Wyoming 1994
Bill Dubois

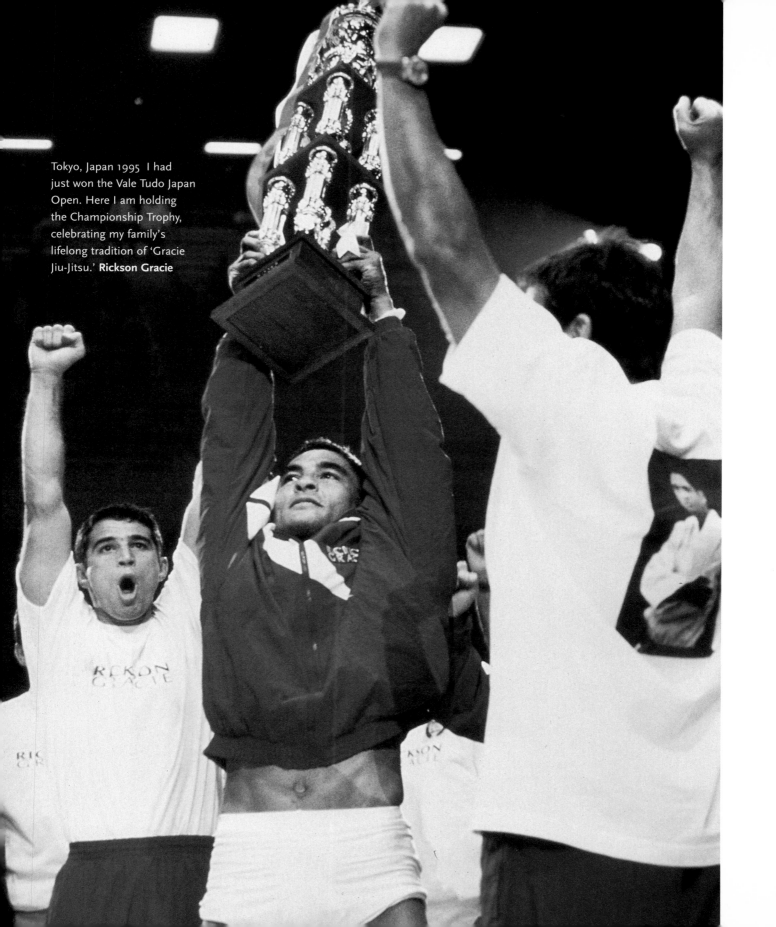

Tokyo, Japan 1995 I had just won the Vale Tudo Japan Open. Here I am holding the Championship Trophy, celebrating my family's lifelong tradition of 'Gracie Jiu-Jitsu.' **Rickson Gracie**

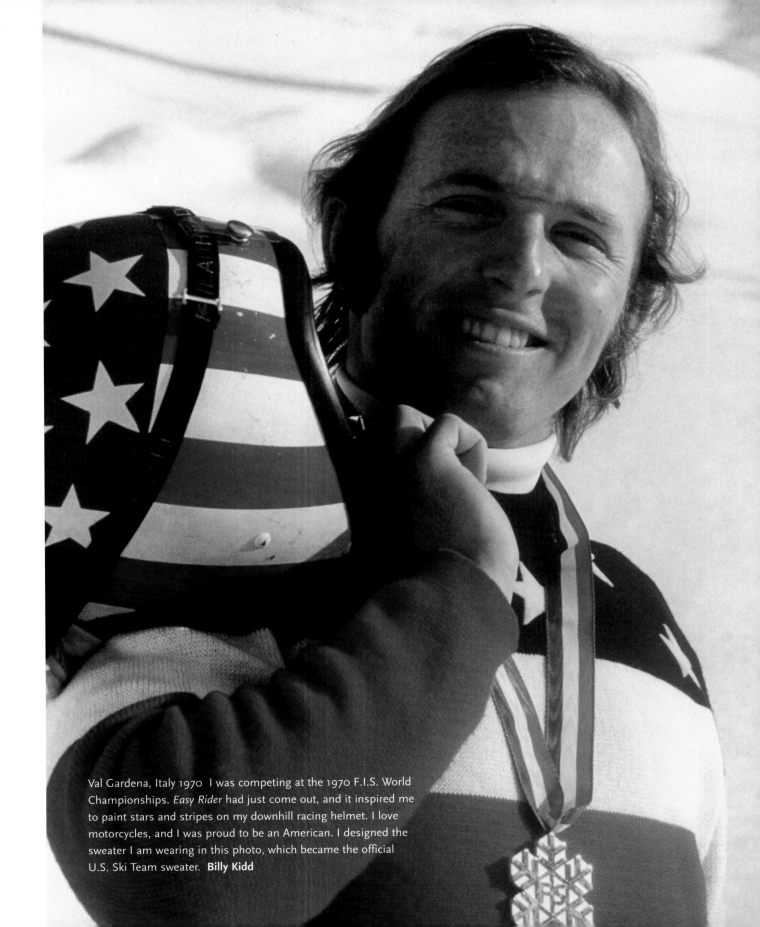

Val Gardena, Italy 1970 I was competing at the 1970 F.I.S. World Championships. *Easy Rider* had just come out, and it inspired me to paint stars and stripes on my downhill racing helmet. I love motorcycles, and I was proud to be an American. I designed the sweater I am wearing in this photo, which became the official U.S. Ski Team sweater. **Billy Kidd**

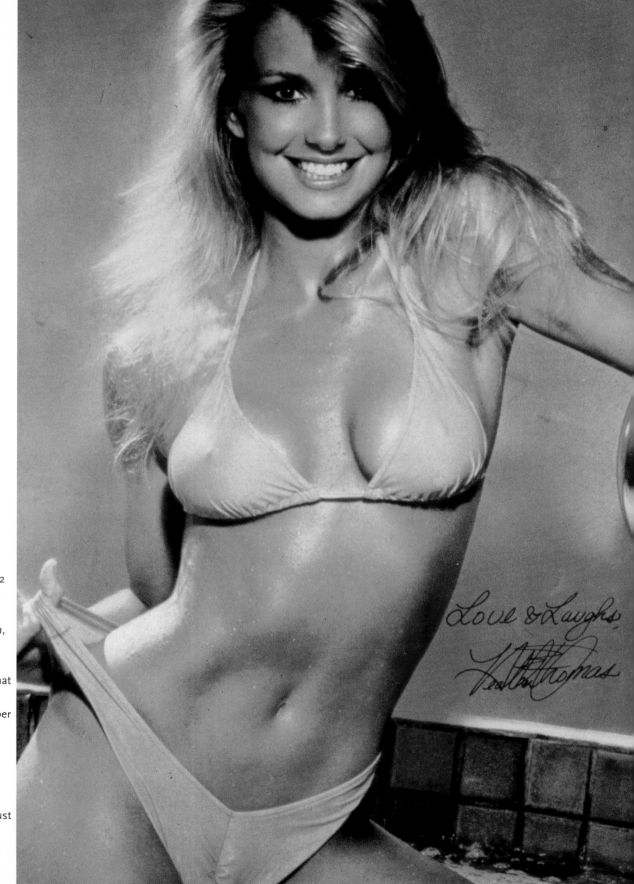

Los Angeles, California 1982 Dick Zimmerman took this picture. His motto was something like, "Get 'em in, get 'em oiled, get 'em wet and shoot 'em." I was too young to even notice that I had a kind of camel-toe thing happening. I remember being a little worried about the Farrah flip wilting. And everyone was saying, "Put more ice down her bra!" I felt good about myself. I was young and dizzy and just happy to have no zits.
Heather Thomas

Love & Laughs,
Heather Thomas

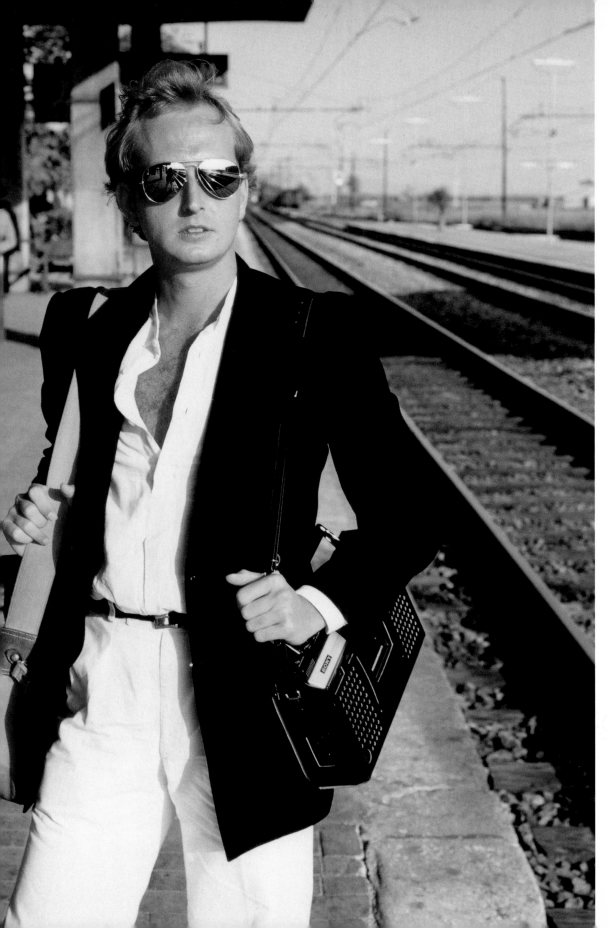

Pisa, Italy 1978
David Hemmings in *Blow Up*
was my fantasy. It was
definitely my coolest look—
the oversized aviators and
the Saint Laurent blazer.
It's all I ever wore. I also
traveled with my Sony cassette
player. It was pre-Walkman
days. **Robert Turner**

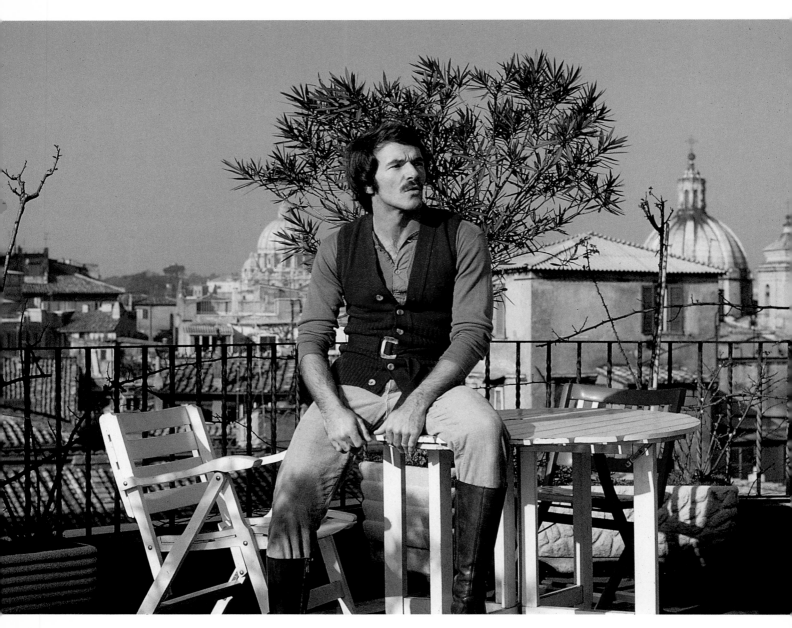

Rome, Italy 1969 This photo was taken on the roof of the
Rafael Hotel while I was drawing Valentino's collection.
This was my Carnaby Street/glamrock/swashbuckler look. My
friend and I would tuck our velveteen jodhpurs into our knee-high
boots and hit the clubs. I thought I was so cool. **Paul Jasmin**

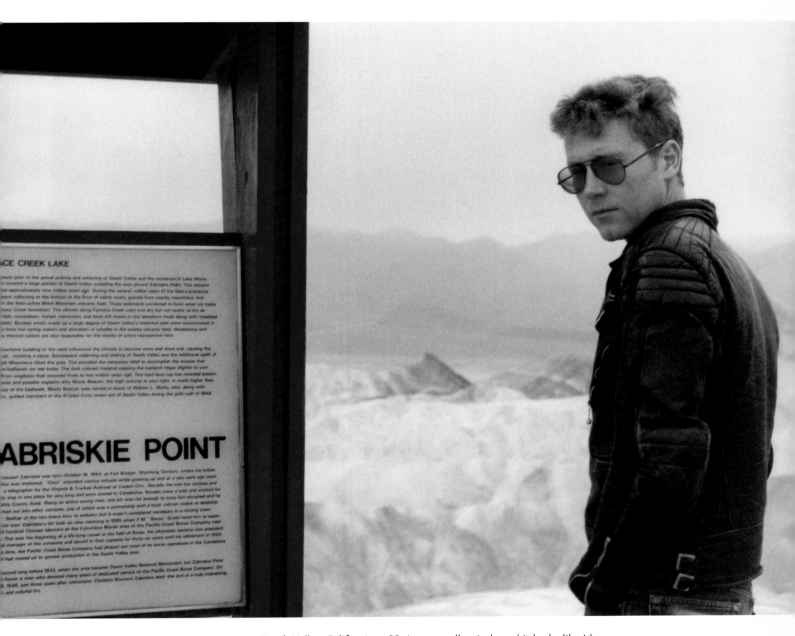

Death Valley, California 1988 It was really windy and it looks like I have
a *Flock of Seagulls* haircut. But I didn't. I'm wearing an old hand-me down leather
jacket that Joan Jett gave me. I used to go to Vegas and Death Valley in the same
trip because they're completely opposite experiences. I always watched the
Antonioni film *Zabriskie Point* so I wanted to go there. As hard as I tried,
I never saw hundreds of naked couples fucking. **Brad Dunning**

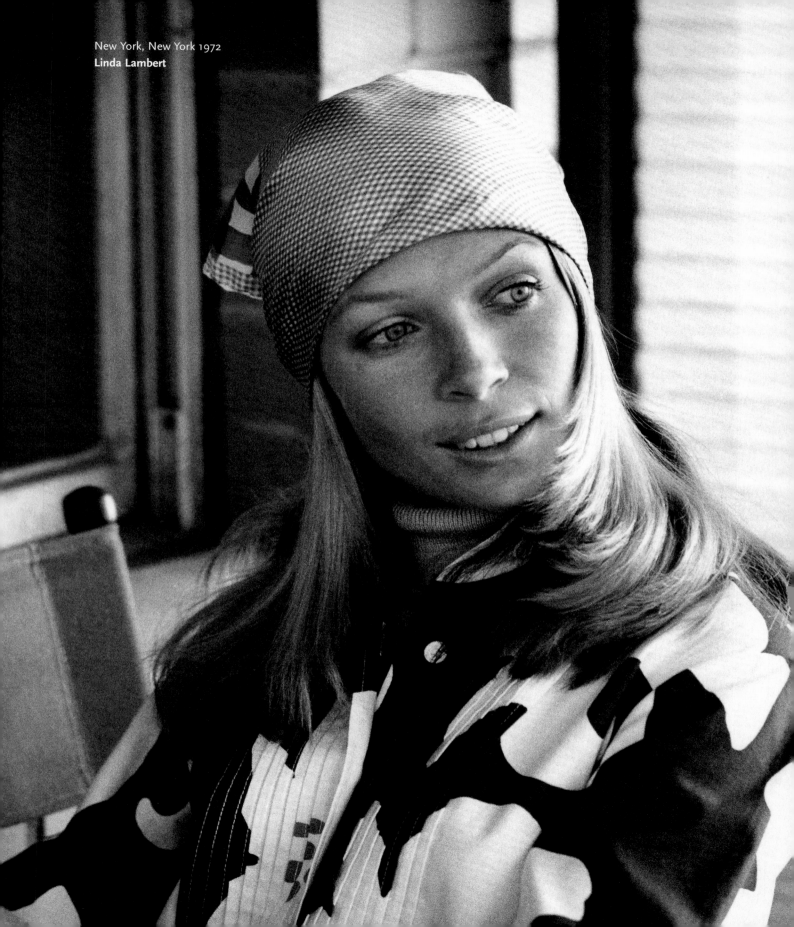

New York, New York 1972
Linda Lambert

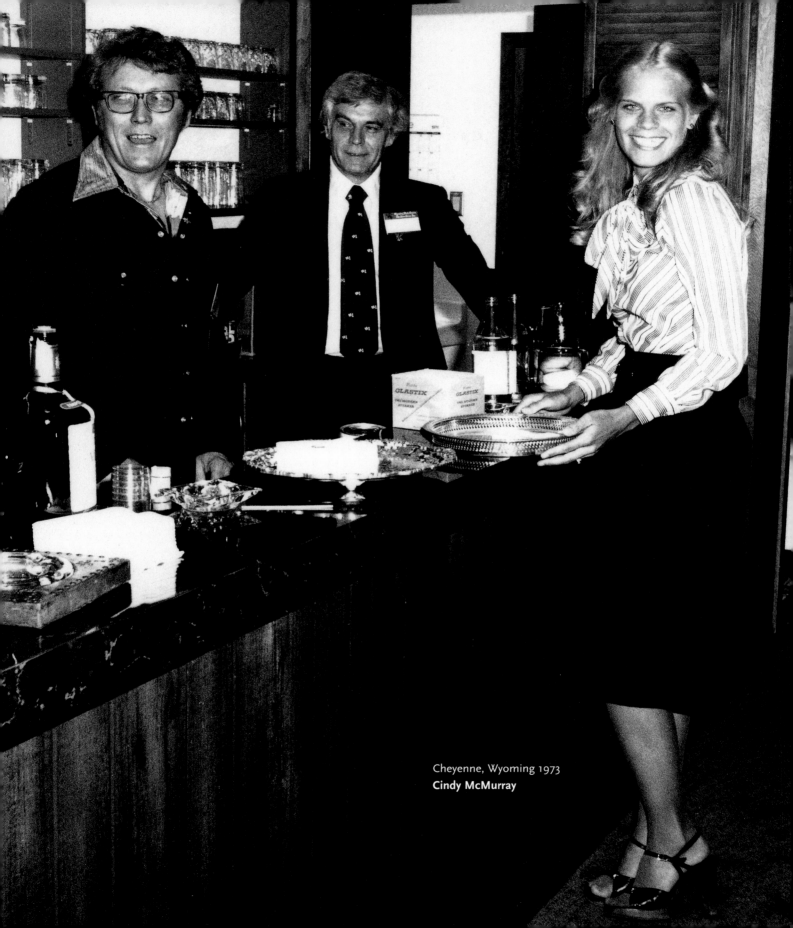

Cheyenne, Wyoming 1973
Cindy McMurray

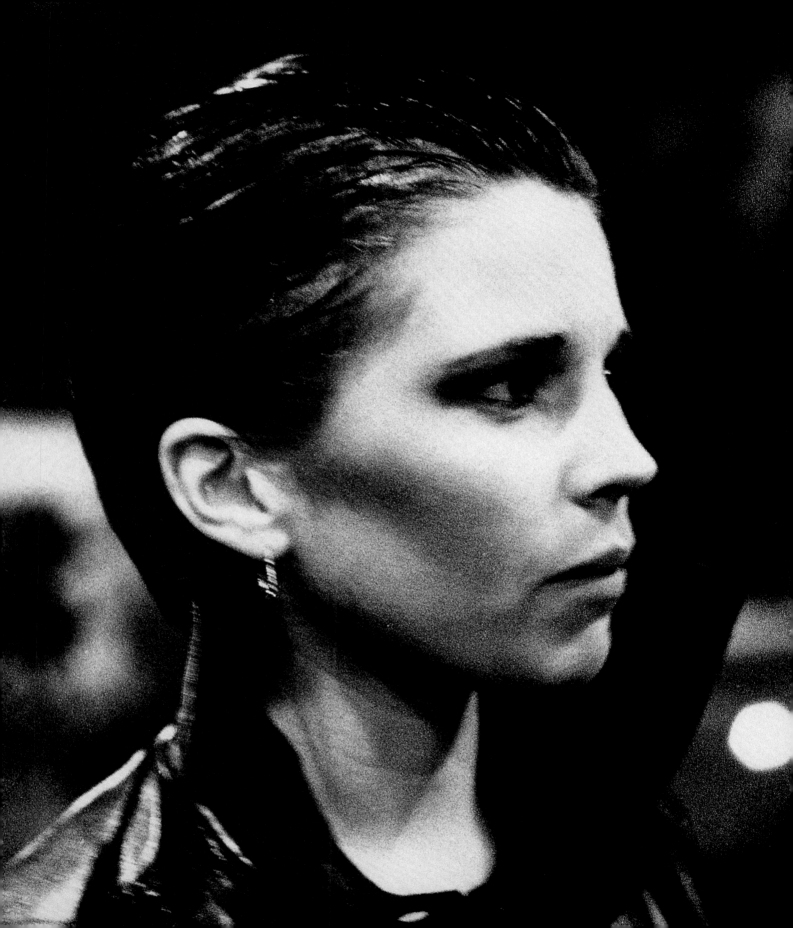

New York, New York 1978
I was Polly Mellen's assistant
at *Vogue*. I was looking through
a Sixties book, and noticed that
I had the same hair do as all
the Beatles' wives. "Oh my God!
I have Sixties hair and it's 1978!"
So I called Christiaan, *Vogue*'s
hairstylist of choice at that time,
and asked him to give me a new
haircut. I knew I wanted some-
thing severe and slicked back.
All of a sudden I had a complete
new look: dark kohl eyes, white
face, brown blush, and oversized
aviators. It was an incredibly
aggressive look for the time. In
fact, I always got a seat on the
subway. By fluke, Cher cut her
hair off and started wearing it
slicked, and I thought for once
I may have been ahead of the
curve. A month later at the open-
ing of the Metropolitan
Museum's Costume Institute,
I was still wallowing in the
attention I was getting with my
new look. I bumped into Polly,
my boss, who was sporting the
same short, slicked-back hair.
All I could think was, "Jesus,
we're going to look like two
dykes walking the halls at Condé
Nast." **Helen Murray**

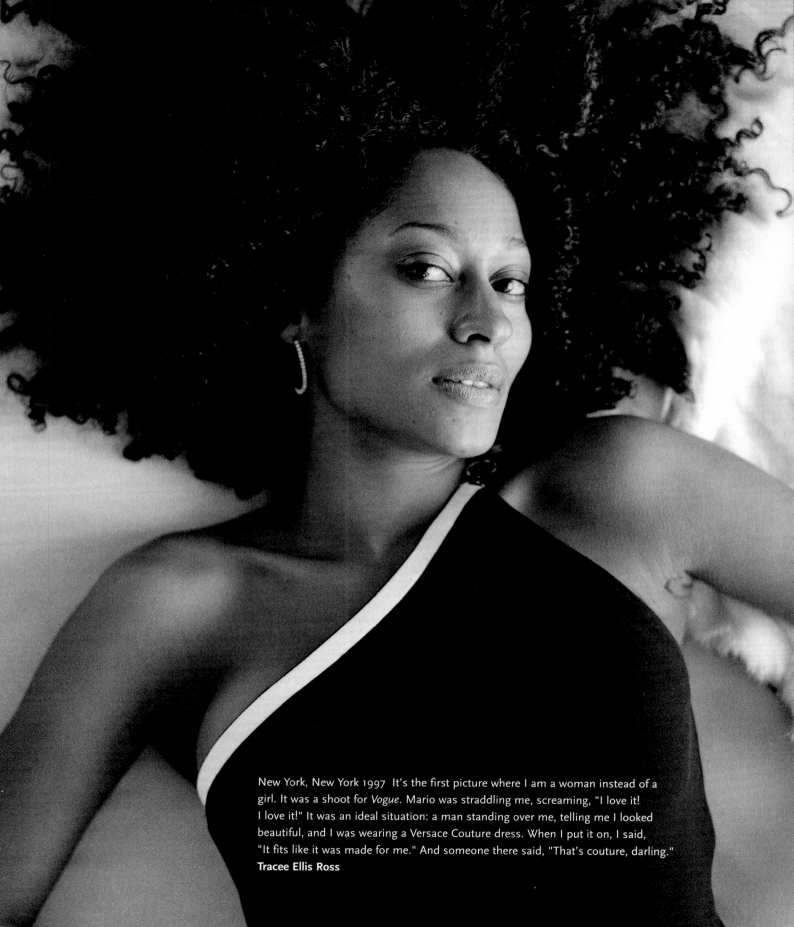

New York, New York 1997 It's the first picture where I am a woman instead of a girl. It was a shoot for *Vogue*. Mario was straddling me, screaming, "I love it! I love it!" It was an ideal situation: a man standing over me, telling me I looked beautiful, and I was wearing a Versace Couture dress. When I put it on, I said, "It fits like it was made for me." And someone there said, "That's couture, darling."
Tracee Ellis Ross

New York, New York 1983 This was the first custom-made suit I
ever had, and the beginning of my Jewish dreadlocks. The fabulous
hairdresser Christiaan told me, "Never wash your hair again"—
so I didn't. "And massage your hair with olive oil every night."
I attracted flies, but I looked fantastic. **Isaac Mizrahi**

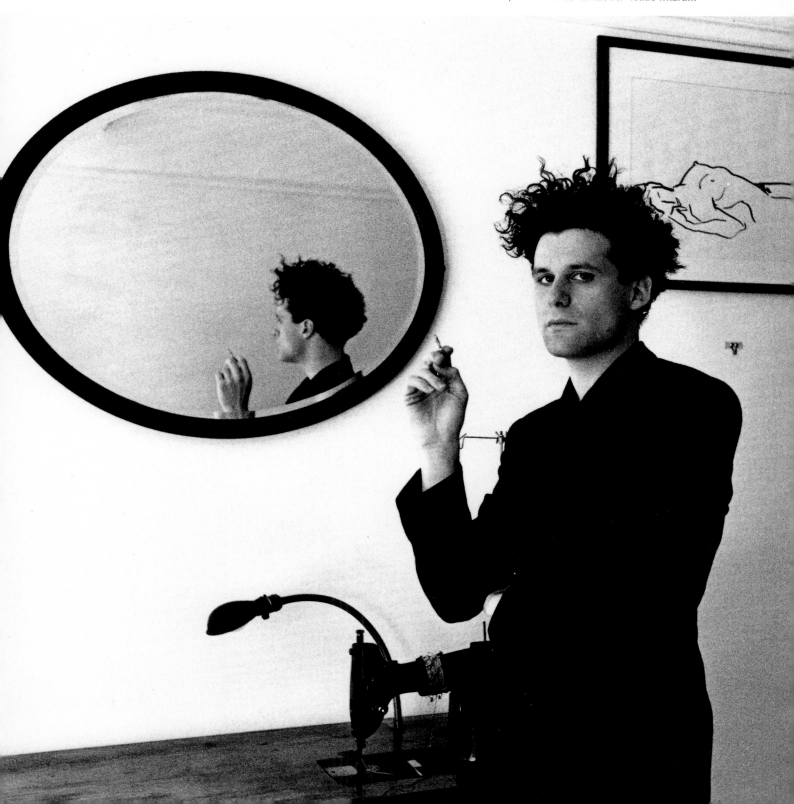

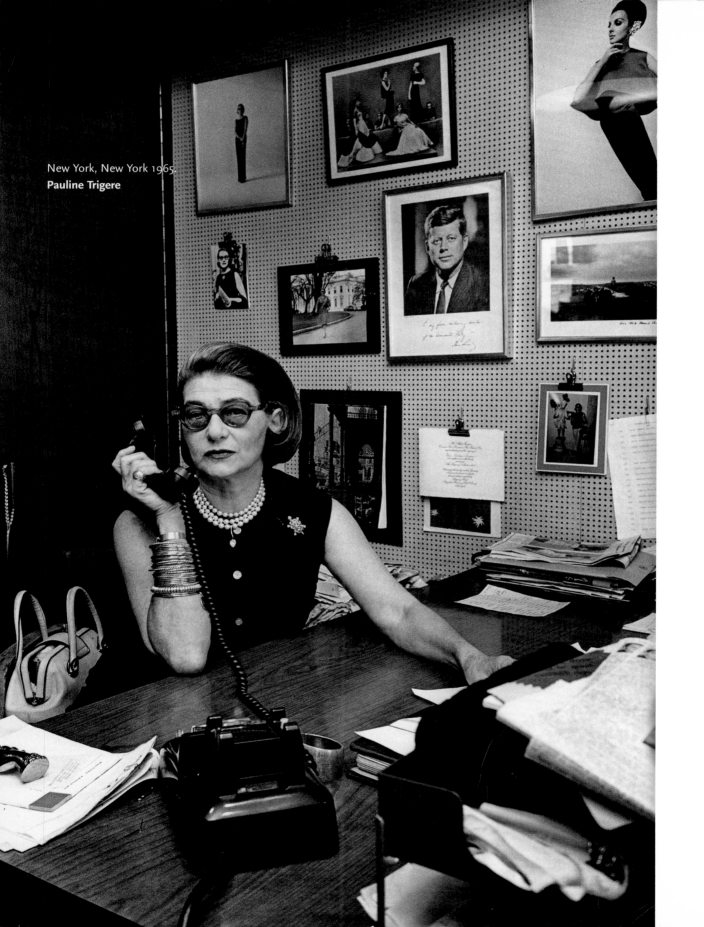

New York, New York 1965.
Pauline Trigere

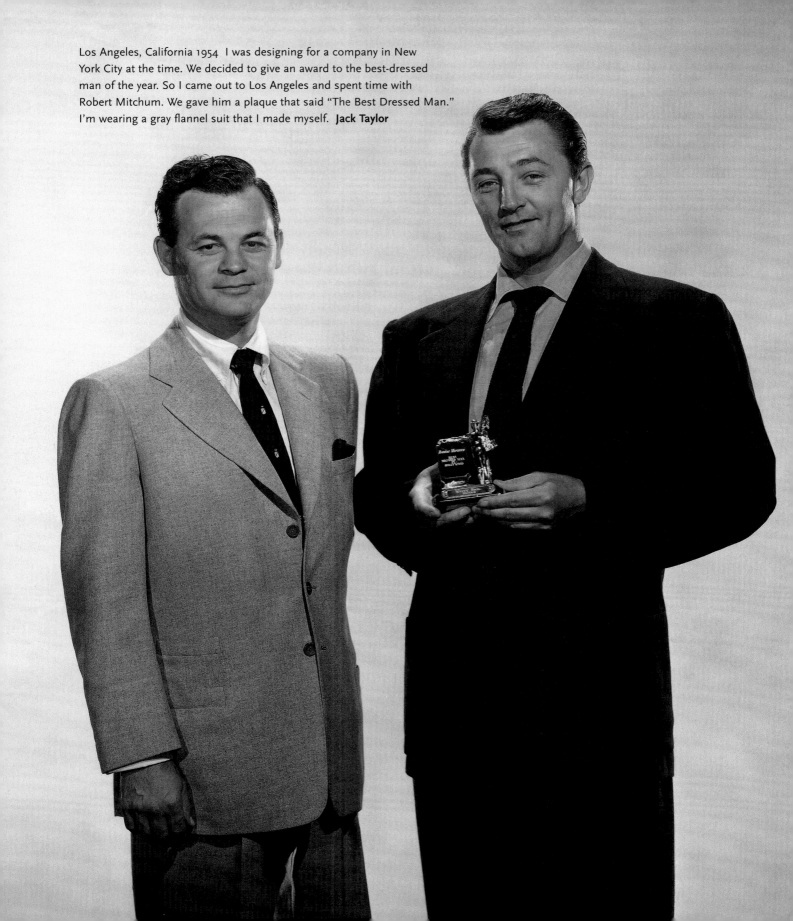

Los Angeles, California 1954 I was designing for a company in New York City at the time. We decided to give an award to the best-dressed man of the year. So I came out to Los Angeles and spent time with Robert Mitchum. We gave him a plaque that said "The Best Dressed Man." I'm wearing a gray flannel suit that I made myself. **Jack Taylor**

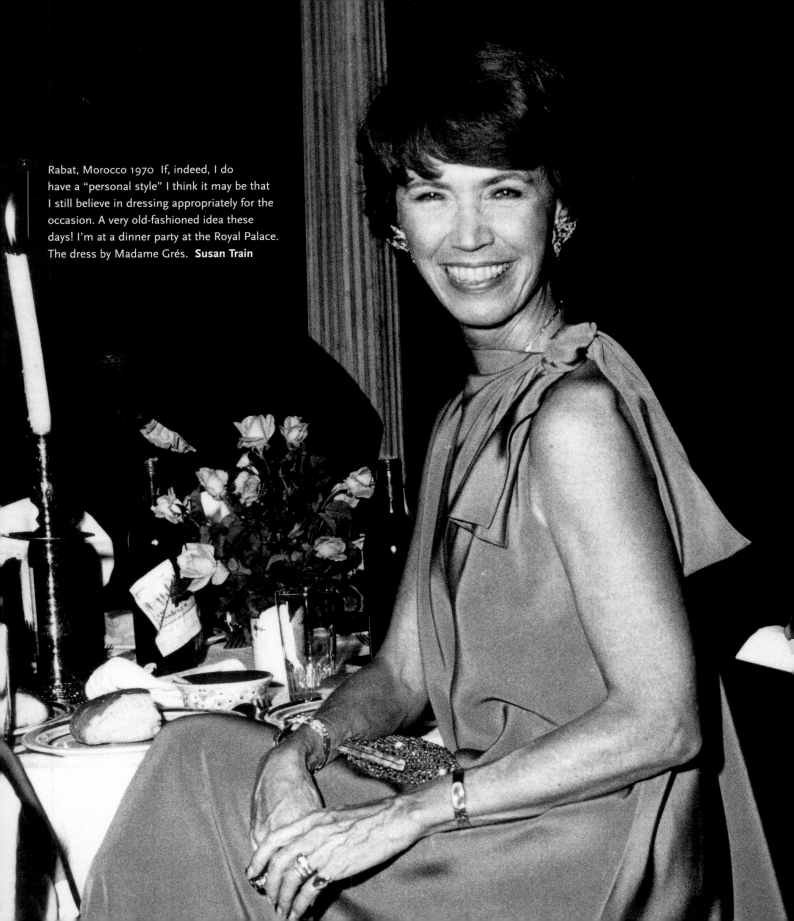

Rabat, Morocco 1970 If, indeed, I do have a "personal style" I think it may be that I still believe in dressing appropriately for the occasion. A very old-fashioned idea these days! I'm at a dinner party at the Royal Palace. The dress by Madame Grés. **Susan Train**

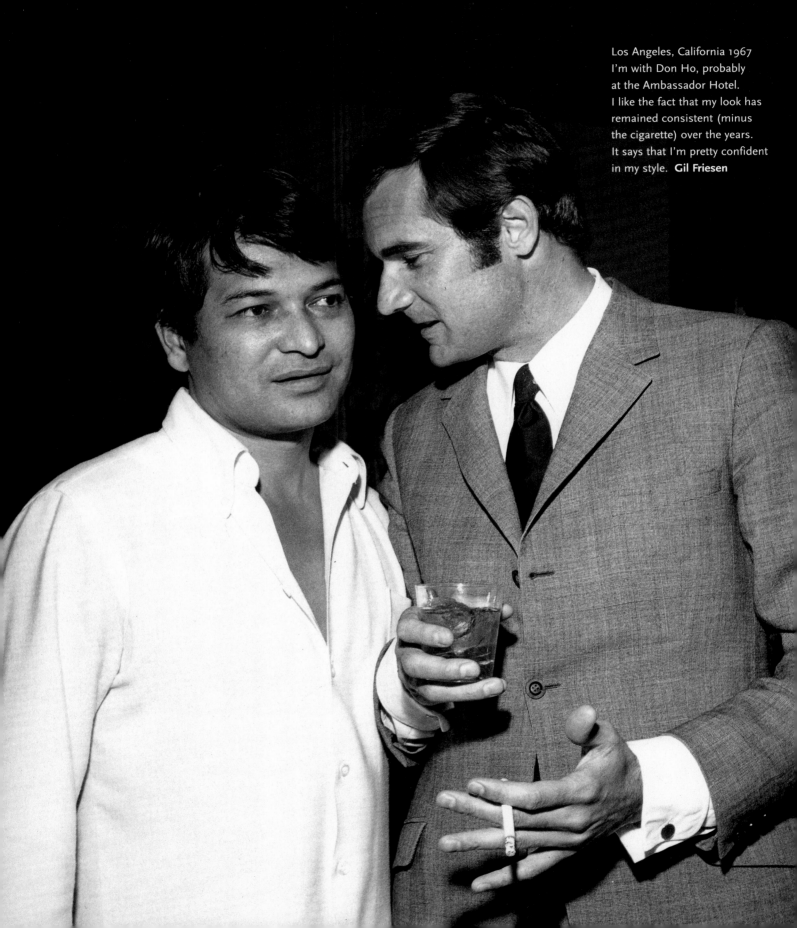

Los Angeles, California 1967
I'm with Don Ho, probably
at the Ambassador Hotel.
I like the fact that my look has
remained consistent (minus
the cigarette) over the years.
It says that I'm pretty confident
in my style. **Gil Friesen**

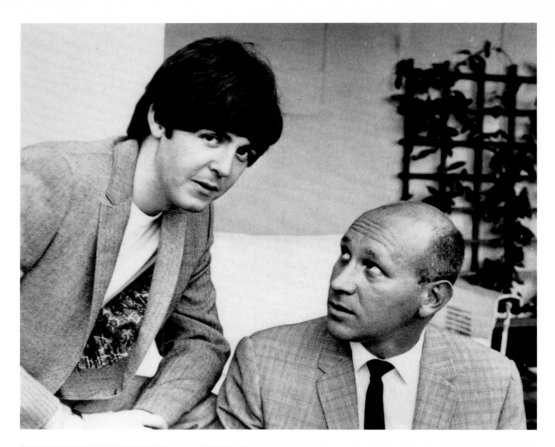

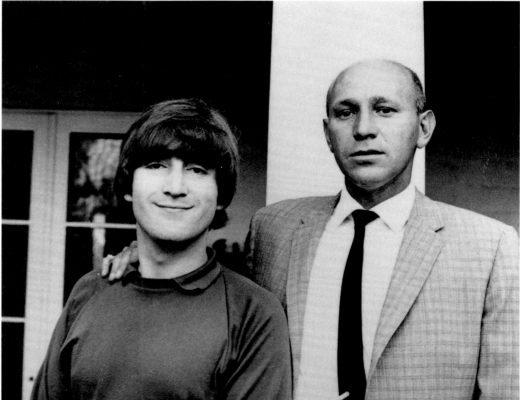

Los Angeles, California 1964
Roy Gerber

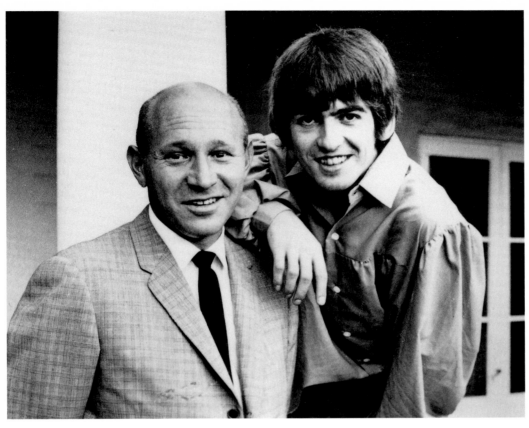

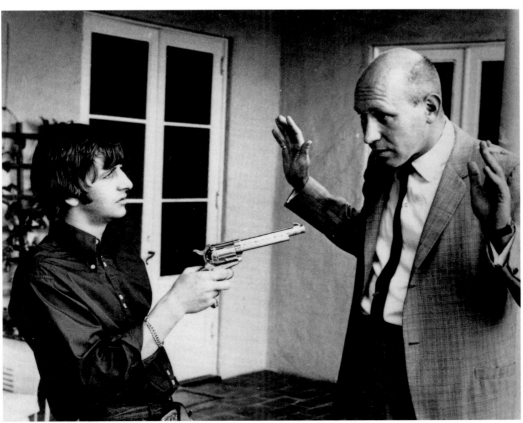

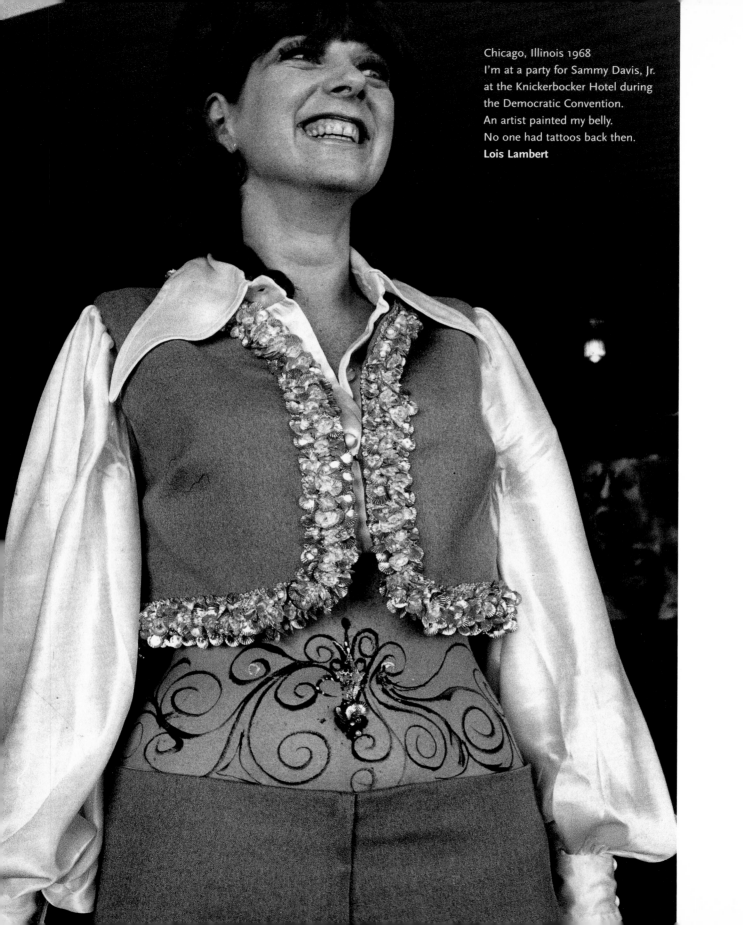

Chicago, Illinois 1968
I'm at a party for Sammy Davis, Jr.
at the Knickerbocker Hotel during
the Democratic Convention.
An artist painted my belly.
No one had tattoos back then.
Lois Lambert

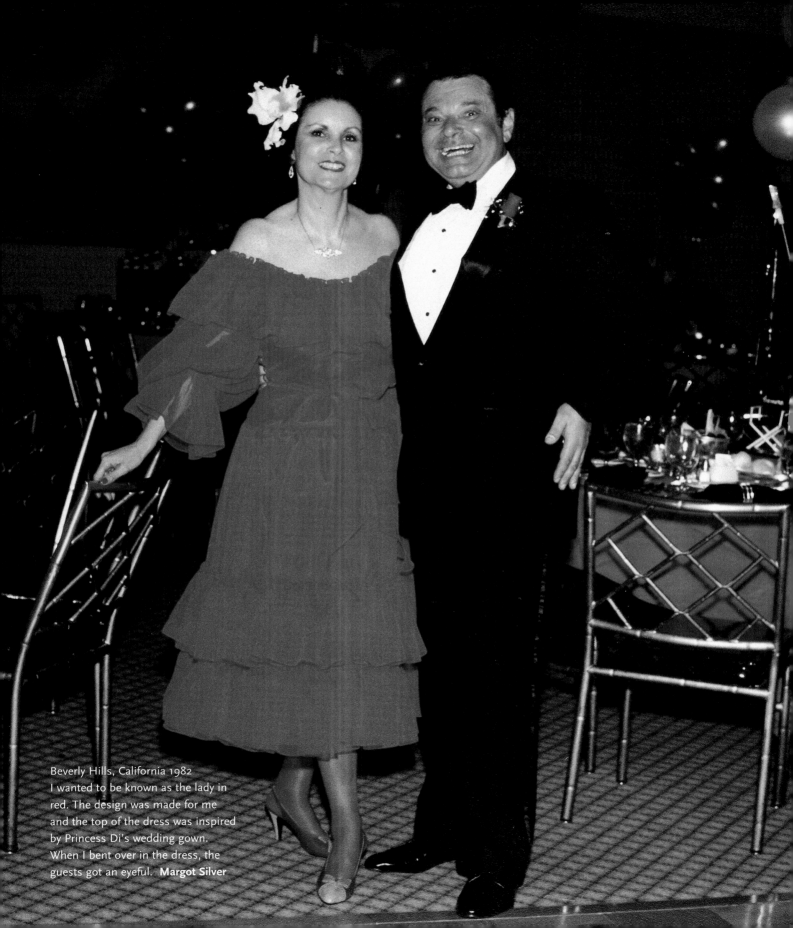

Beverly Hills, California 1982
I wanted to be known as the lady in
red. The design was made for me
and the top of the dress was inspired
by Princess Di's wedding gown.
When I bent over in the dress, the
guests got an eyeful. **Margot Silver**

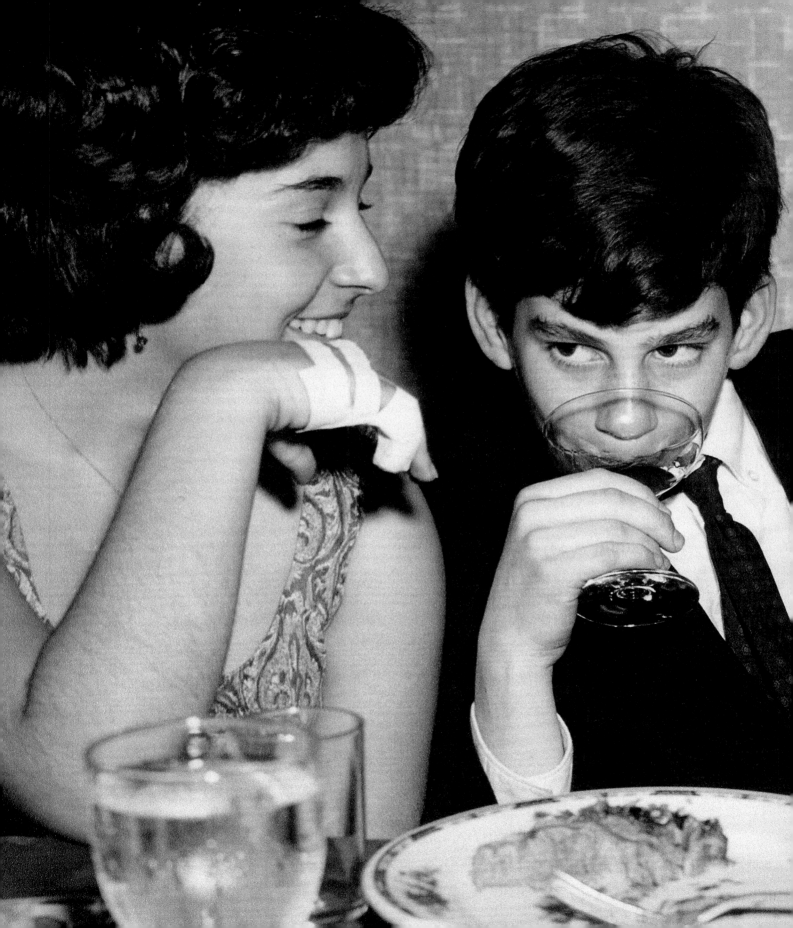

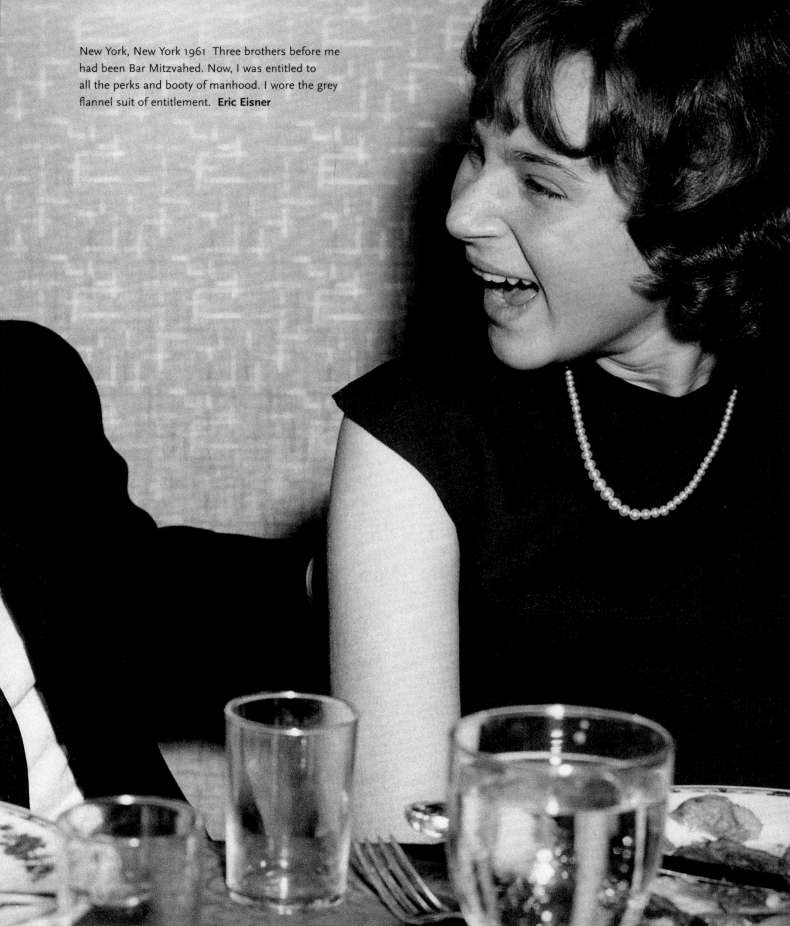

New York, New York 1961 Three brothers before me
had been Bar Mitzvahed. Now, I was entitled to
all the perks and booty of manhood. I wore the grey
flannel suit of entitlement. **Eric Eisner**

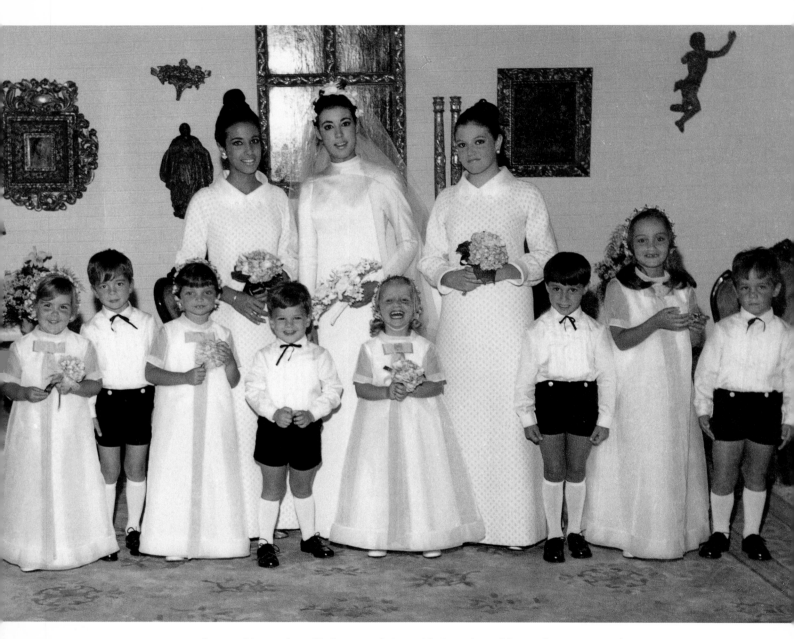

Caracas, Venezuela 1968 At my uncle Leopoldo Lopez's wedding to Antonieta Mendoza.
I'm the flower girl in the center, the one laughing hysterically. **Titina Penzini**

West New York, New Jersey 1970 It was my First Holy Communion and all I could think about, was that I was walking down the aisle with my 1st grade boyfriend Chuckie and this was our wedding day. **Nely Galán**

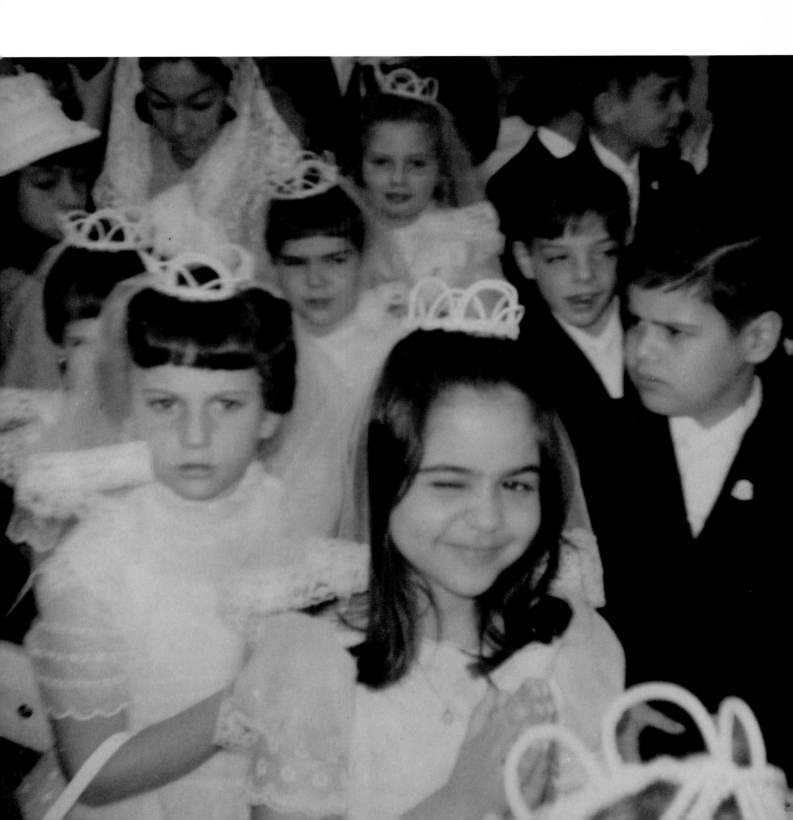

Miami, Florida 1981 I was part of the 14 couples dancing a *quinces*. We all had to wear these awful burgundy tuxedos and the girls weren't so crazy about their pink hoop skirts. But it was my first experience with the manhood ceremony of putting on a tux. **Guillermo Zalamea**

Los Angeles, California 1994 It was my *quinces*. I had seen a bridal dress I liked and had it made in pink.
As a *quinceañera* you are supposed to wear pink because you are a special rose starting to blossom.
I paid for the dress with my baby-sitting money. It was the first time I ever wore make-up. I didn't feel like
a child anymore. **Ana Isabel Grande**

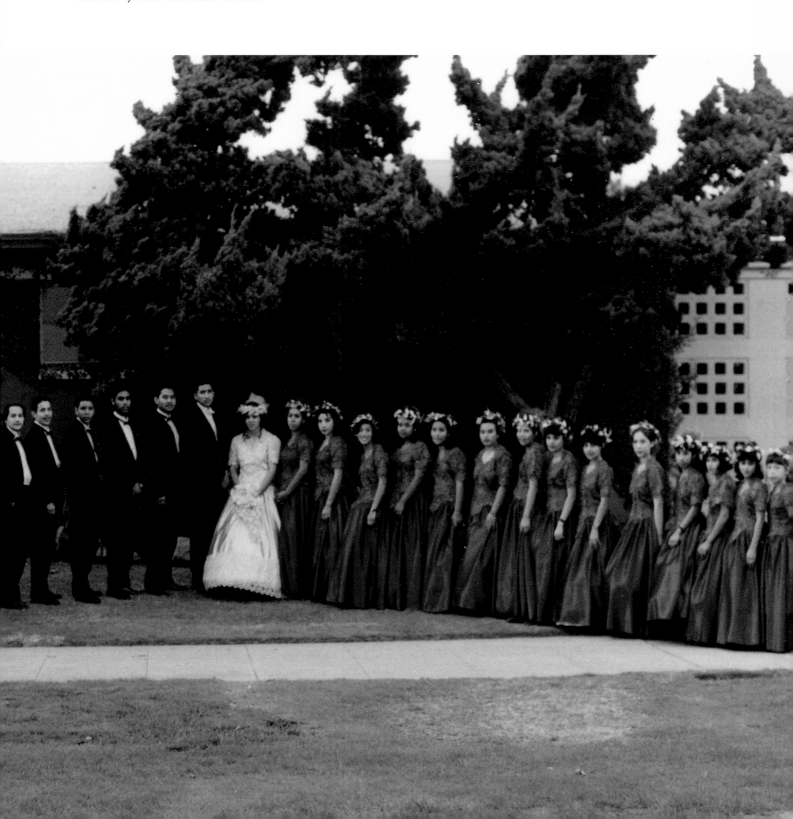

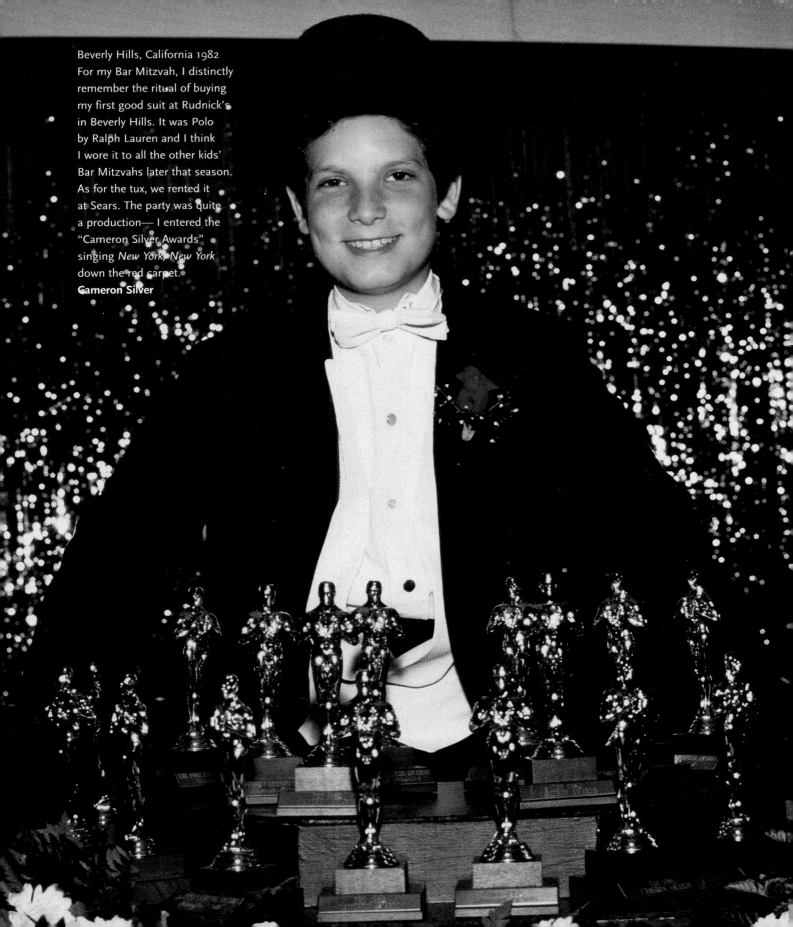

Beverly Hills, California 1982
For my Bar Mitzvah, I distinctly
remember the ritual of buying
my first good suit at Rudnick's
in Beverly Hills. It was Polo
by Ralph Lauren and I think
I wore it to all the other kids'
Bar Mitzvahs later that season.
As for the tux, we rented it
at Sears. The party was quite
a production— I entered the
"Cameron Silver Awards"
singing *New York, New York*
down the red carpet.
Cameron Silver

Los Angeles, California 1984 This was taken on the set of *Press Your Luck*. I was the only game show host who wore Ralph Lauren clothes exclusively. **Peter Tomarken**

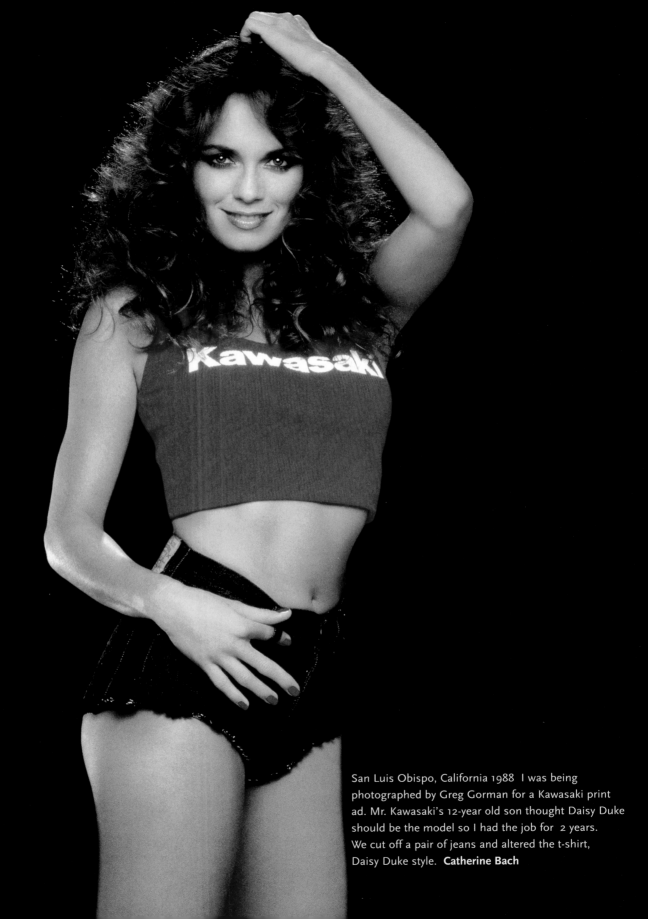

San Luis Obispo, California 1988 I was being
photographed by Greg Gorman for a Kawasaki print
ad. Mr. Kawasaki's 12-year old son thought Daisy Duke
should be the model so I had the job for 2 years.
We cut off a pair of jeans and altered the t-shirt,
Daisy Duke style. **Catherine Bach**

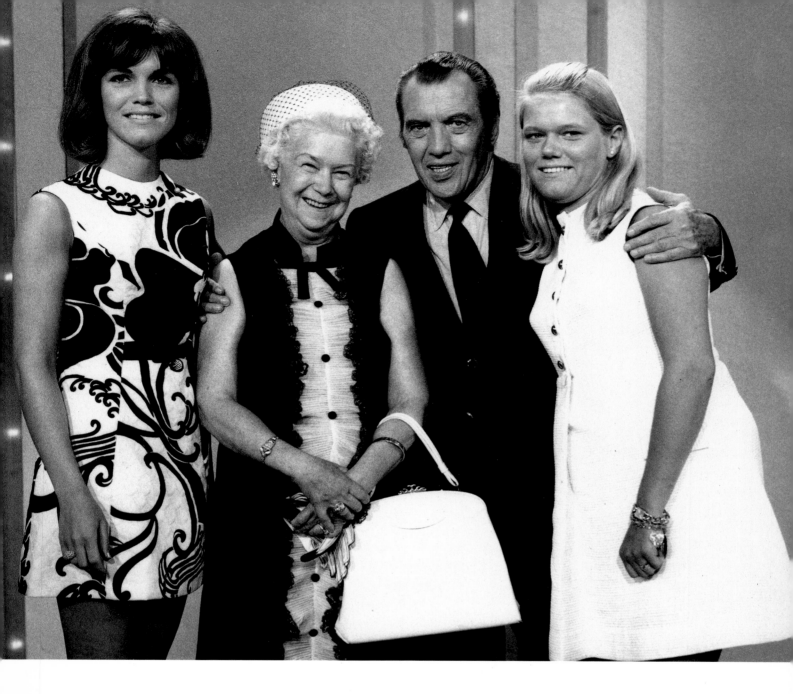

New York, New York 1968 I was working for *The Ed Sullivan Show*. This picture was taken the day my Granny and sister came to visit the set. Granny, who always wore a hat, was the best clairvoyant in the world. My fashion inspiration was *That Girl* and Mary Tyler Moore: mini-skirts, boots and panty hose, which had just been invented. **Barbara Gallagher**

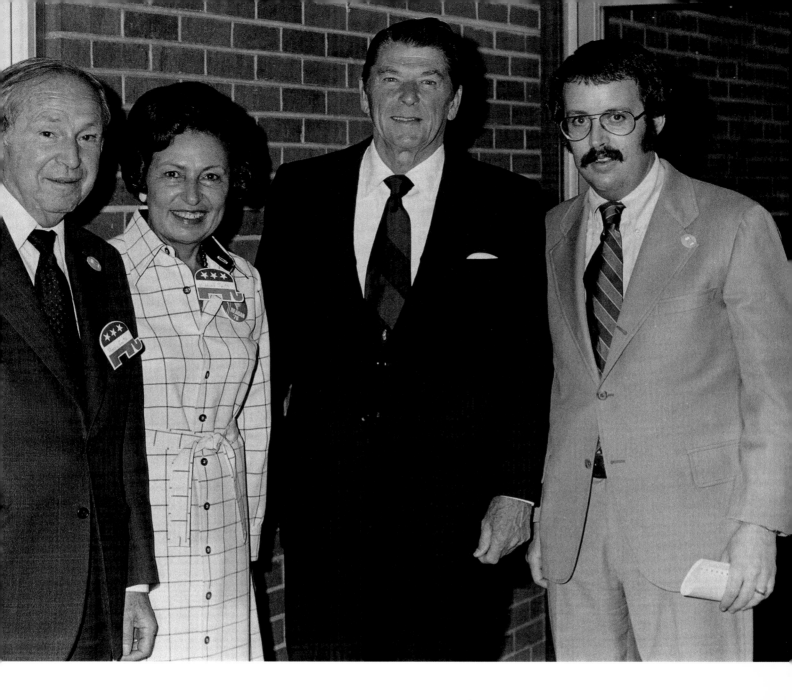

Cheyenne, Wyoming 1972 Governor Ronald Reagan was running for
Presidential candidate when he came to my family's hotel, The Hitching Post.
The suit, which I bought especially for the occasion, was Shafner & Marx.
The moustache was my first sign of rebellion. I had bought one months earlier
in Denver, and had glued it on securely, so I thought. But when I walked
outside, half of it blew off and the other half was flapping around in the air.
But I liked it so much I decided to grow my own. **Paul Smith**

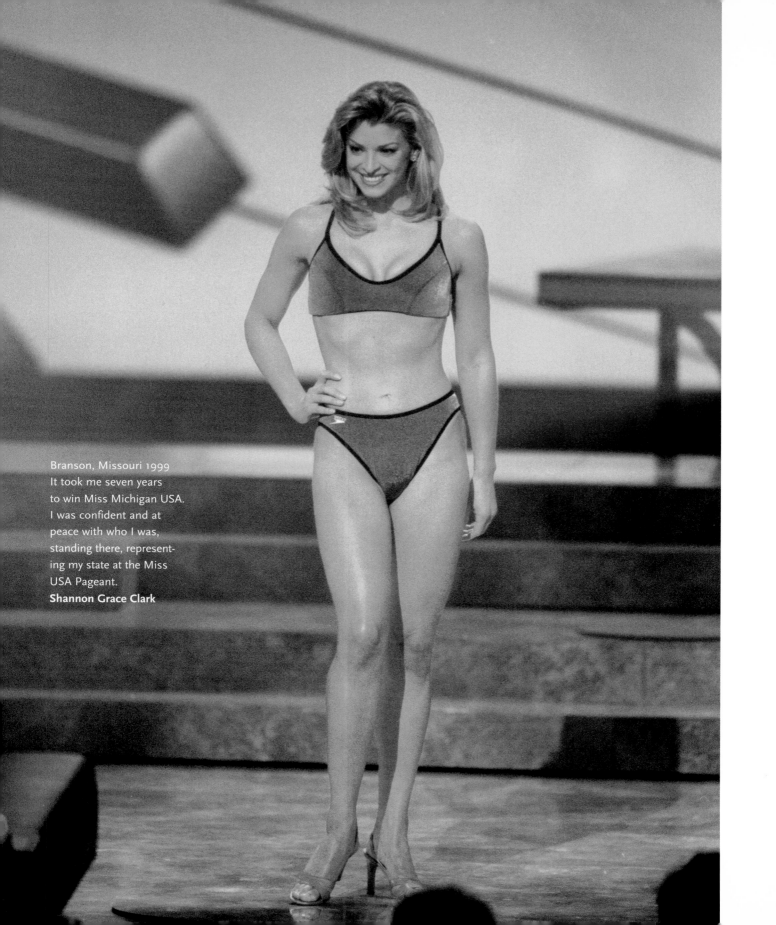

Branson, Missouri 1999
It took me seven years
to win Miss Michigan USA.
I was confident and at
peace with who I was,
standing there, represent-
ing my state at the Miss
USA Pageant.
Shannon Grace Clark

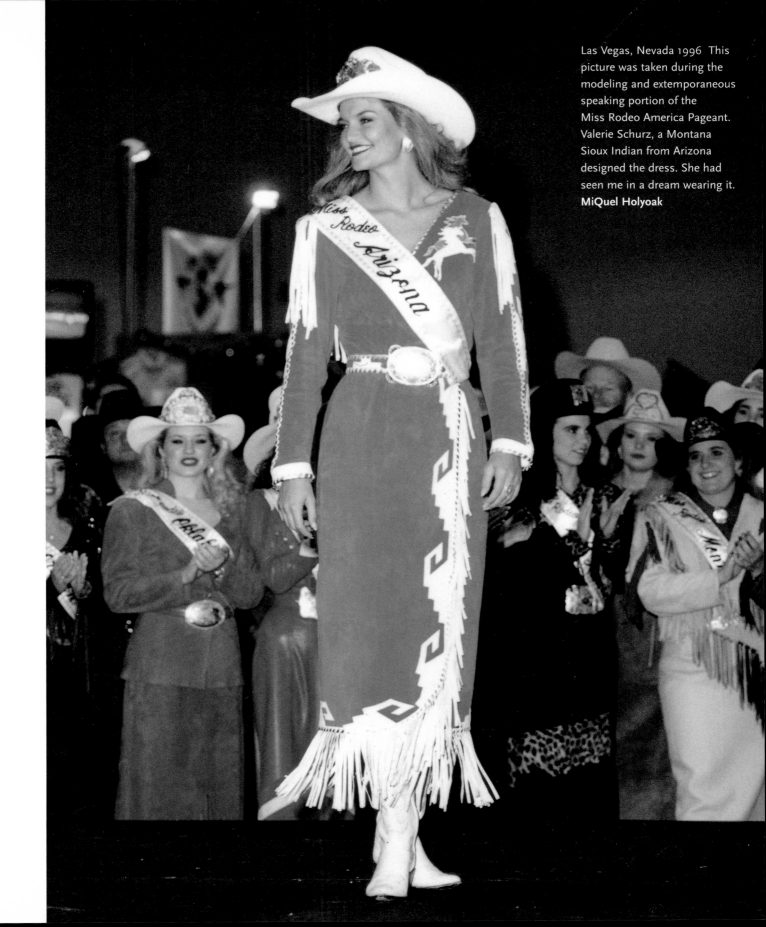

Las Vegas, Nevada 1996 This picture was taken during the modeling and extemporaneous speaking portion of the Miss Rodeo America Pageant. Valerie Schurz, a Montana Sioux Indian from Arizona designed the dress. She had seen me in a dream wearing it. **MiQuel Holyoak**

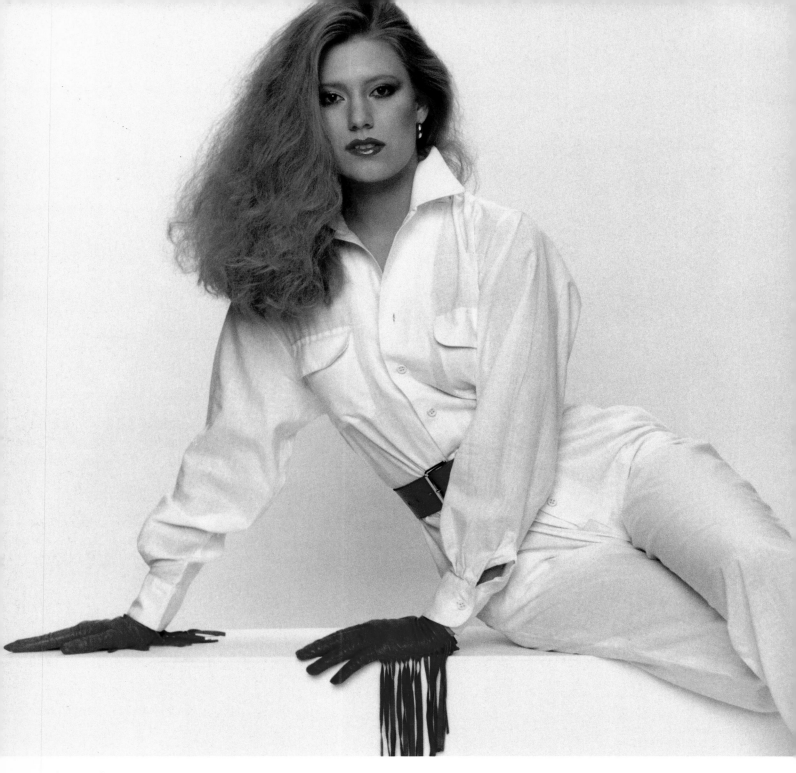

Chicago, Illinois 1980
Stephanie Nicks

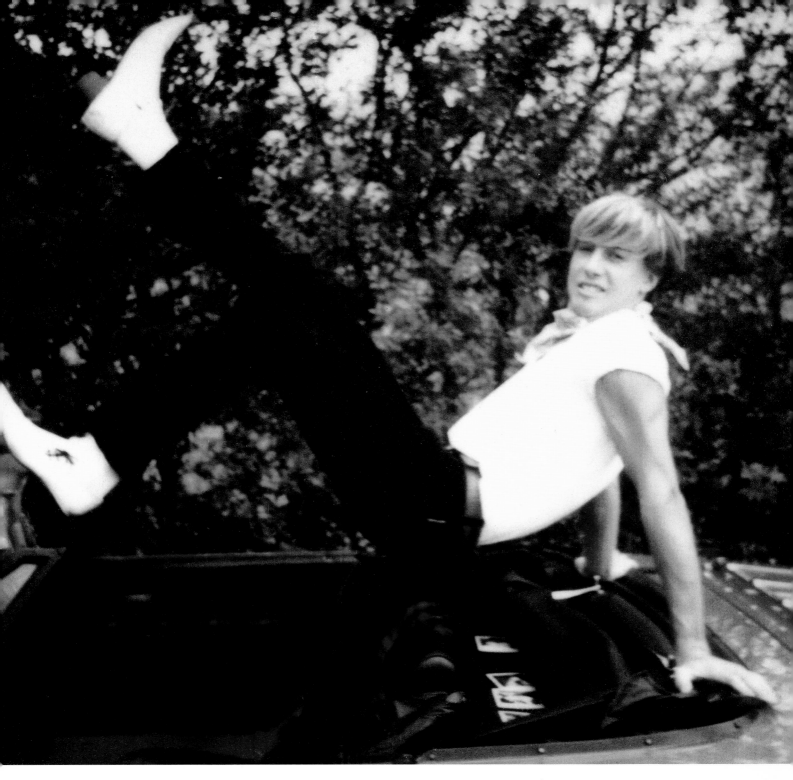

Les Pyrénées Orientales, France 1982
Thierry Crozier

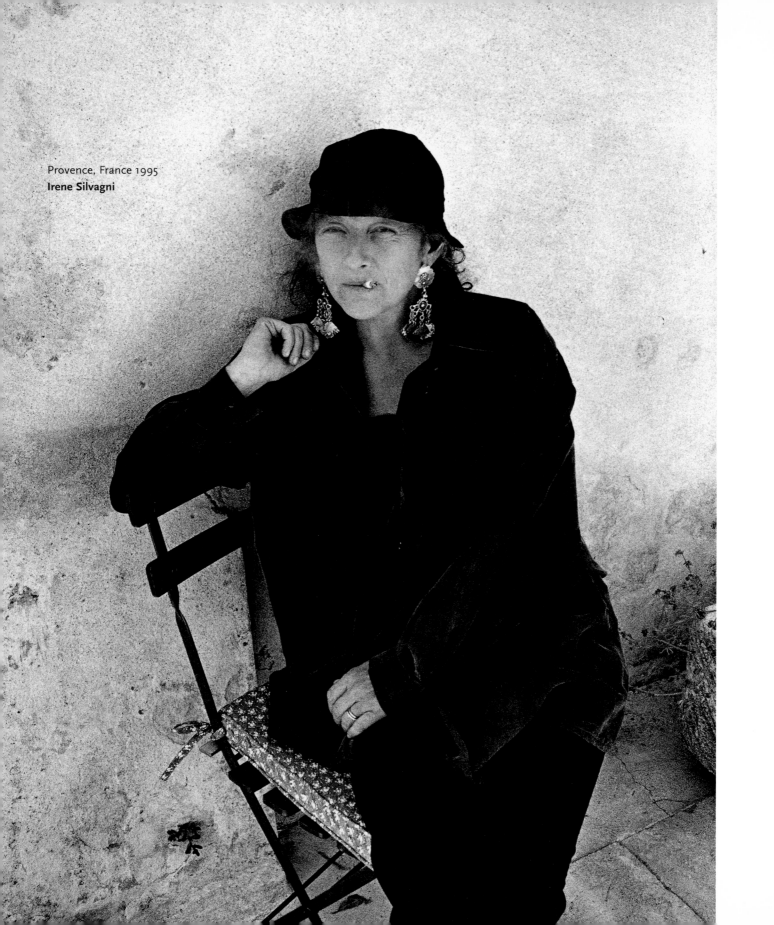

Provence, France 1995
Irene Silvagni

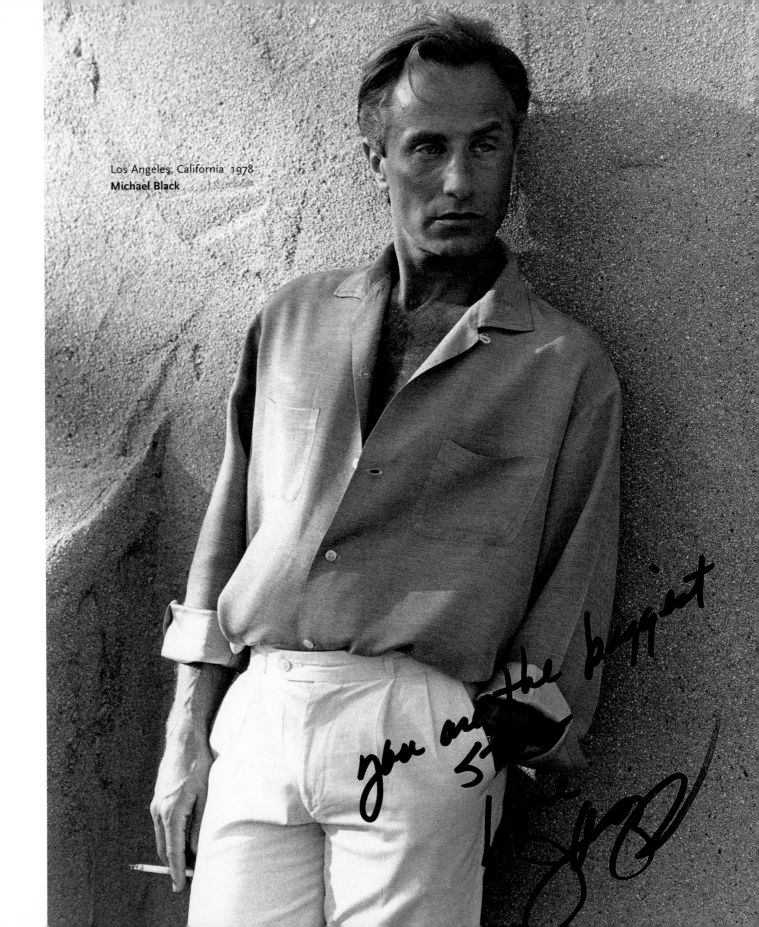

Los Angeles, California 1978
Michael Black

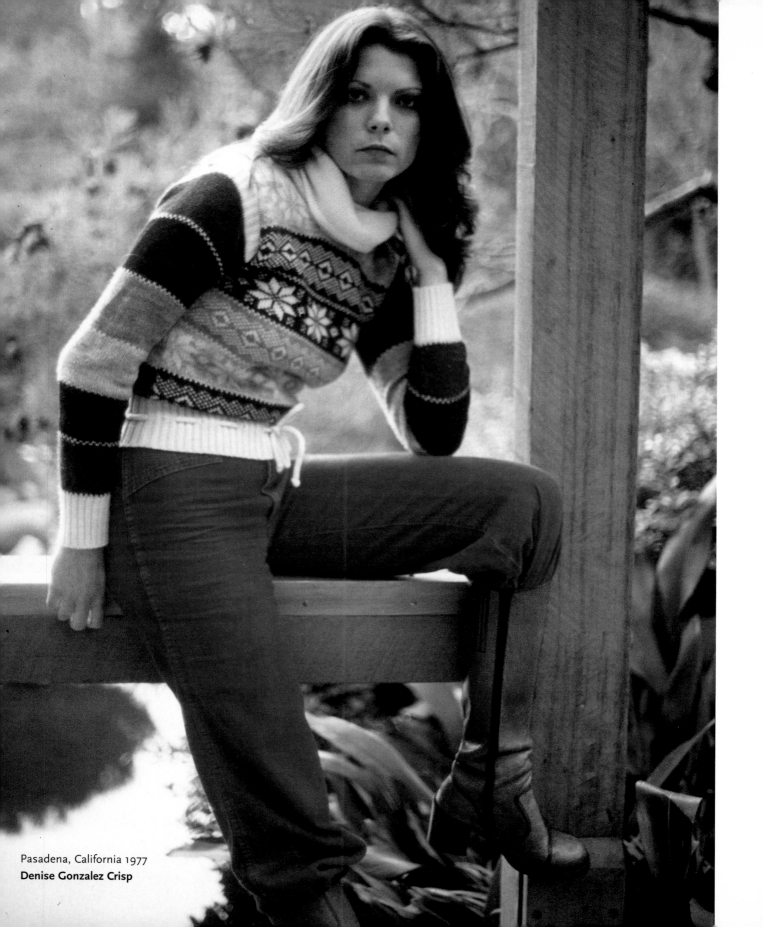

Pasadena, California 1977
Denise Gonzalez Crisp

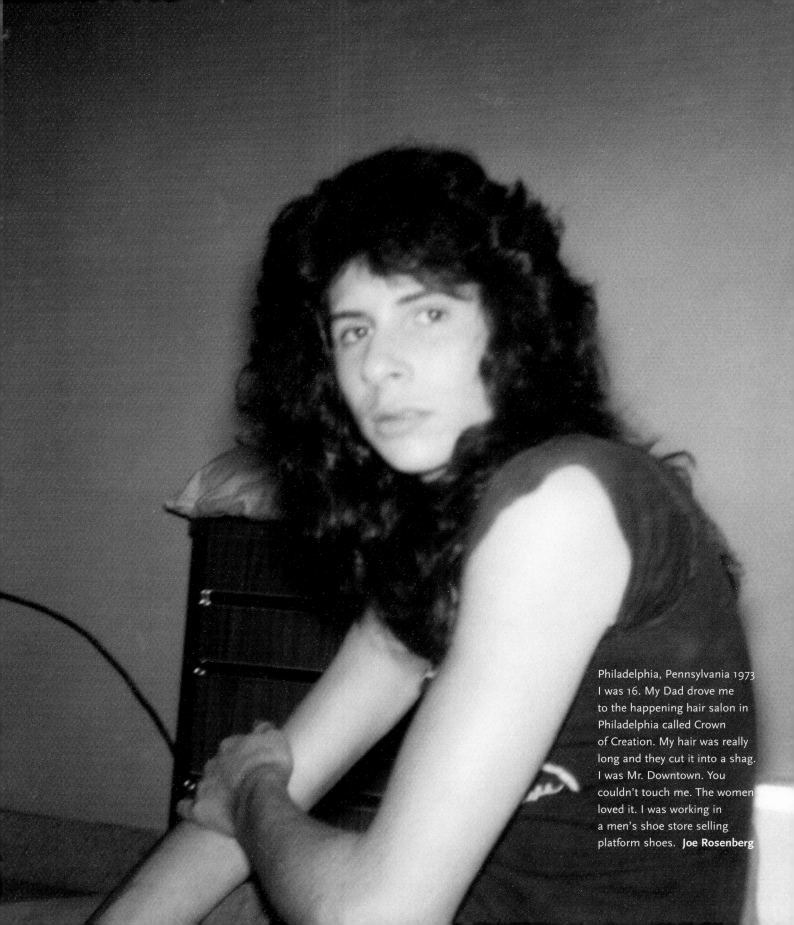

Philadelphia, Pennsylvania 1973
I was 16. My Dad drove me
to the happening hair salon in
Philadelphia called Crown
of Creation. My hair was really
long and they cut it into a shag.
I was Mr. Downtown. You
couldn't touch me. The women
loved it. I was working in
a men's shoe store selling
platform shoes. **Joe Rosenberg**

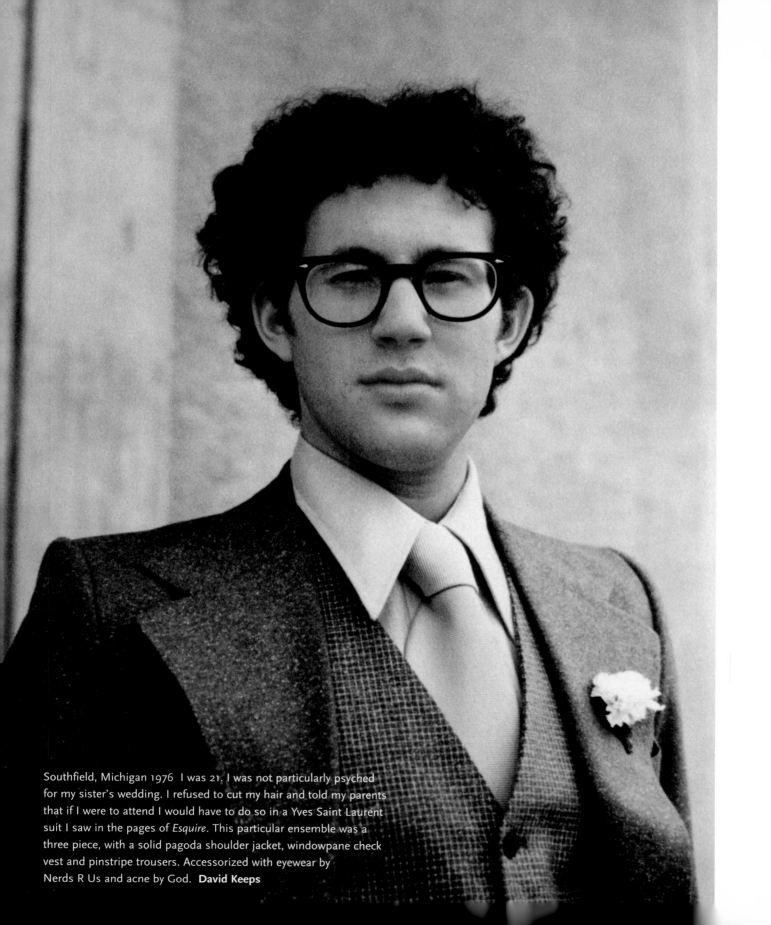

Southfield, Michigan 1976 I was 21. I was not particularly psyched
for my sister's wedding. I refused to cut my hair and told my parents
that if I were to attend I would have to do so in a Yves Saint Laurent
suit I saw in the pages of *Esquire*. This particular ensemble was a
three piece, with a solid pagoda shoulder jacket, windowpane check
vest and pinstripe trousers. Accessorized with eyewear by
Nerds R Us and acne by God. **David Keeps**

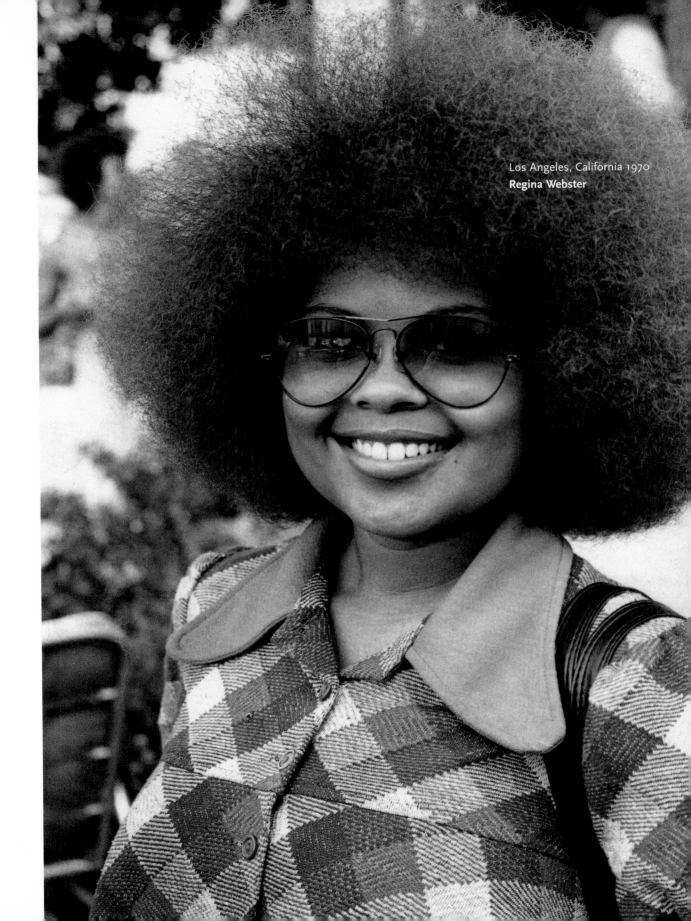

Los Angeles, California 1970
Regina Webster

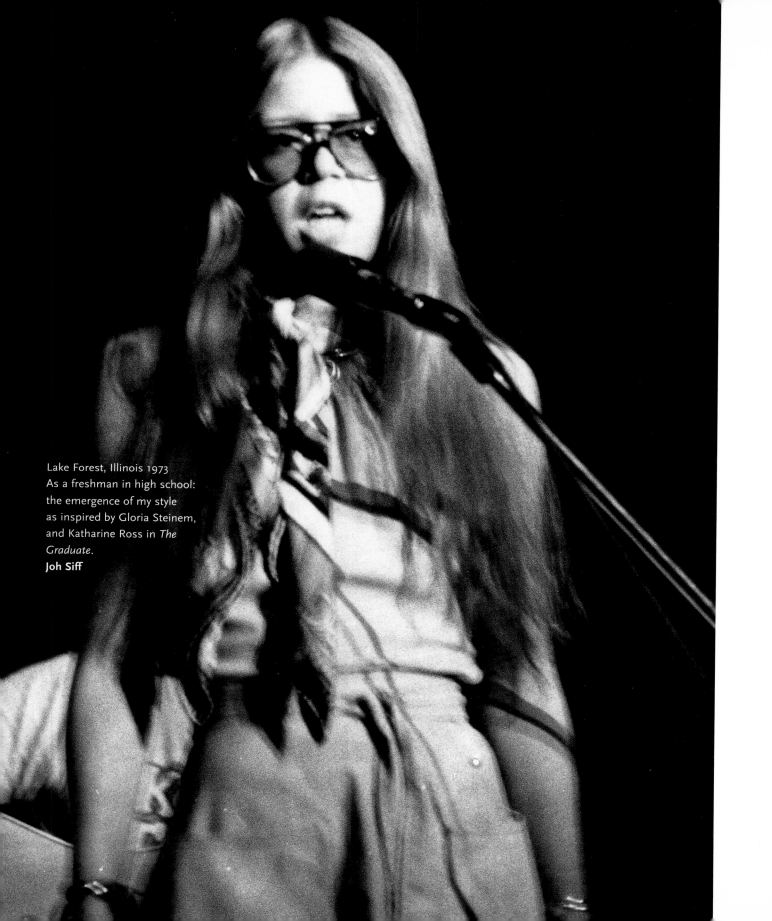

Lake Forest, Illinois 1973
As a freshman in high school:
the emergence of my style
as inspired by Gloria Steinem,
and Katharine Ross in *The
Graduate*.
Joh Siff

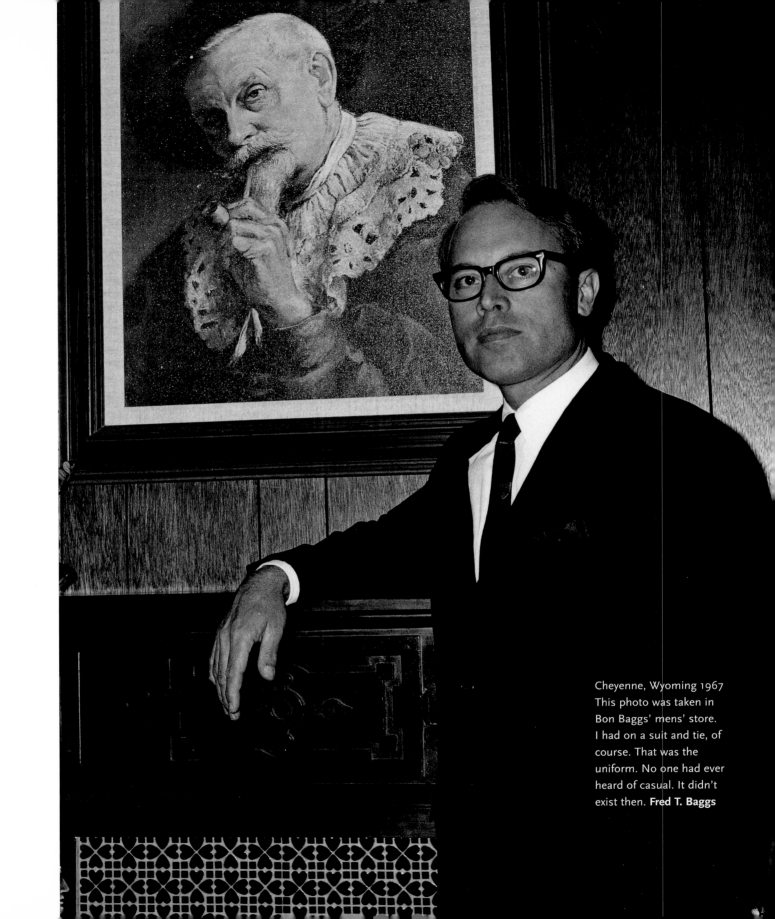

Cheyenne, Wyoming 1967
This photo was taken in
Bon Baggs' mens' store.
I had on a suit and tie, of
course. That was the
uniform. No one had ever
heard of casual. It didn't
exist then. **Fred T. Baggs**

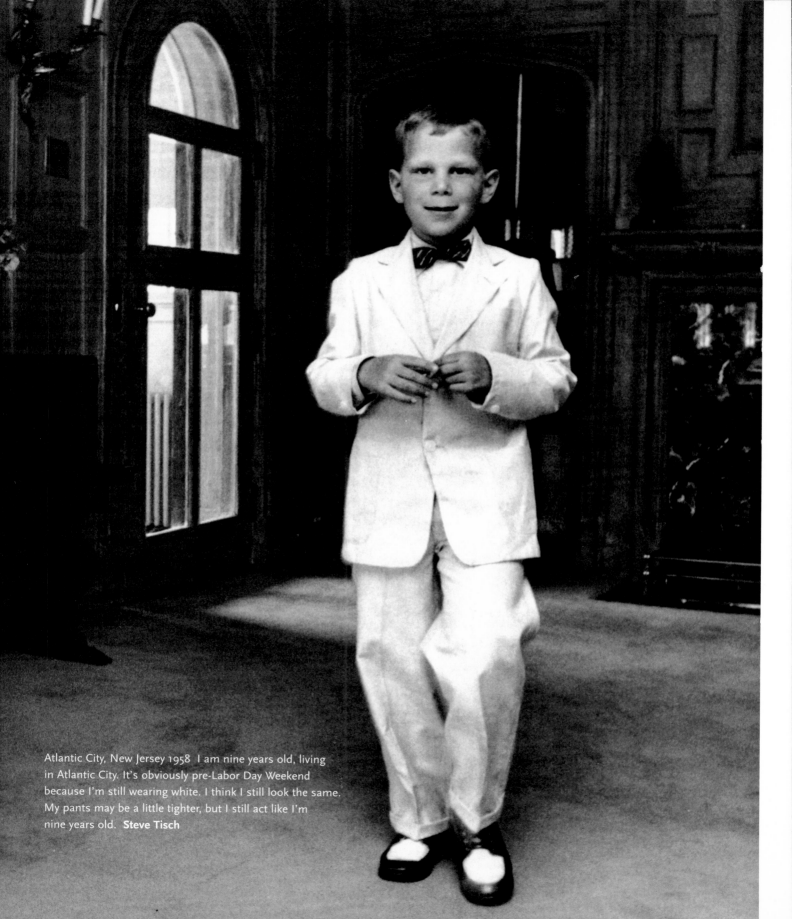

Atlantic City, New Jersey 1958 I am nine years old, living in Atlantic City. It's obviously pre-Labor Day Weekend because I'm still wearing white. I think I still look the same. My pants may be a little tighter, but I still act like I'm nine years old. **Steve Tisch**

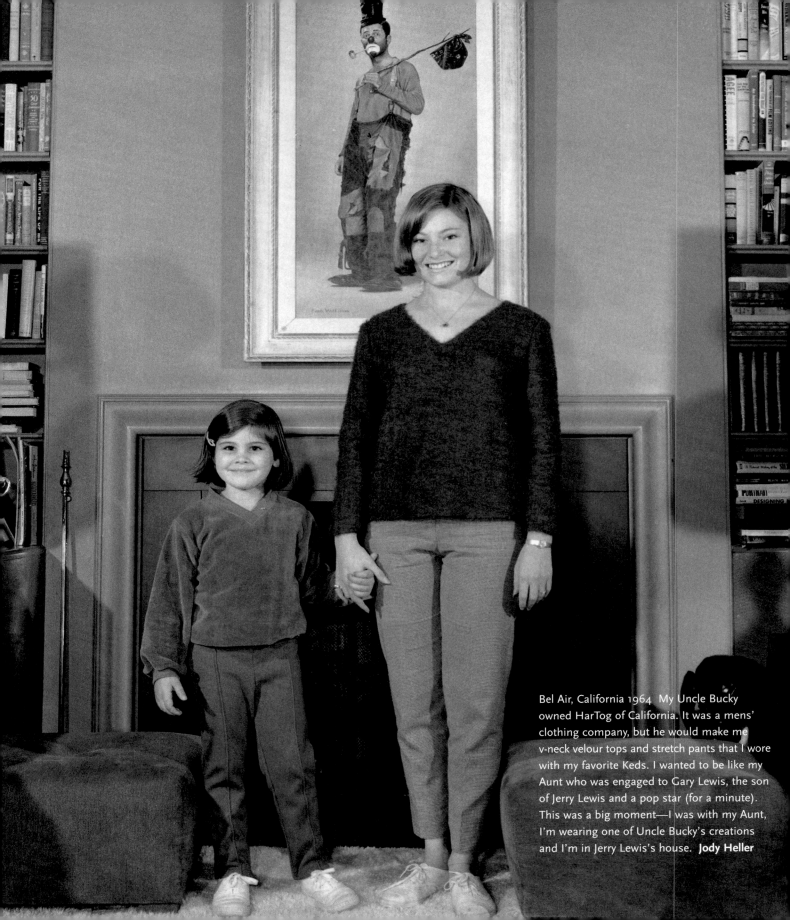

Bel Air, California 1964 My Uncle Bucky owned HarTog of California. It was a mens' clothing company, but he would make me v-neck velour tops and stretch pants that I wore with my favorite Keds. I wanted to be like my Aunt who was engaged to Gary Lewis, the son of Jerry Lewis and a pop star (for a minute). This was a big moment—I was with my Aunt, I'm wearing one of Uncle Bucky's creations and I'm in Jerry Lewis's house. **Jody Heller**

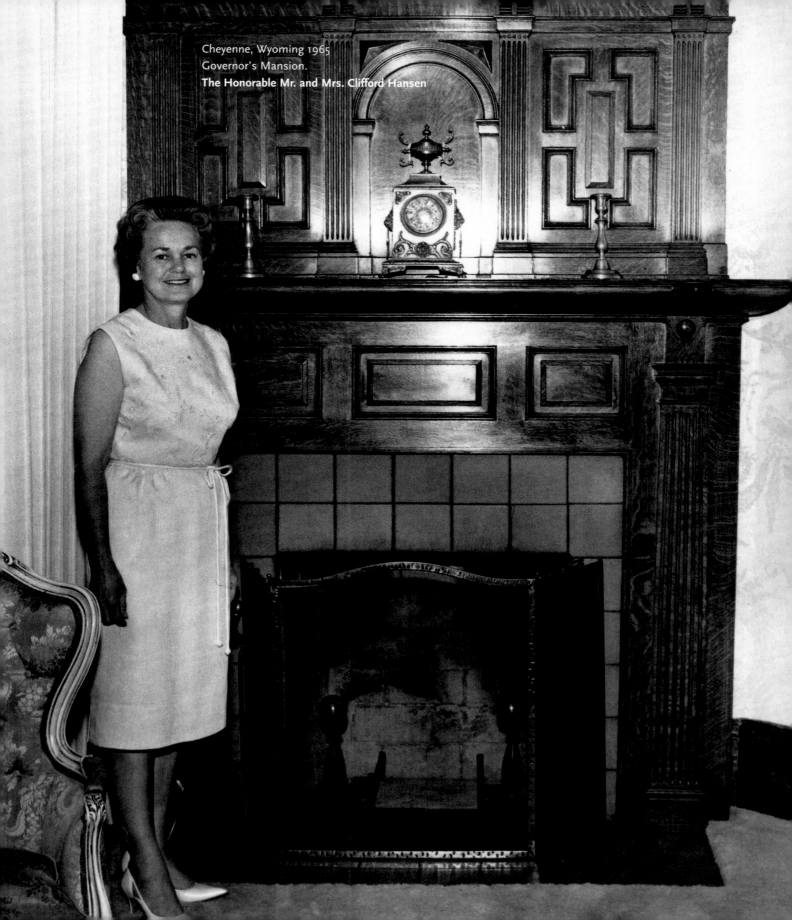

Cheyenne, Wyoming 1965
Governor's Mansion.
The Honorable Mr. and Mrs. Clifford Hansen

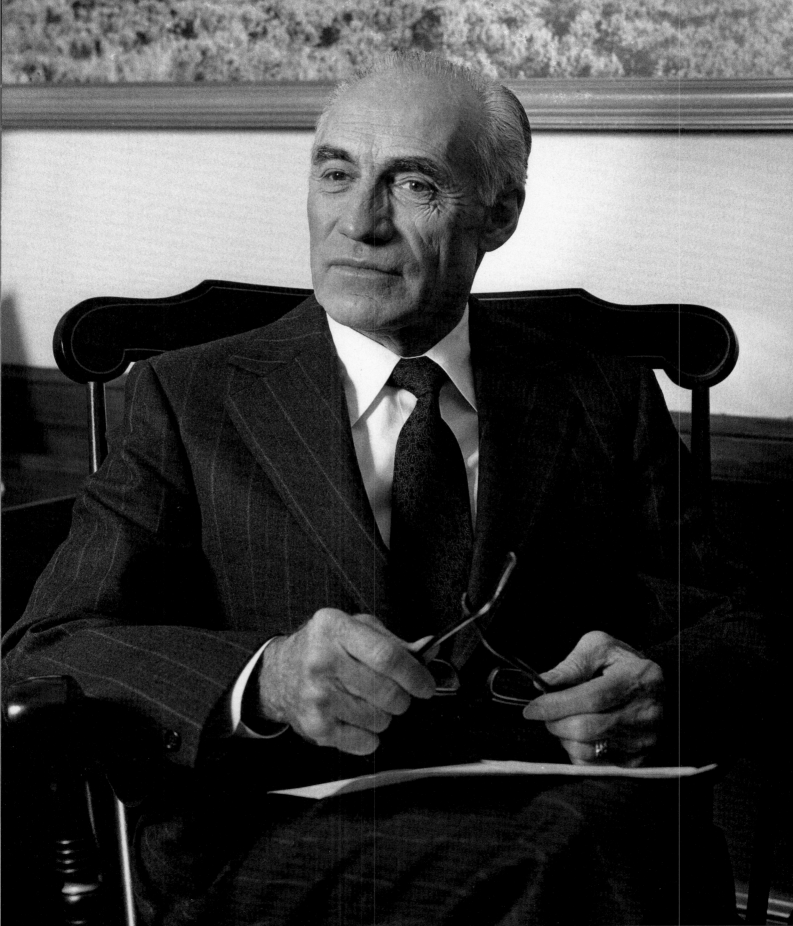

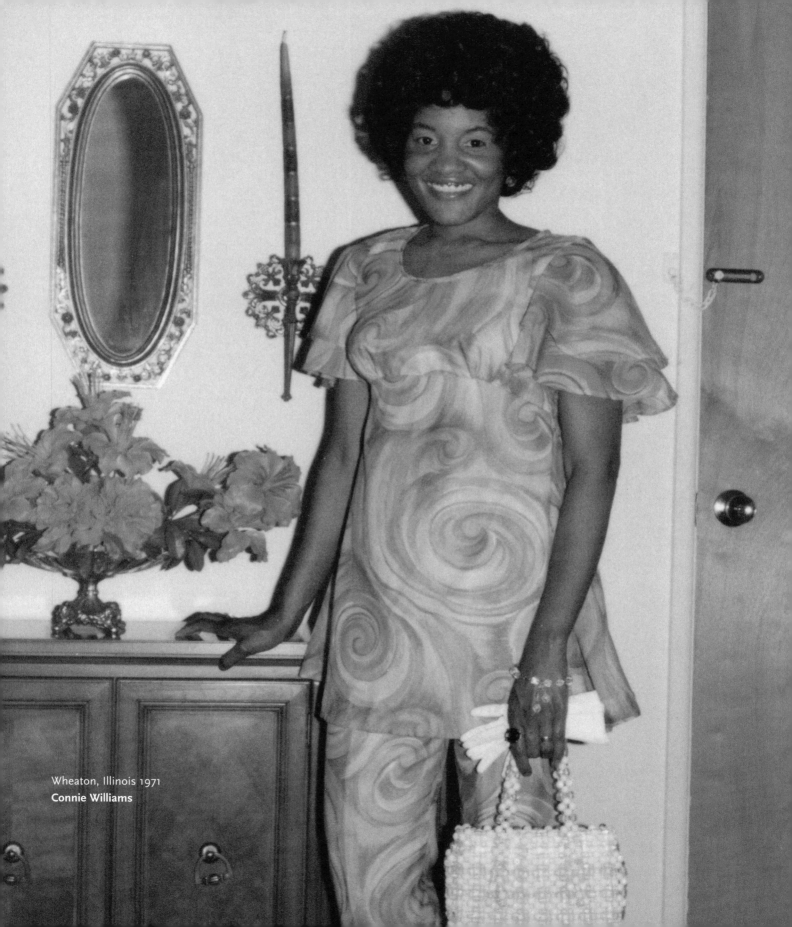

Wheaton, Illinois 1971
Connie Williams

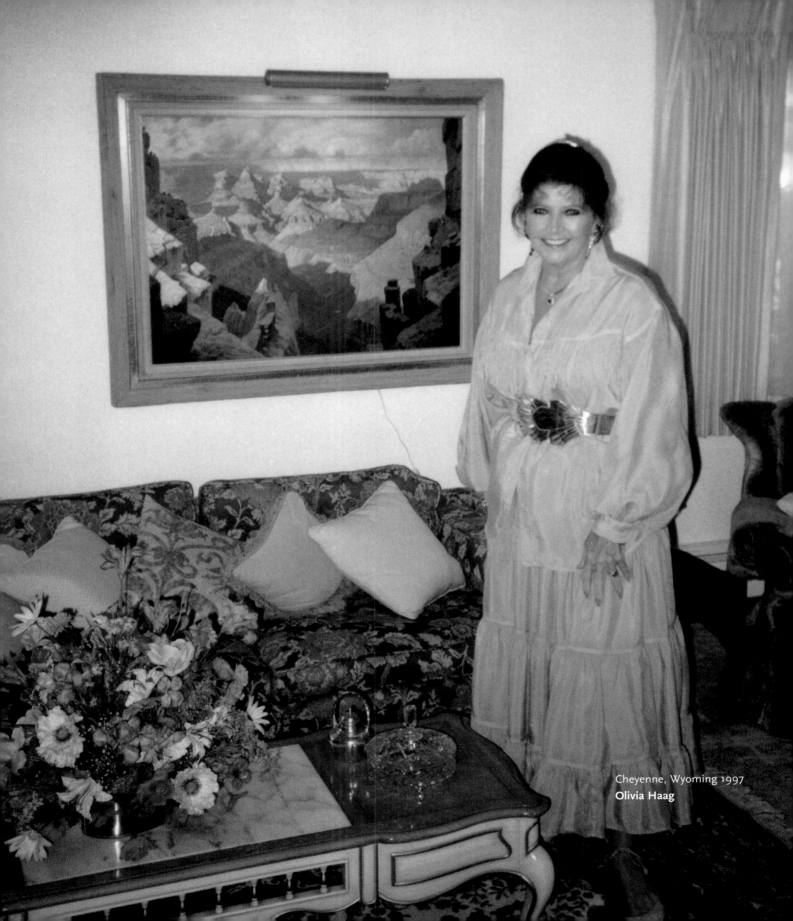

Cheyenne, Wyoming 1997
Olivia Haag

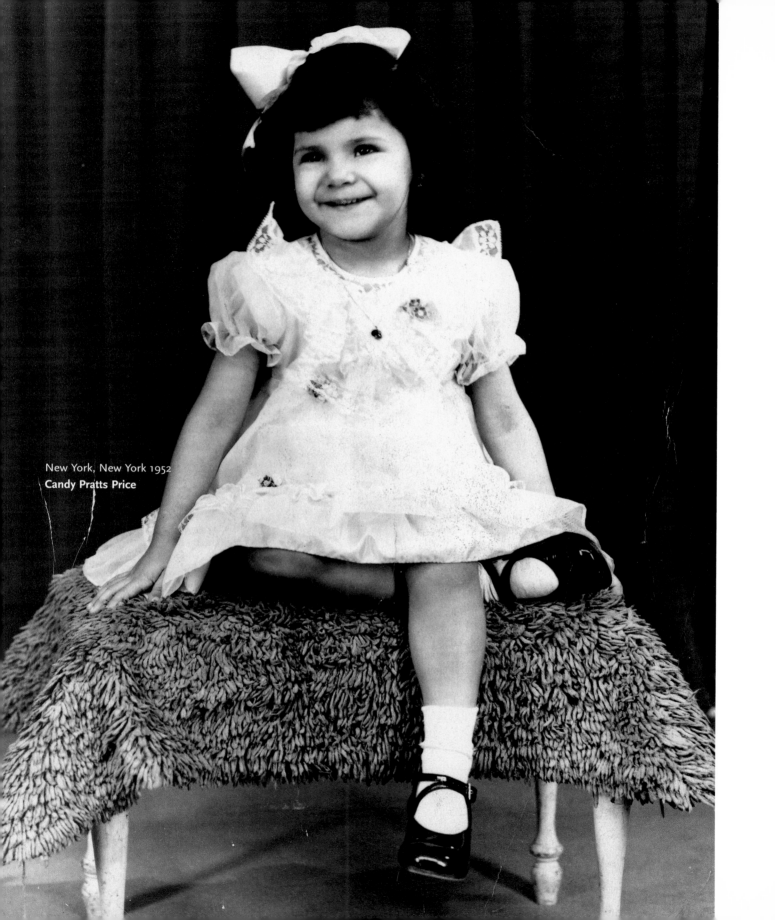

New York, New York 1952
Candy Pratts Price

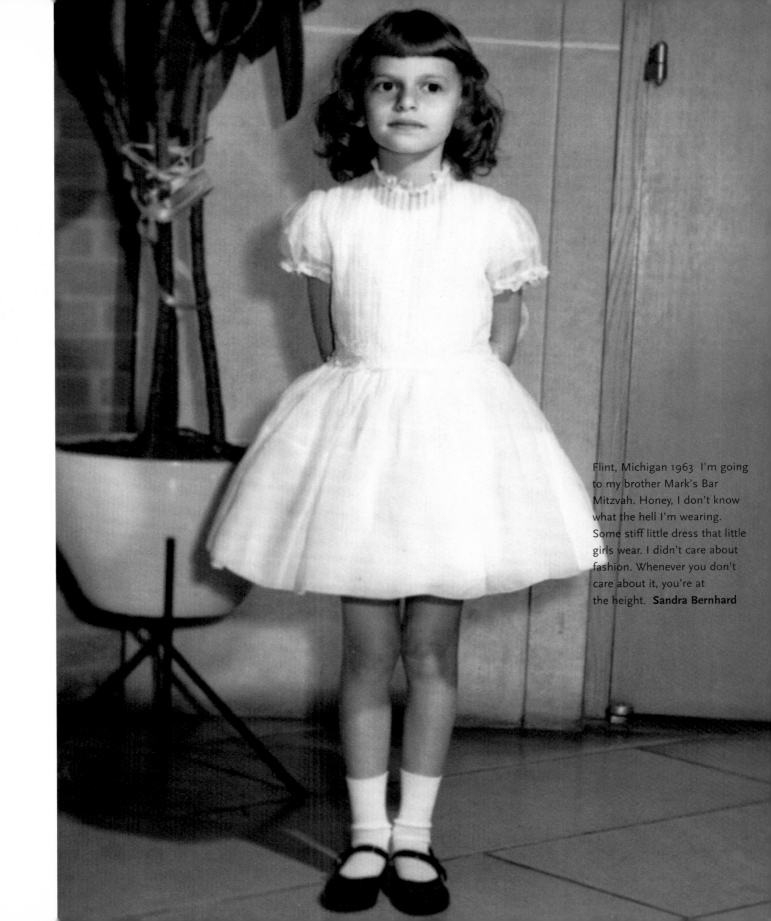

Flint, Michigan 1963 I'm going to my brother Mark's Bar Mitzvah. Honey, I don't know what the hell I'm wearing. Some stiff little dress that little girls wear. I didn't care about fashion. Whenever you don't care about it, you're at the height. **Sandra Bernhard**

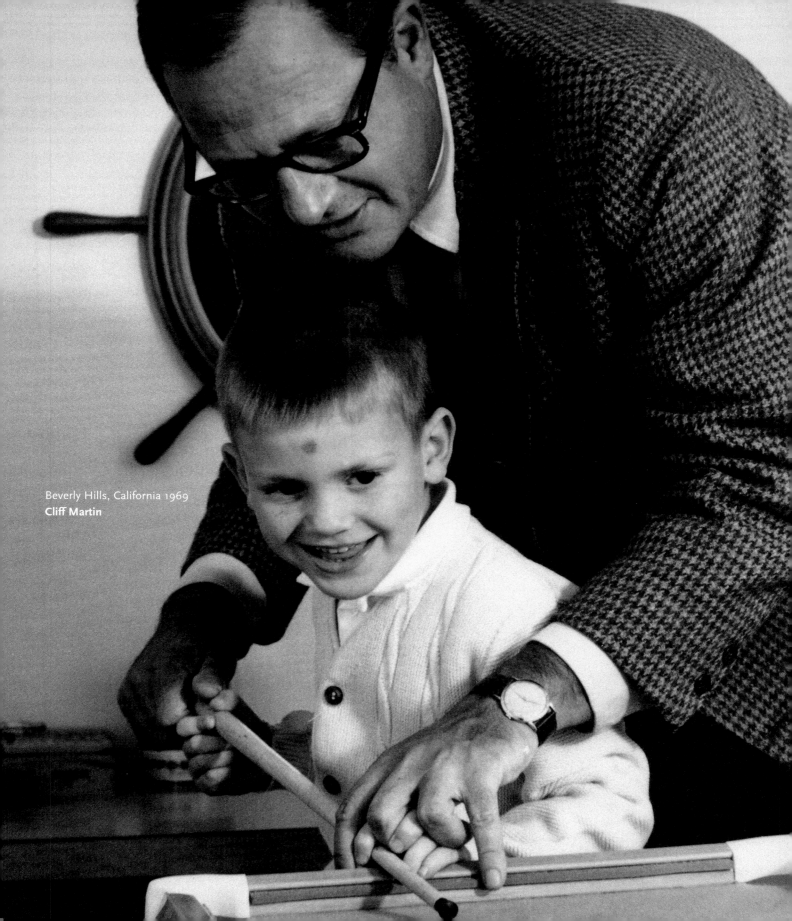

Beverly Hills, California 1969
Cliff Martin

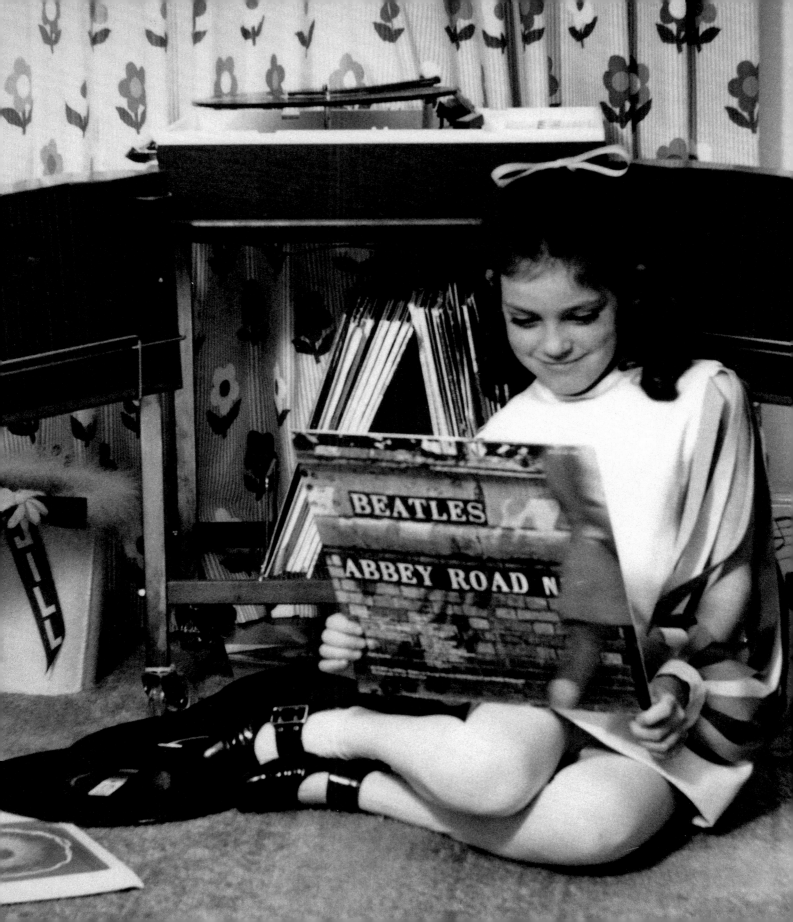

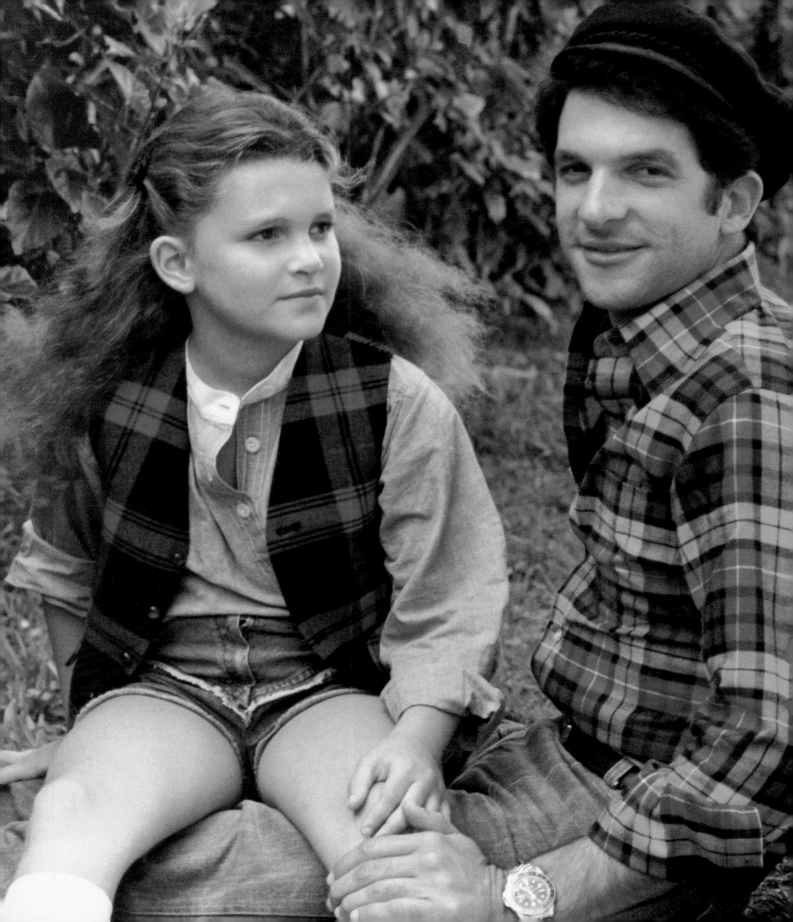

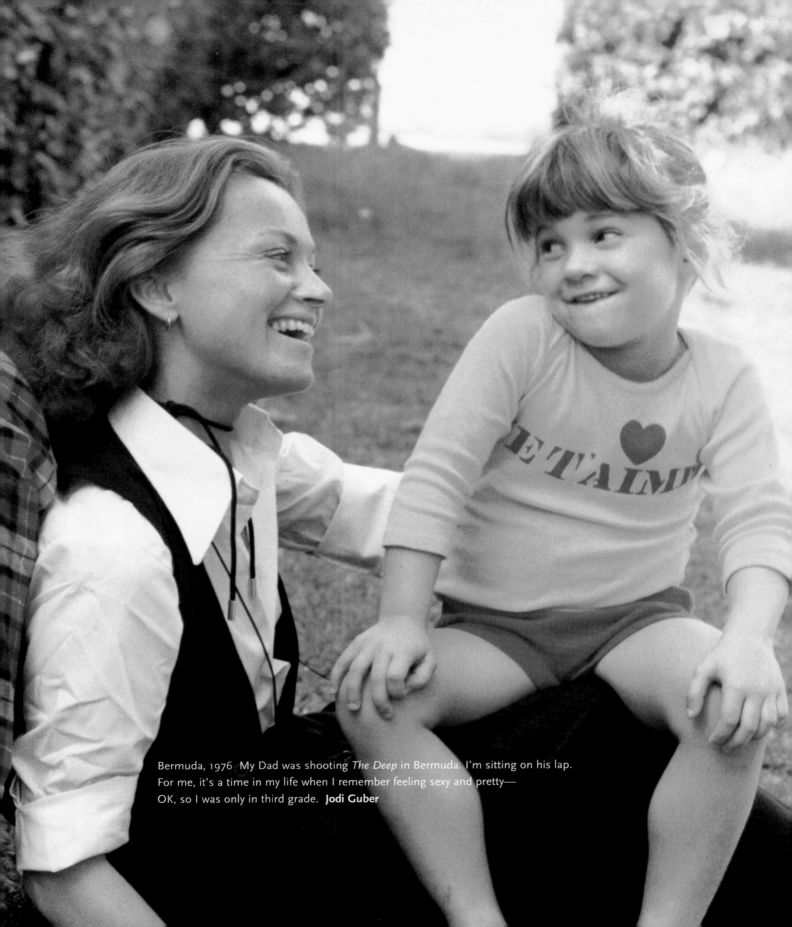

Bermuda, 1976 My Dad was shooting *The Deep* in Bermuda. I'm sitting on his lap.
For me, it's a time in my life when I remember feeling sexy and pretty—
OK, so I was only in third grade. **Jodi Guber**

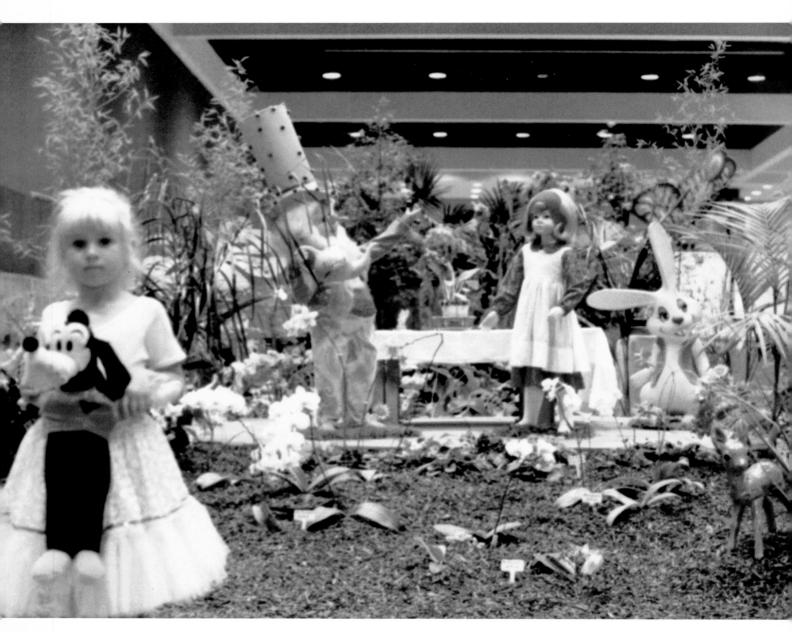

La Jolla, California 1977
Ariana Lambert

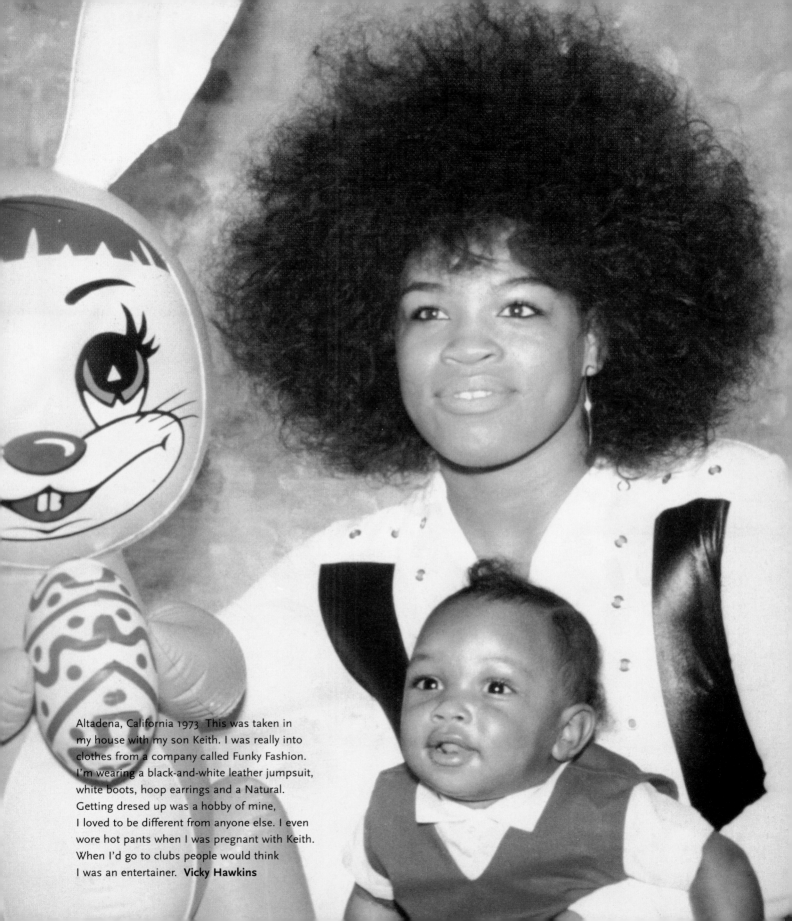

Altadena, California 1973 This was taken in my house with my son Keith. I was really into clothes from a company called Funky Fashion. I'm wearing a black-and-white leather jumpsuit, white boots, hoop earrings and a Natural. Getting dresed up was a hobby of mine, I loved to be different from anyone else. I even wore hot pants when I was pregnant with Keith. When I'd go to clubs people would think I was an entertainer. **Vicky Hawkins**

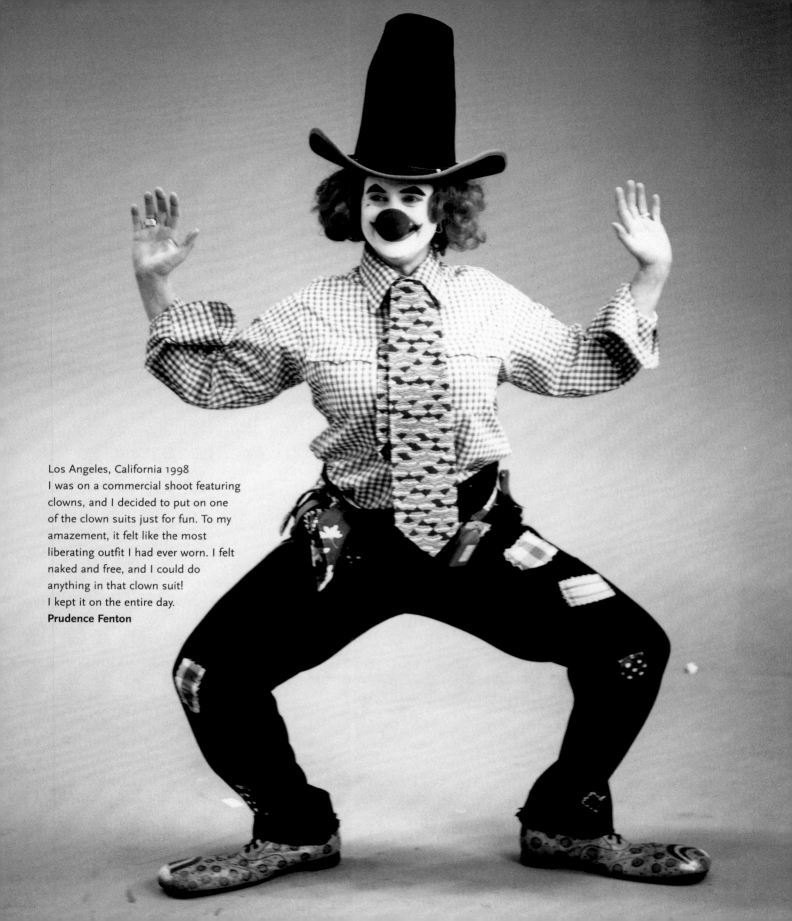

Los Angeles, California 1998
I was on a commercial shoot featuring clowns, and I decided to put on one of the clown suits just for fun. To my amazement, it felt like the most liberating outfit I had ever worn. I felt naked and free, and I could do anything in that clown suit!
I kept it on the entire day.
Prudence Fenton

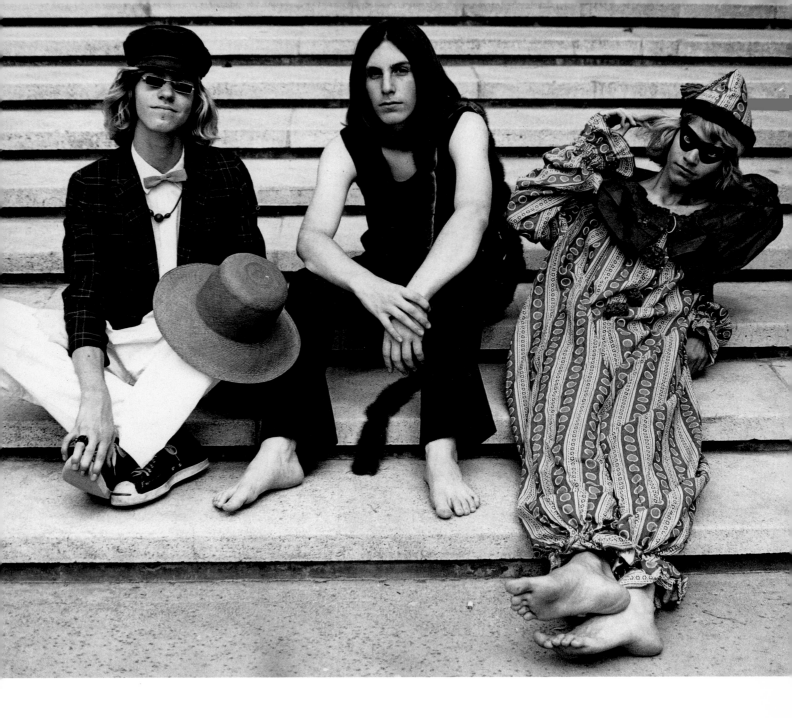

Los Angeles, California 1973 I'm with Alex and Nels Cline in the sculpture garden at UCLA. We were all in a high school band together. It's the only picture of myself that I've ever liked.
I'm wearing a knit thrift store vest, mink trimming draped like a boa, and pin-striped, flocked bell bottoms. The name of our band was *Android Funnel*. **Lee Kaplan**

New York, New York 1968 This photo was taken
by my husband, Bill Claxton, in New York for
Rudi Gernreich. As always, I designed my make-up.
That's mercurochrome painted on my feet.
I think that fashion is not nearly as important as
personal style, humanity, conviction and humor.
Peggy Moffitt

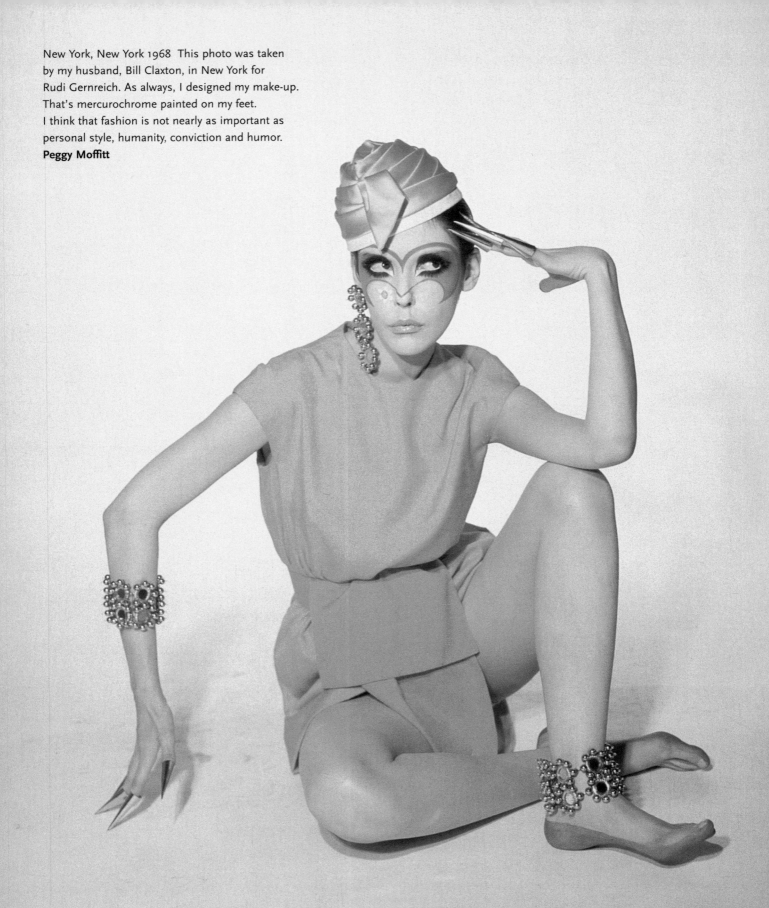

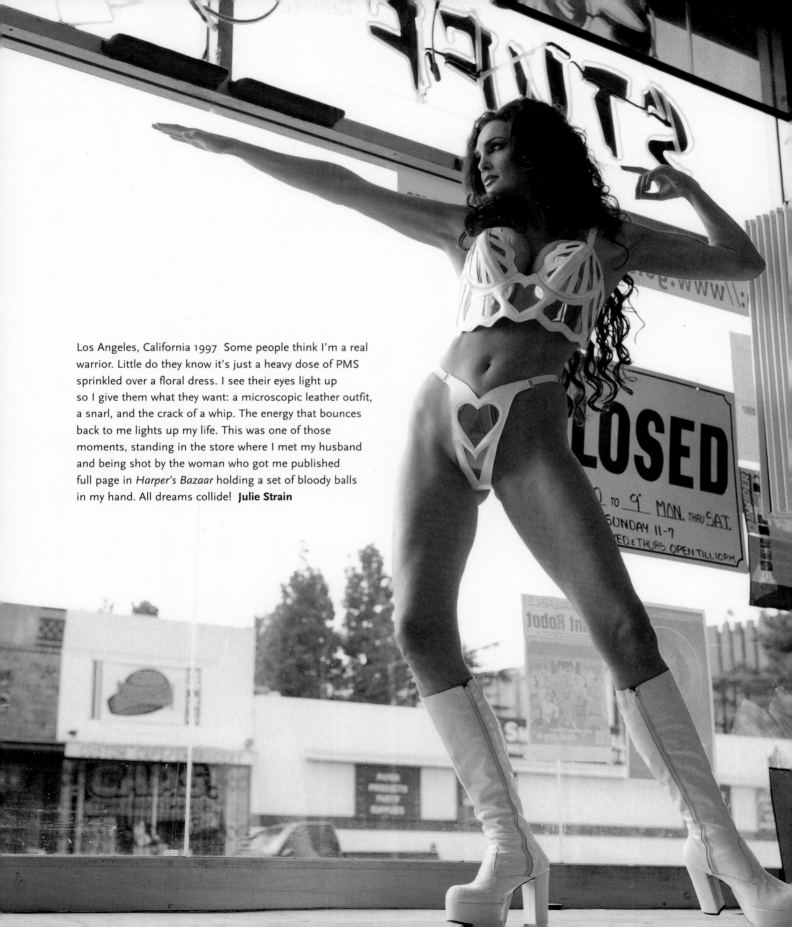

Los Angeles, California 1997 Some people think I'm a real warrior. Little do they know it's just a heavy dose of PMS sprinkled over a floral dress. I see their eyes light up so I give them what they want: a microscopic leather outfit, a snarl, and the crack of a whip. The energy that bounces back to me lights up my life. This was one of those moments, standing in the store where I met my husband and being shot by the woman who got me published full page in *Harper's Bazaar* holding a set of bloody balls in my hand. All dreams collide! **Julie Strain**

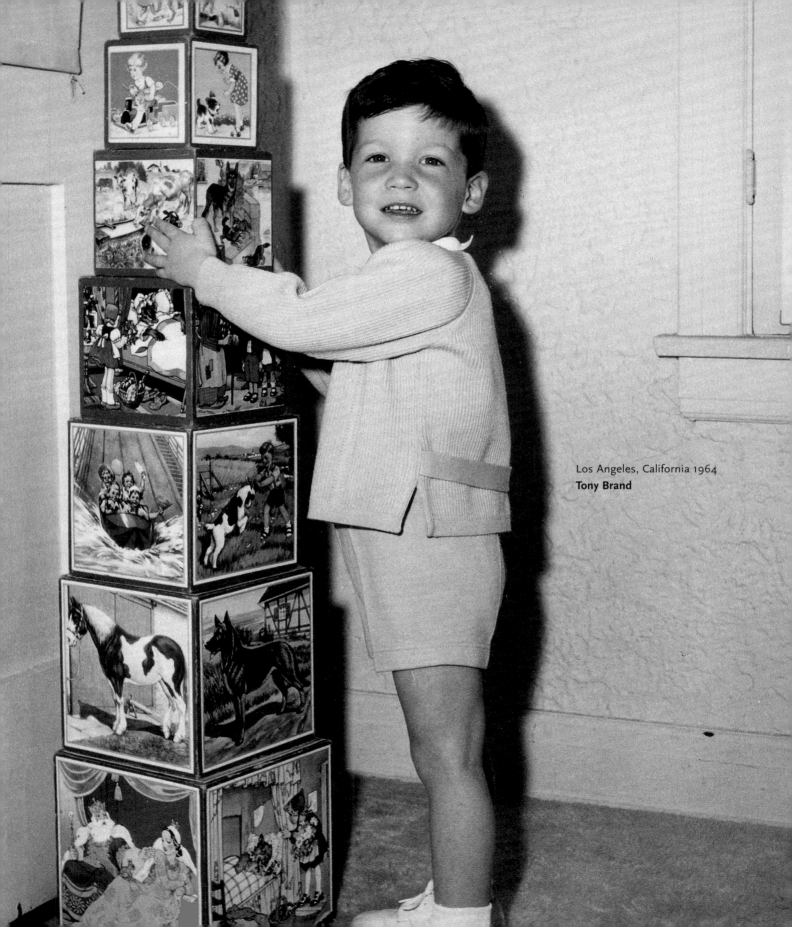

Los Angeles, California 1964
Tony Brand

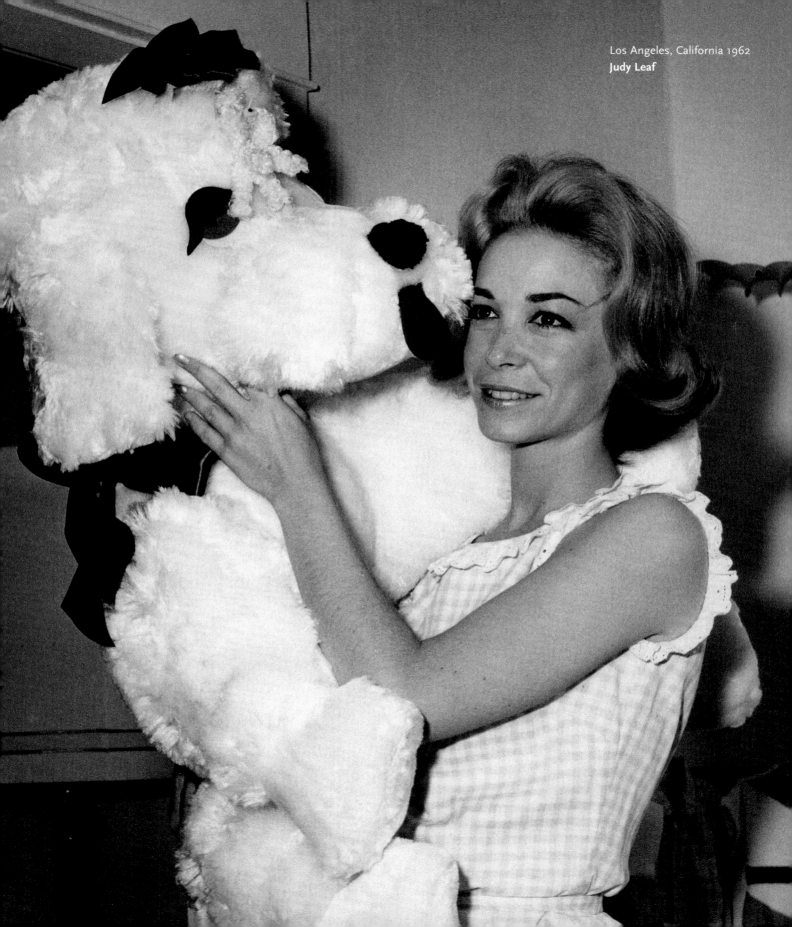

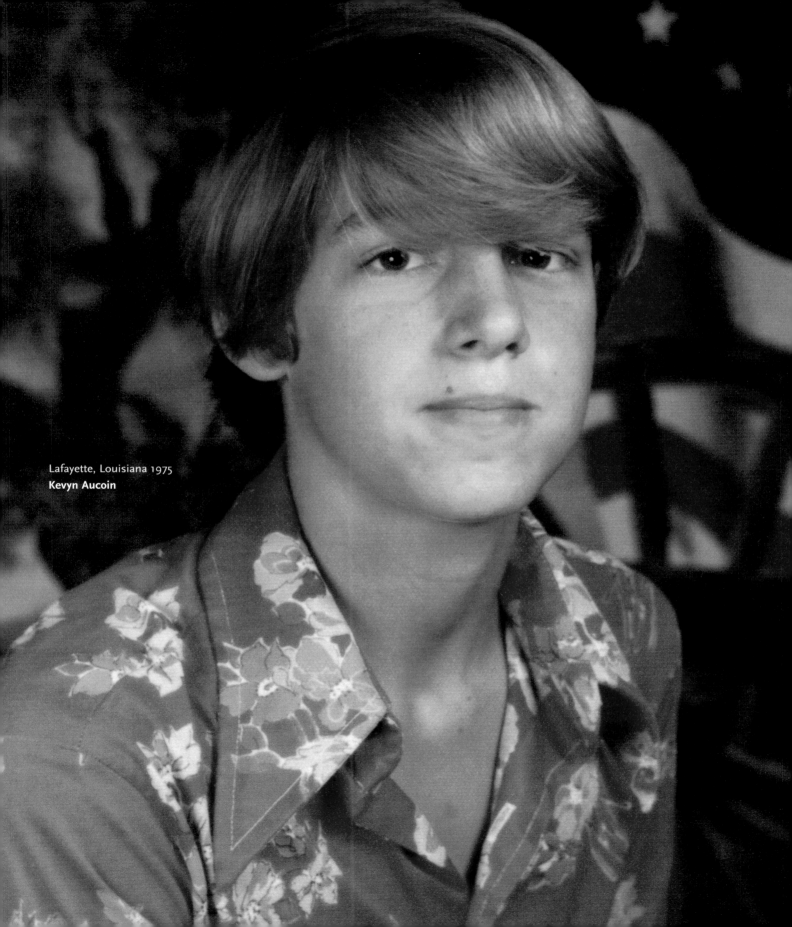

Lafayette, Louisiana 1975
Kevyn Aucoin

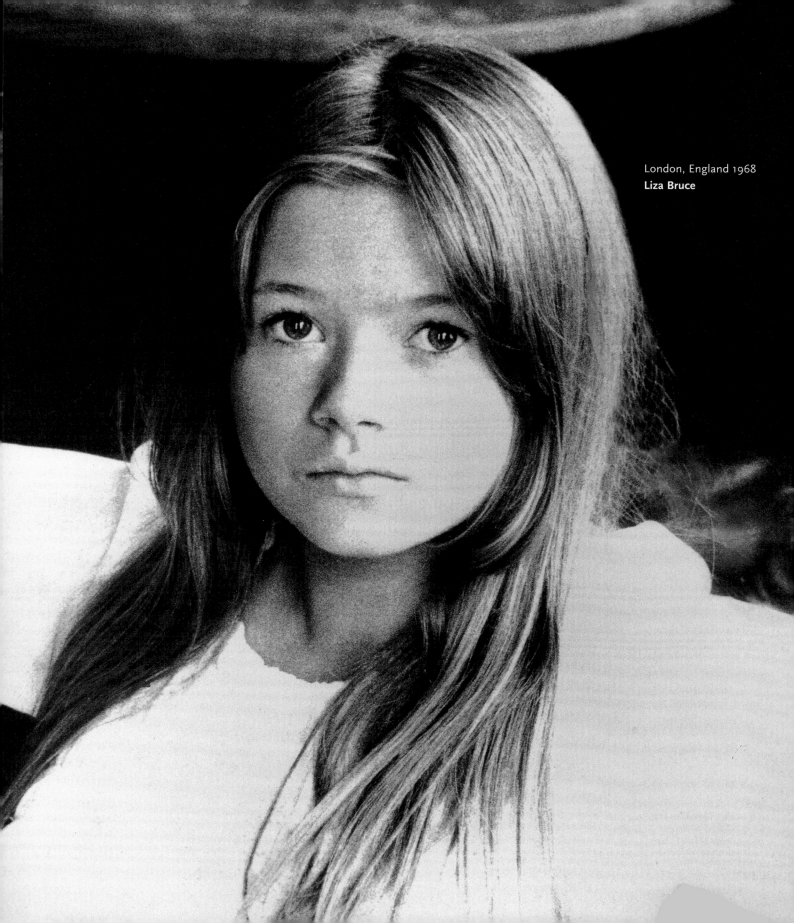

London, England 1968
Liza Bruce

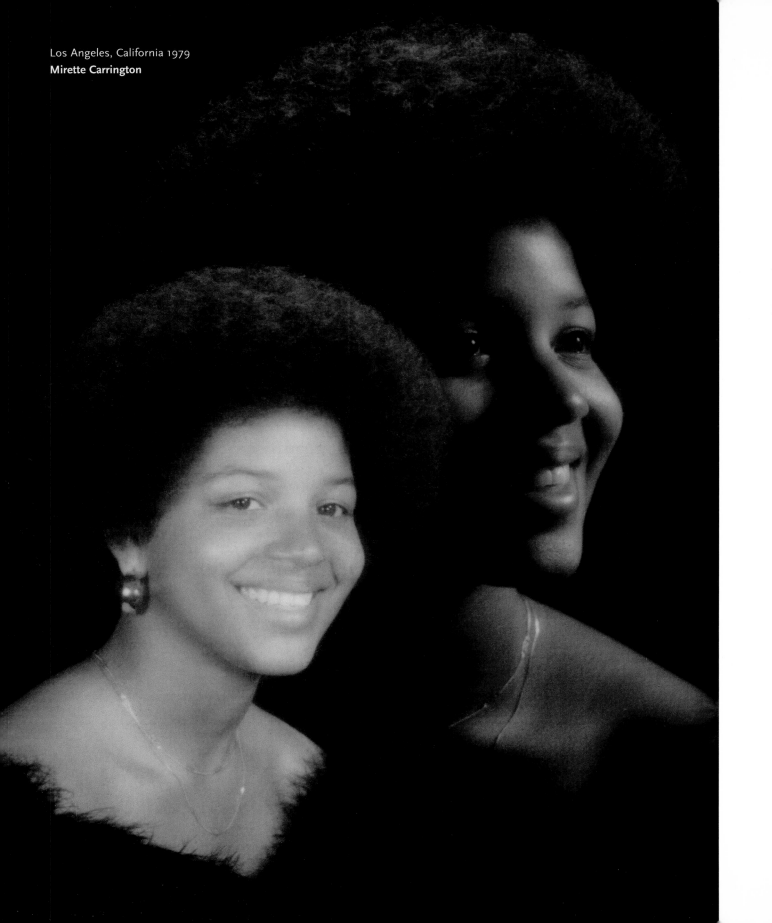

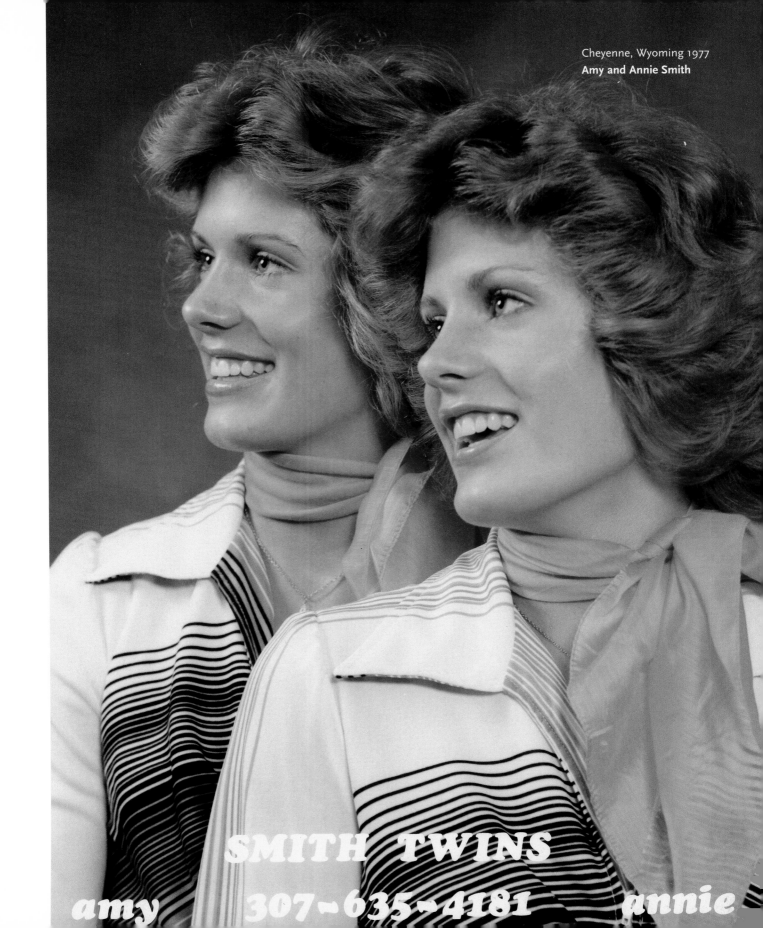

Cheyenne, Wyoming 1977
Amy and Annie Smith

SMITH TWINS

amy 307~635~4181 annie

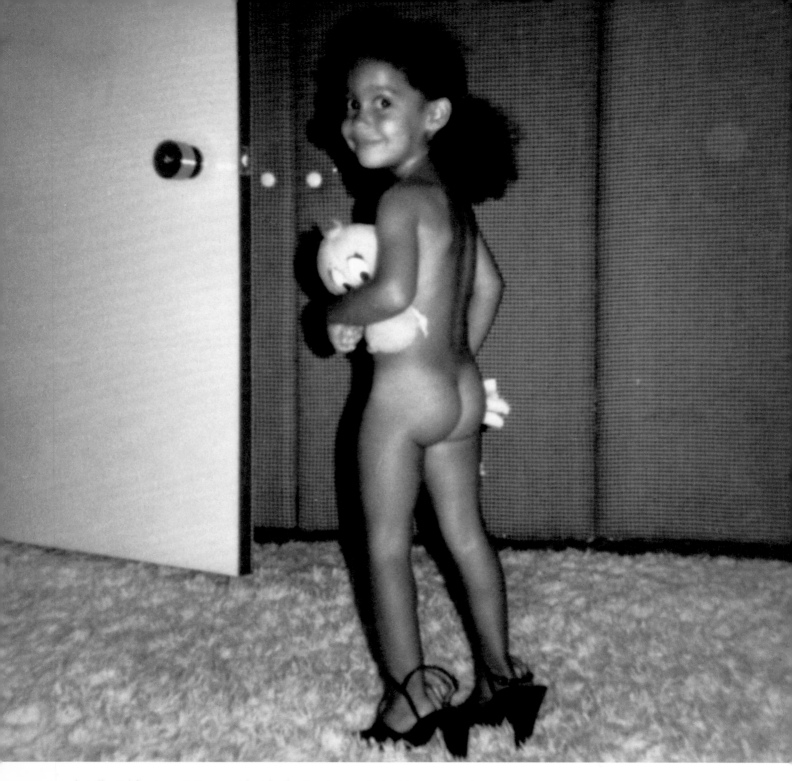

Beverly Hills, California 1978 It was evident by the time I was 3 that raiding my mom's
closet would prove to be fuel for a life as a lover of beautiful clothes. At my best all I needed
was Tweety Bird, a pair of Mom's fabulous heels, a firm tush and a smile.
To this day that combination works. **Tracee Ellis Ross**

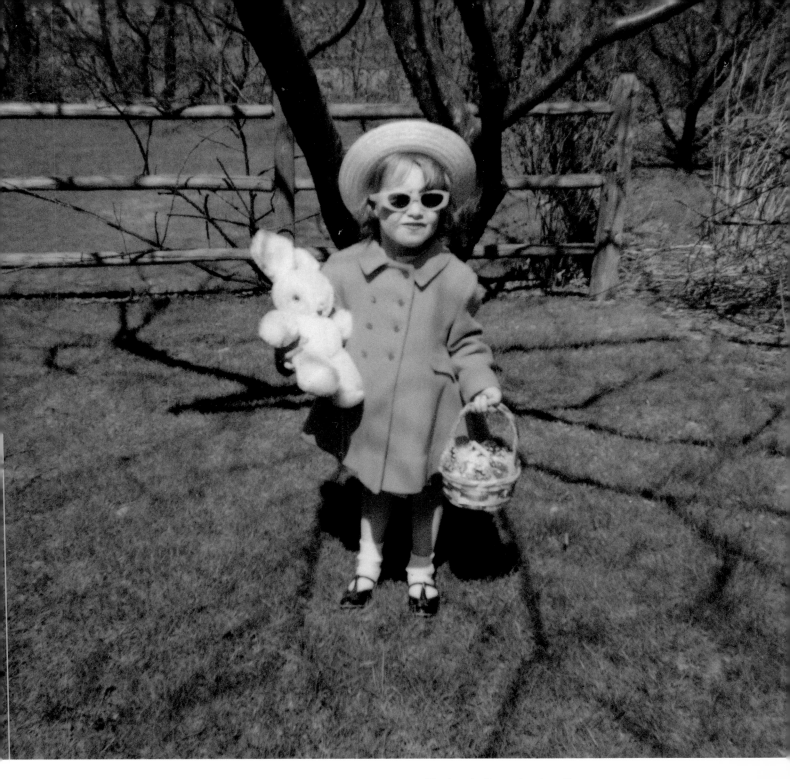

Pittsburgh, Pennsylvania 1963
Sharon Gallagher

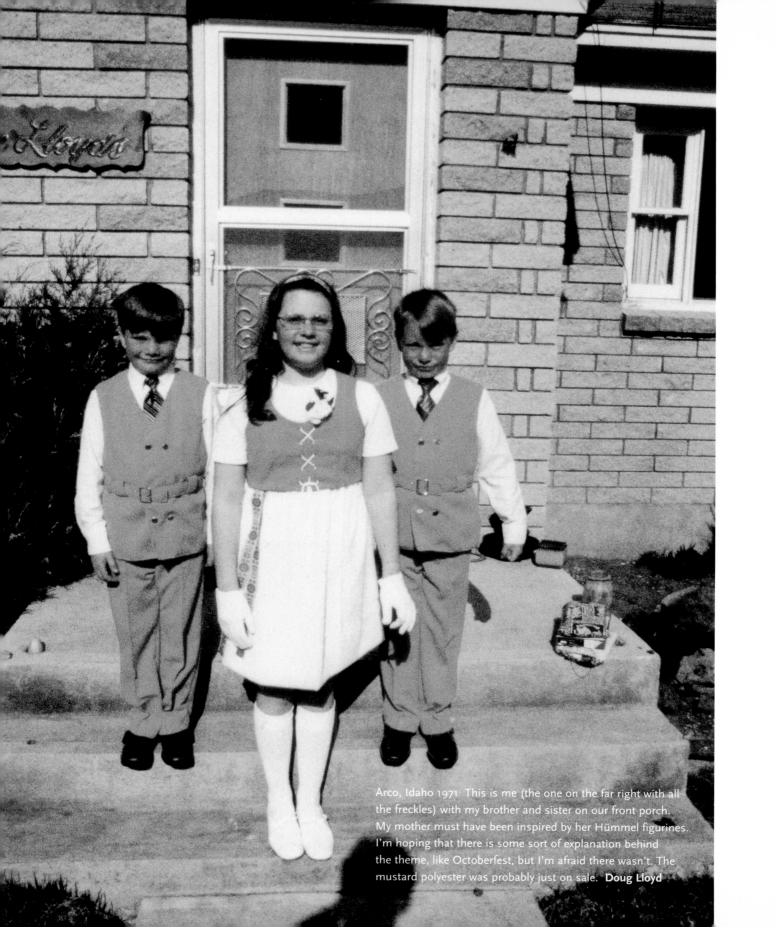

Arco, Idaho 1971 This is me (the one on the far right with all the freckles) with my brother and sister on our front porch. My mother must have been inspired by her Hümmel figurines. I'm hoping that there is some sort of explanation behind the theme, like Octoberfest, but I'm afraid there wasn't. The mustard polyester was probably just on sale. **Doug Lloyd**

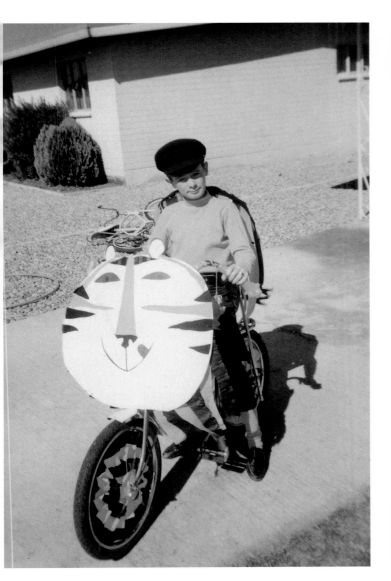

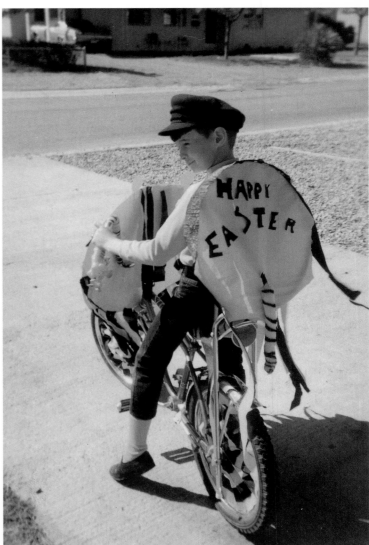

Sierra Vista, Arizona 1966 In Sierra Vista we loved a parade.
My bike was a tiny Ray and had a tiger seat, but Tony was the only Tiger
I knew. I thought I was really cool. **Jeffery Keedy**

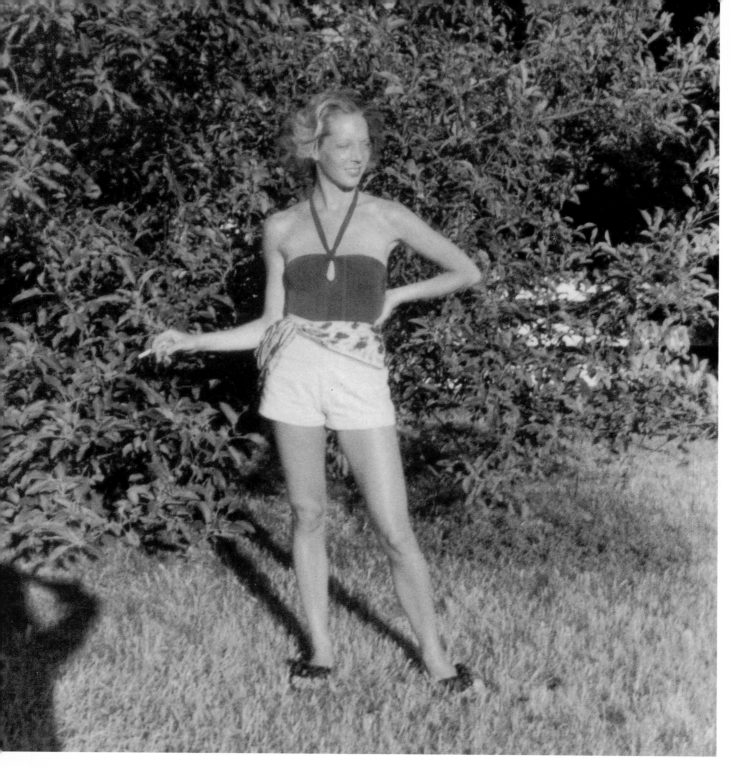

Urbandale, Iowa 1975 We had some Europeans on the way to our house to visit. I was trying to look sleek and sophisticated. My inspirations were the jet set, Capri, the von Furstenbergs and Marisa Berenson. I am wearing white shorts, a scarf tied around my waist, a red halter body suit, platform sandals and a cigarette. The hair had been done by Vidal Sassoon when they came into town for a show—it was a 30's revival perm. **Catherine Cole**

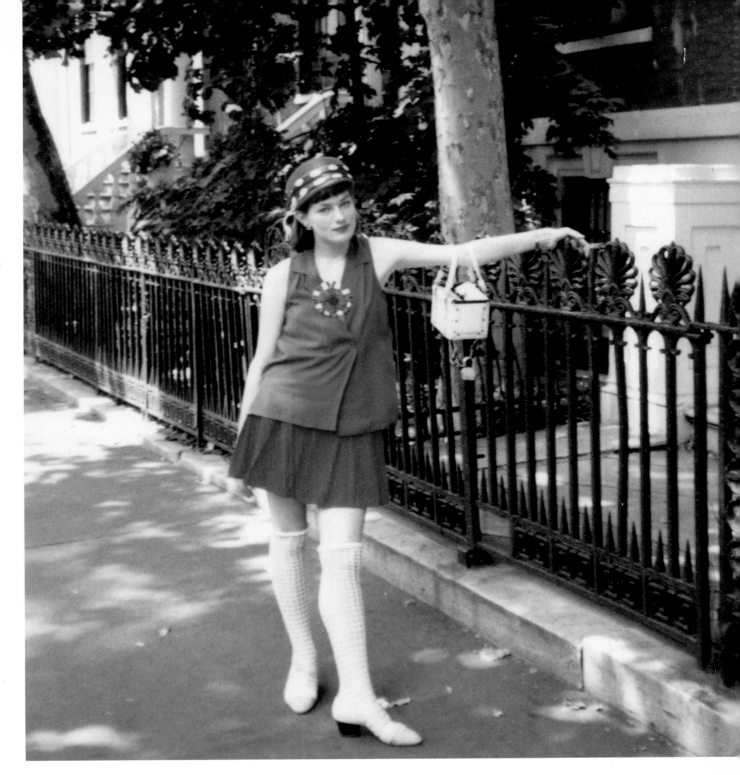

New York, New York 1988
Laurie Pike

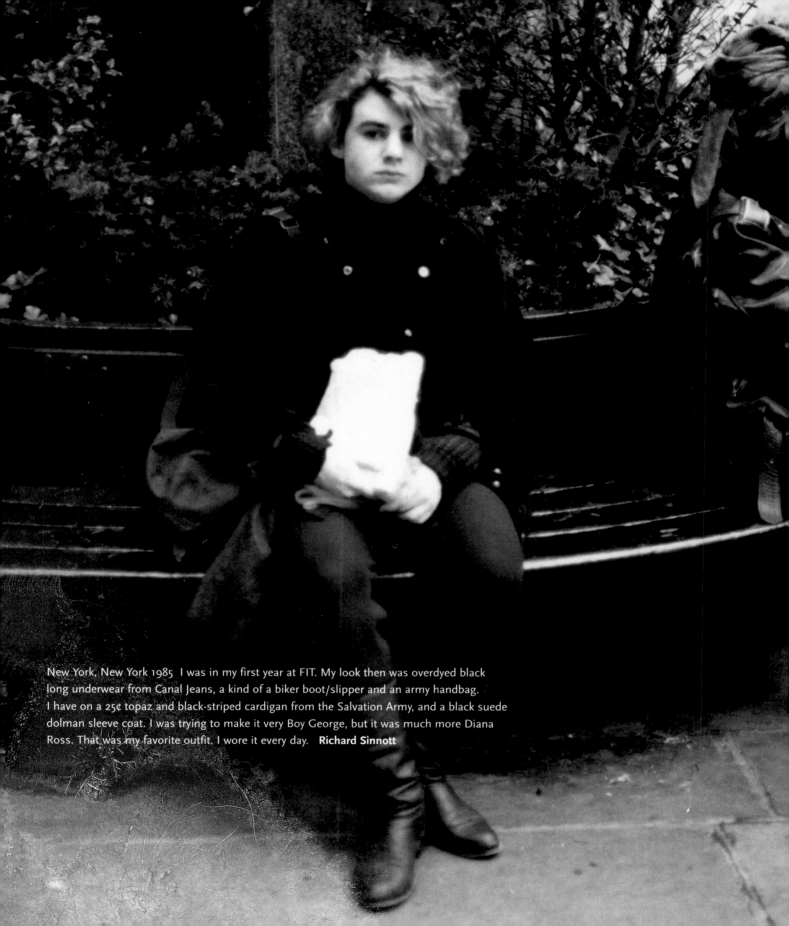

New York, New York 1985 I was in my first year at FIT. My look then was overdyed black
long underwear from Canal Jeans, a kind of a biker boot/slipper and an army handbag.
I have on a 25¢ topaz and black-striped cardigan from the Salvation Army, and a black suede
dolman sleeve coat. I was trying to make it very Boy George, but it was much more Diana
Ross. That was my favorite outfit. I wore it every day. **Richard Sinnott**

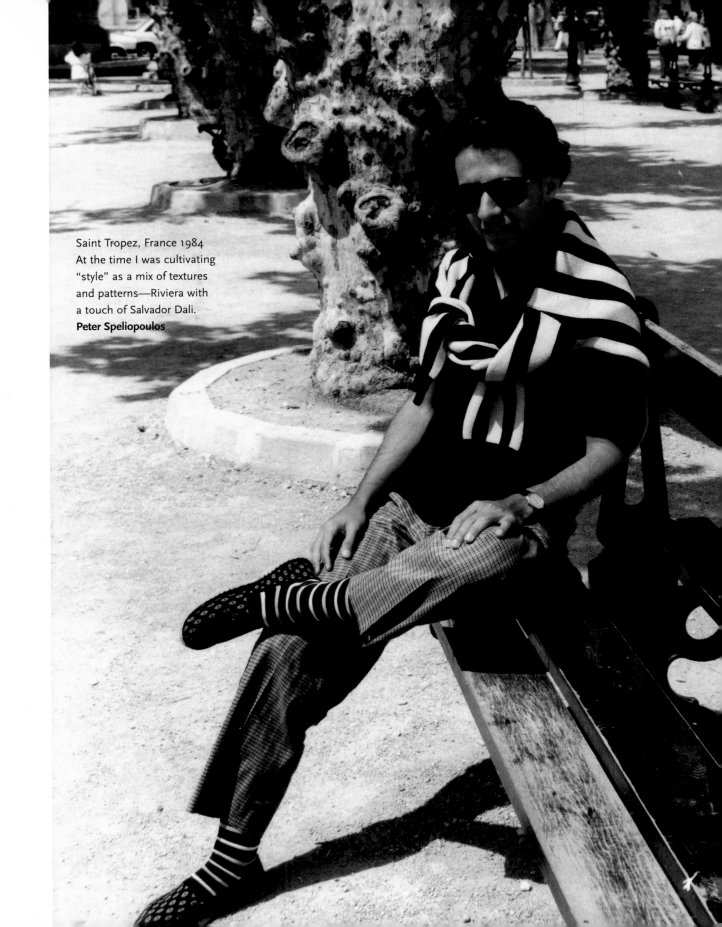

Saint Tropez, France 1984
At the time I was cultivating
"style" as a mix of textures
and patterns—Riviera with
a touch of Salvador Dali.
Peter Speliopoulos

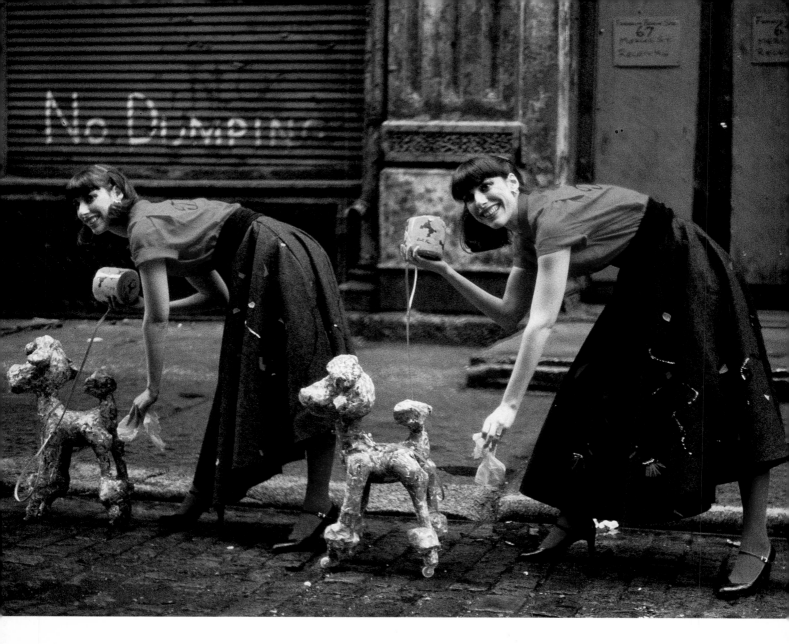

New York, New York 1979
Ellen and Lynda Kahn

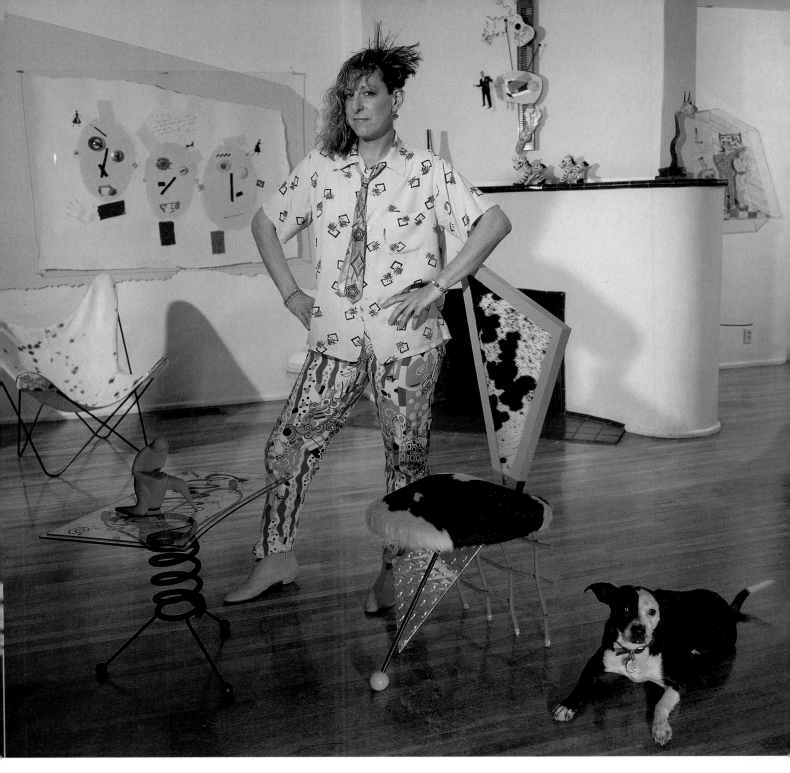

Valley Village, California 1985
Allee Willis

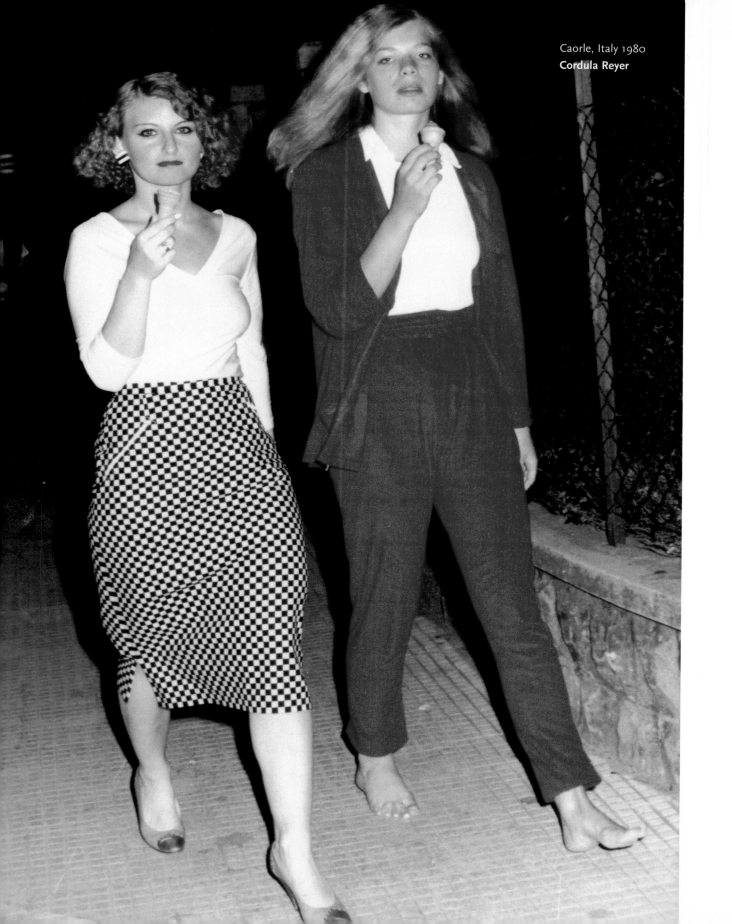

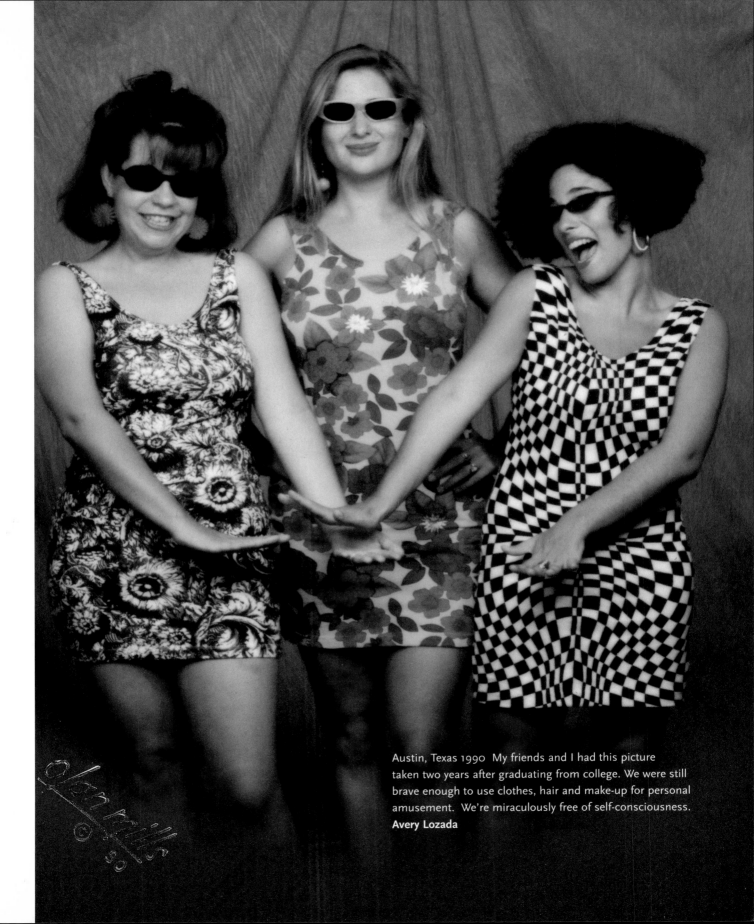

Austin, Texas 1990 My friends and I had this picture taken two years after graduating from college. We were still brave enough to use clothes, hair and make-up for personal amusement. We're miraculously free of self-consciousness.
Avery Lozada

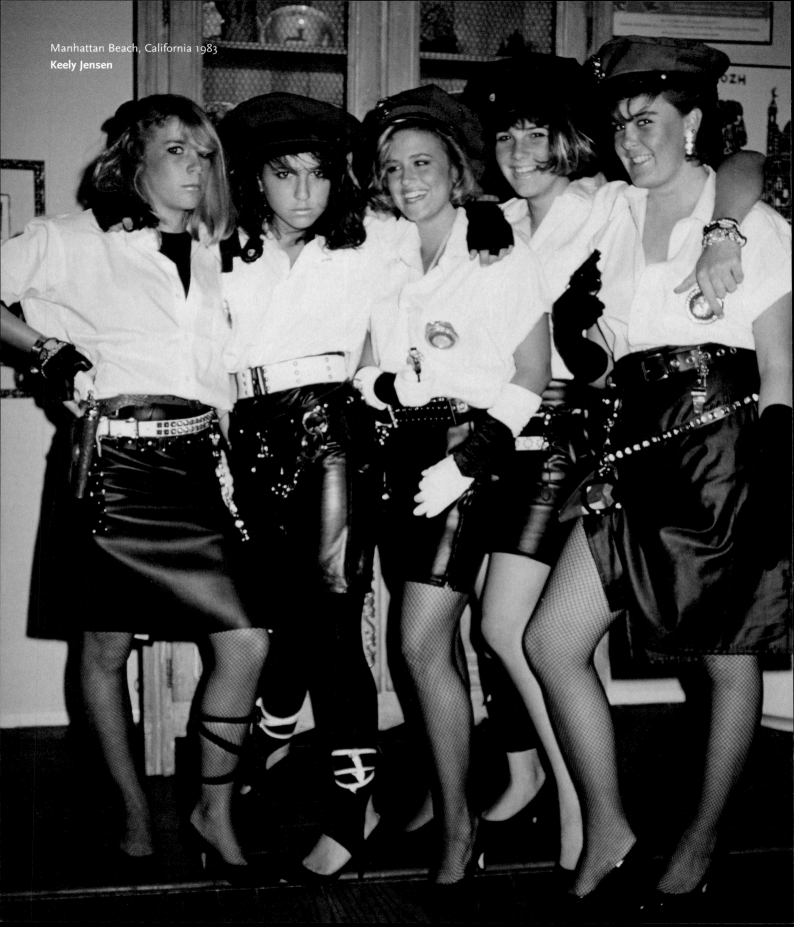

Manhattan Beach, California 1983
Keely Jensen

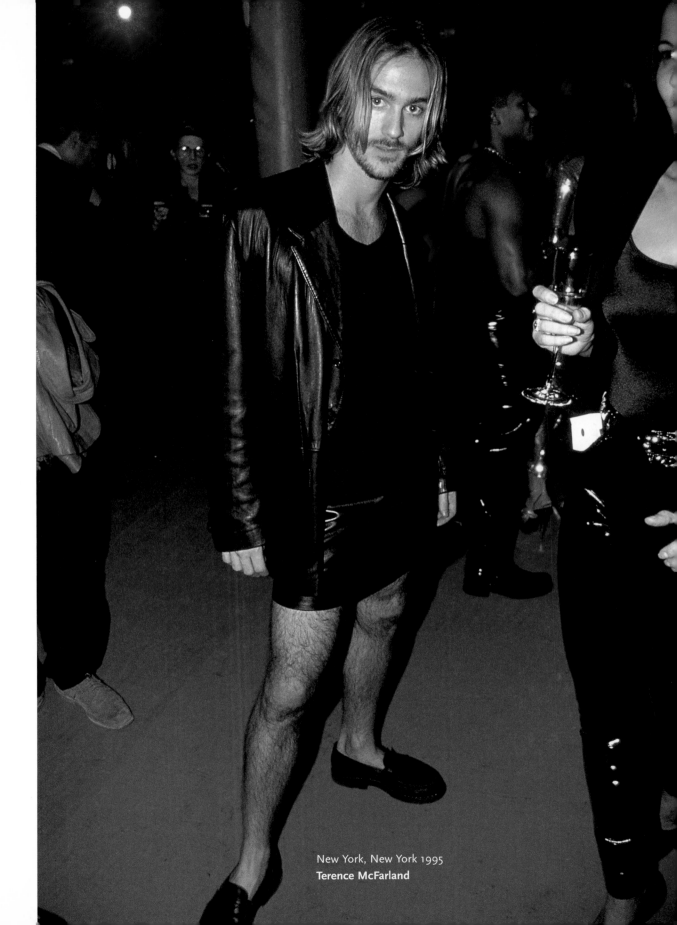

New York, New York 1995
Terence McFarland

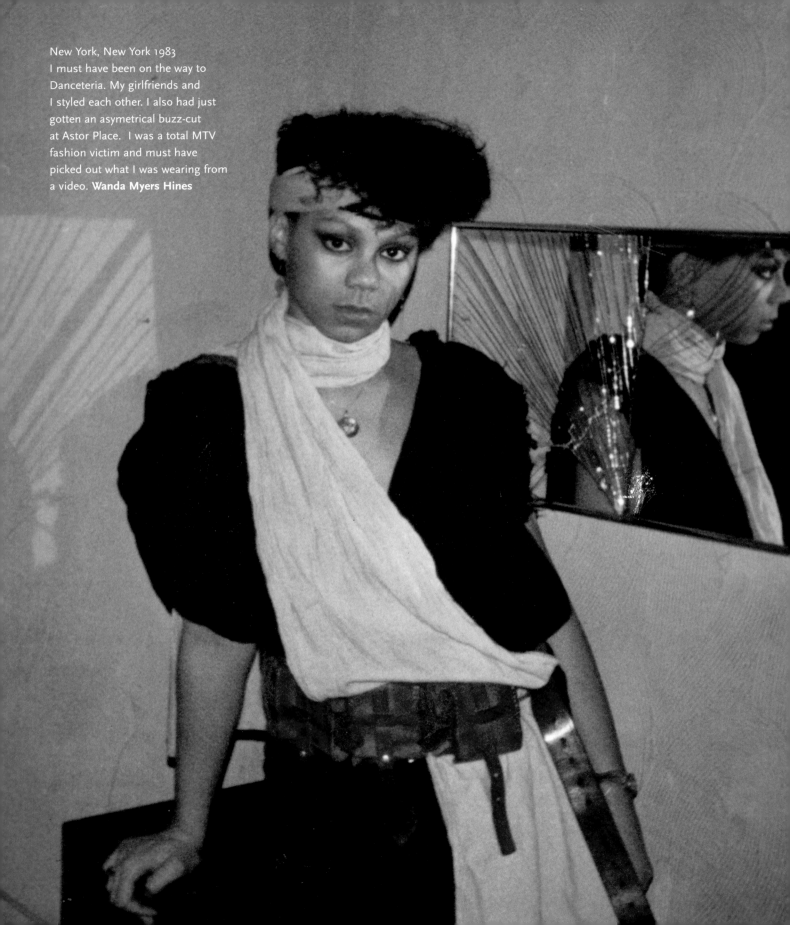

New York, New York 1983
I must have been on the way to
Danceteria. My girlfriends and
I styled each other. I also had just
gotten an asymetrical buzz-cut
at Astor Place. I was a total MTV
fashion victim and must have
picked out what I was wearing from
a video. **Wanda Myers Hines**

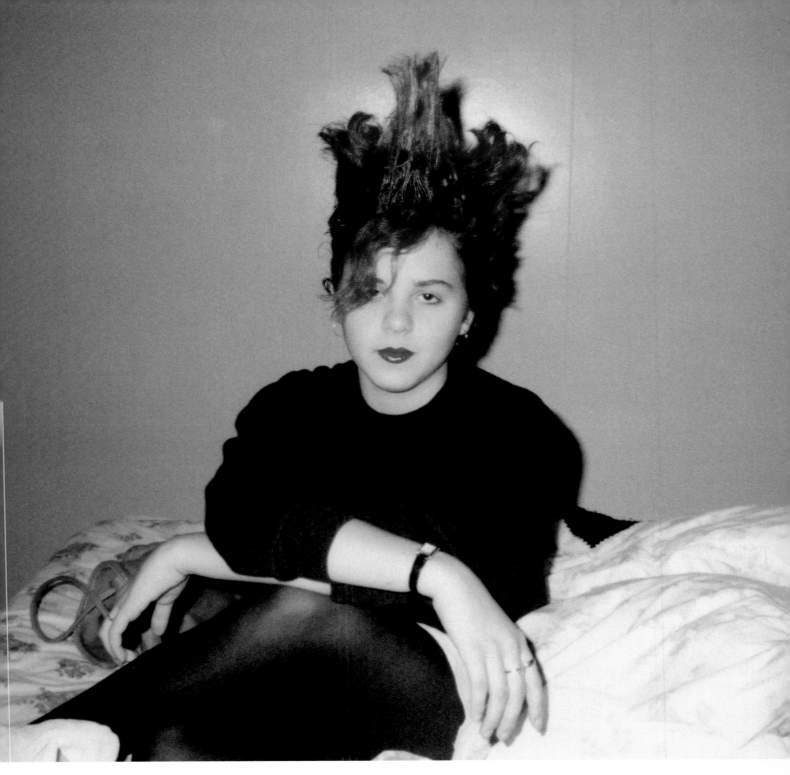

Encino, California 1982 I didn't wash my hair for six weeks
in preparation for Homecoming—I didn't want the Knox gelatin
(the preferred punk rock hair product) to crack or flake.
Sofie Howard

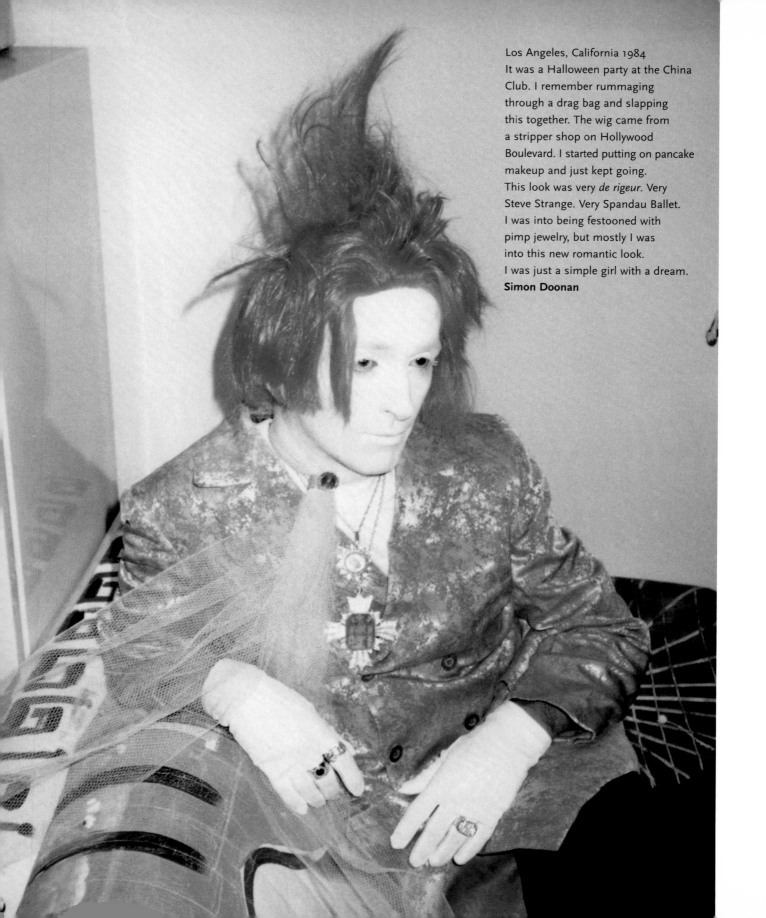

Los Angeles, California 1984
It was a Halloween party at the China Club. I remember rummaging through a drag bag and slapping this together. The wig came from a stripper shop on Hollywood Boulevard. I started putting on pancake makeup and just kept going. This look was very *de rigeur*. Very Steve Strange. Very Spandau Ballet. I was into being festooned with pimp jewelry, but mostly I was into this new romantic look. I was just a simple girl with a dream.
Simon Doonan

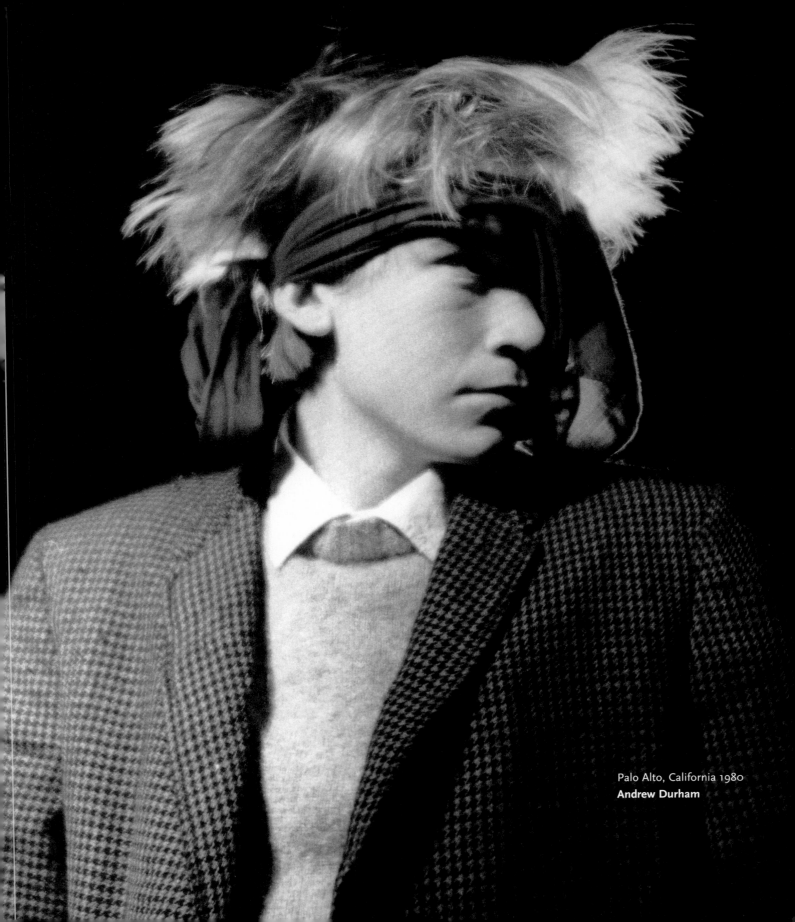

Palo Alto, California 1980
Andrew Durham

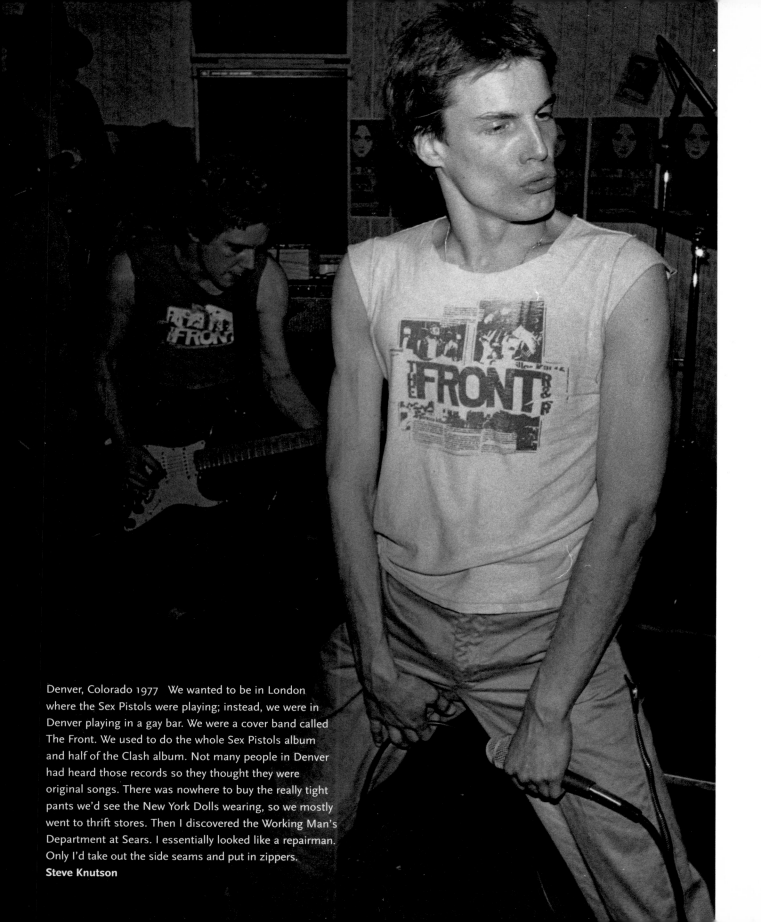

Denver, Colorado 1977 We wanted to be in London where the Sex Pistols were playing; instead, we were in Denver playing in a gay bar. We were a cover band called The Front. We used to do the whole Sex Pistols album and half of the Clash album. Not many people in Denver had heard those records so they thought they were original songs. There was nowhere to buy the really tight pants we'd see the New York Dolls wearing, so we mostly went to thrift stores. Then I discovered the Working Man's Department at Sears. I essentially looked like a repairman. Only I'd take out the side seams and put in zippers.
Steve Knutson

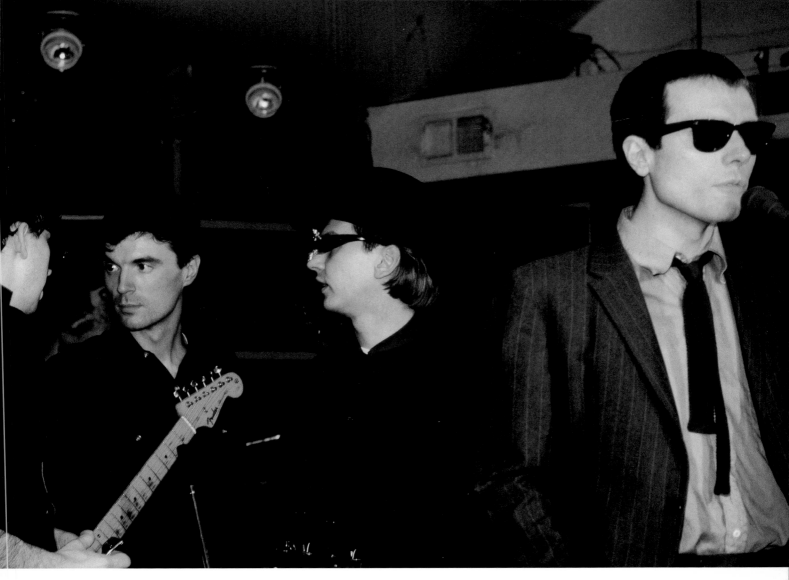

New York, New York 1979 This is from a live broadcast of *Glenn O'Brien's T.V. Party*.
David Byrne was playing along with Chris Stein, Walter Steding and the T.V. Party Orchestra.
I think the gray chalk-stripe suit is Yves Saint Laurent about 1970. It's a blue oxford button-
down shirt from Brooks Brothers. The casual flying-collar style may be the influence of Ezra Pound.
The purple knit tie is vintage. The sunglasses are the original Ray Ban Wayfarers which hadn't
yet been popularized by the *Blues Brothers*. I have the same haircut now, except gray. I think
I would wear all of these items today, which is, I believe, the way men's style should be: permanent.
Glenn O'Brien

Los Angeles, California 1975 I'm on the right, holding the camera with my left hand. I had stopped by to visit my best friend, Phil Hartman. At that time, he was working at the Crossroads of the World on Sunset Boulevard, doing album covers. The cashmere jacket was custom-made and I'm still wearing it today. **Steve Small**

London, England 1973
Peter Morton

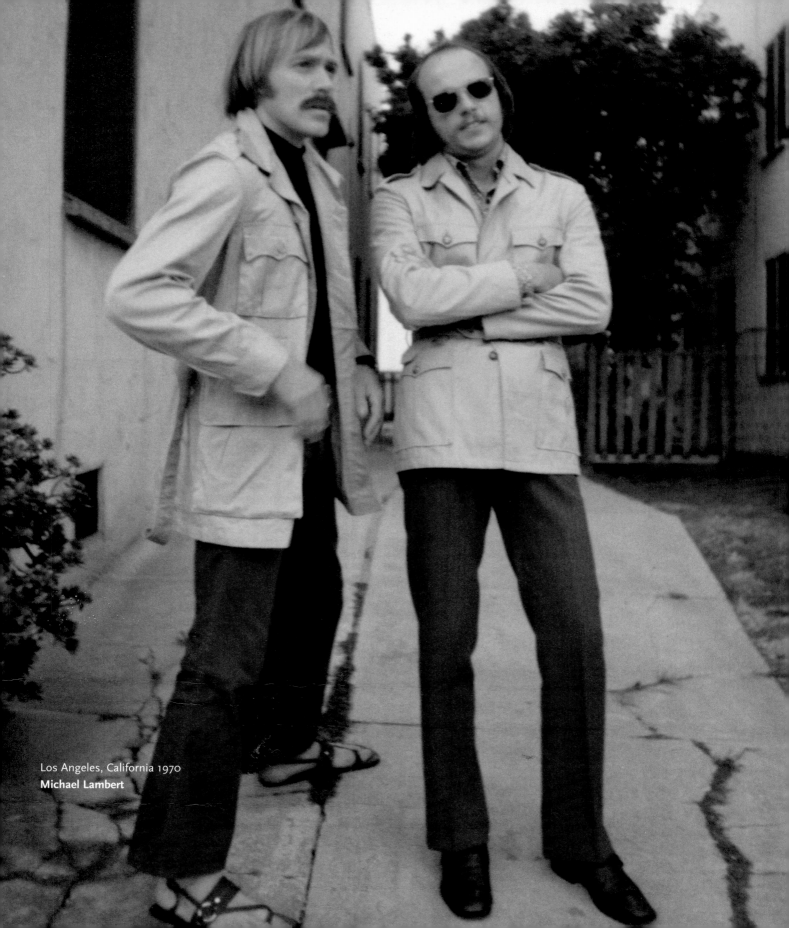

Los Angeles, California 1970
Michael Lambert

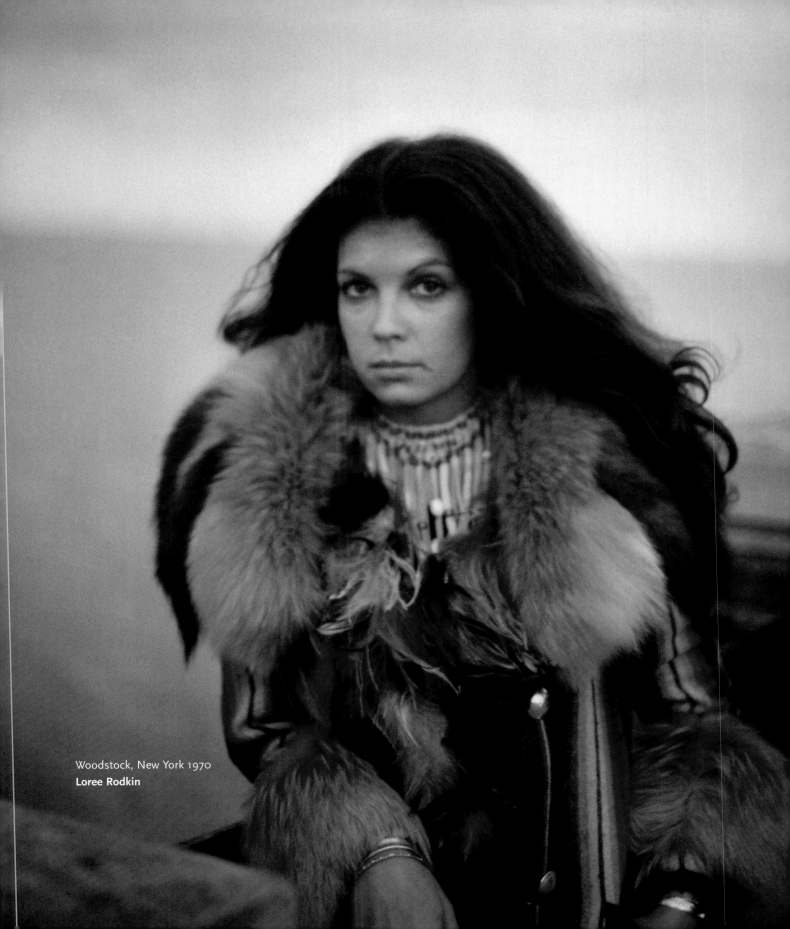

Woodstock, New York 1970
Loree Rodkin

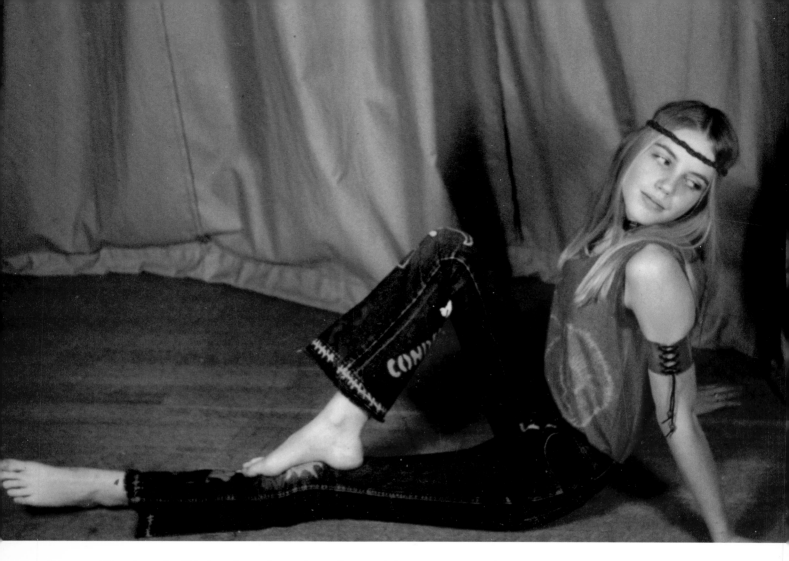

Cheyenne, Wyoming 1969 This is a picture from a dance routine I did at Carey Junior High.
I'm very hippie chic. It was very loving hippie hands at home—everyone pitched in. My brother
painted my jeans with blacklight poster paint, my friend did the tie-dye, I made the armbands.
We all slept with our hair in tiny braids the night before to crimp it. The song we
were dancing to was In-A-Gadda-Da-Vida. **Trish Grady**

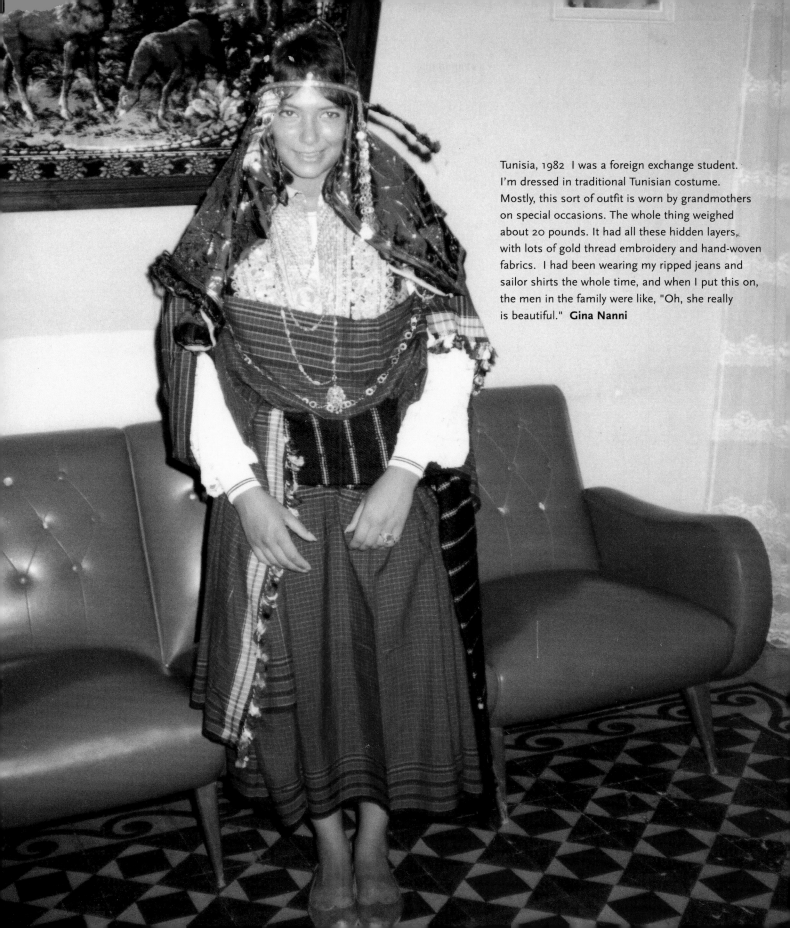

Tunisia, 1982 I was a foreign exchange student. I'm dressed in traditional Tunisian costume. Mostly, this sort of outfit is worn by grandmothers on special occasions. The whole thing weighed about 20 pounds. It had all these hidden layers, with lots of gold thread embroidery and hand-woven fabrics. I had been wearing my ripped jeans and sailor shirts the whole time, and when I put this on, the men in the family were like, "Oh, she really is beautiful." **Gina Nanni**

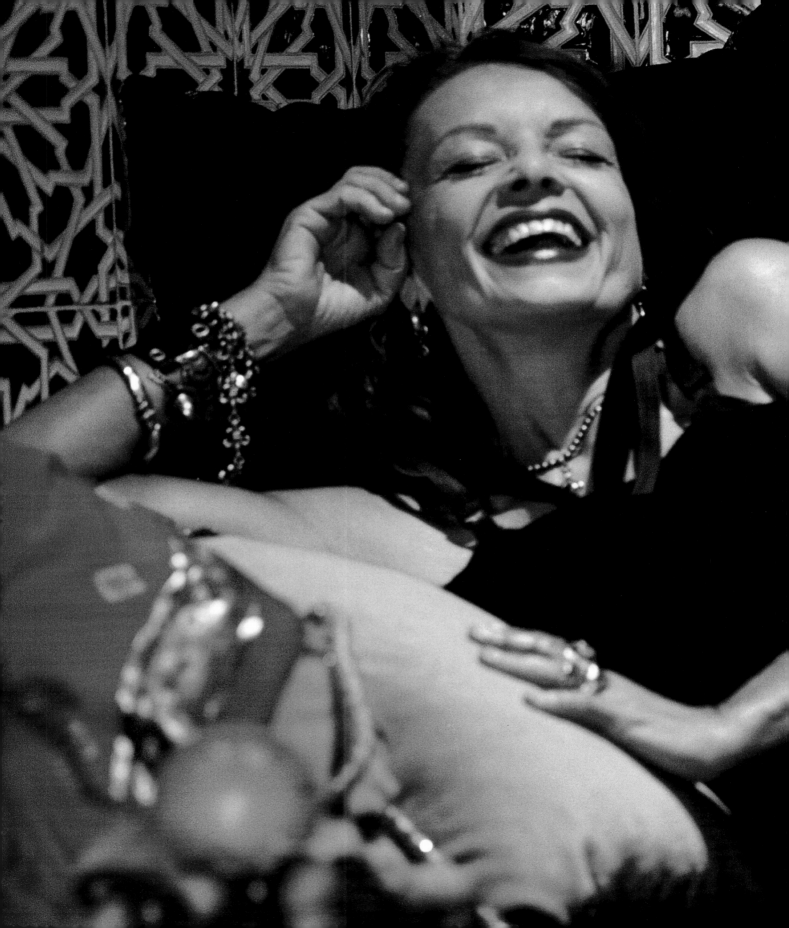

Hollywood, California 1998
Michele Lamy

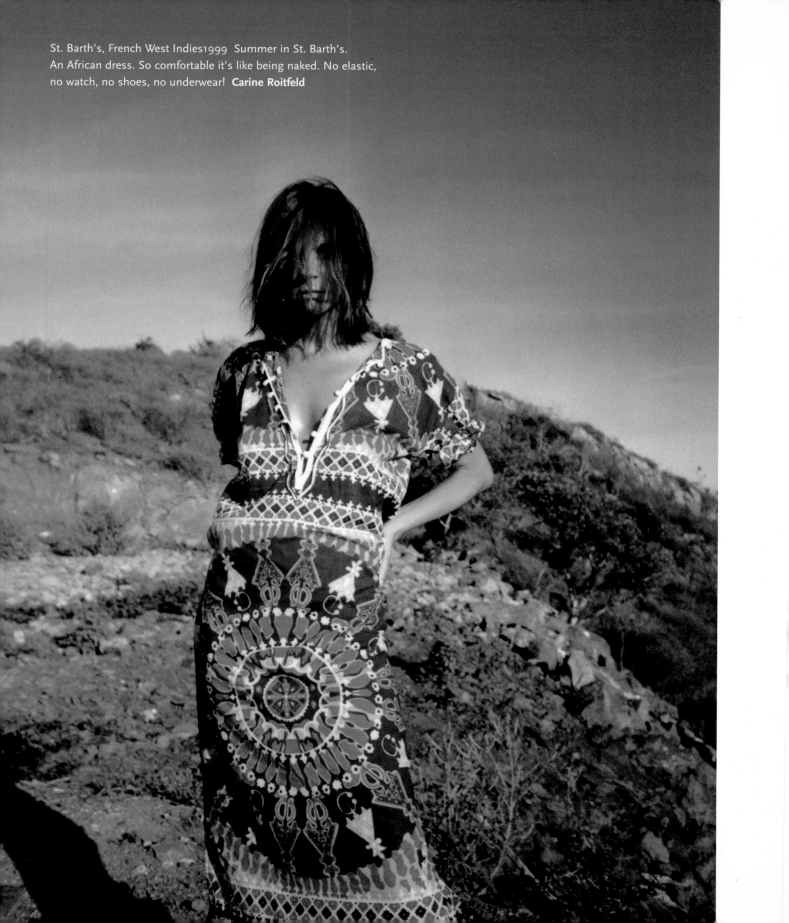

St. Barth's, French West Indies 1999 Summer in St. Barth's.
An African dress. So comfortable it's like being naked. No elastic,
no watch, no shoes, no underwear! **Carine Roitfeld**

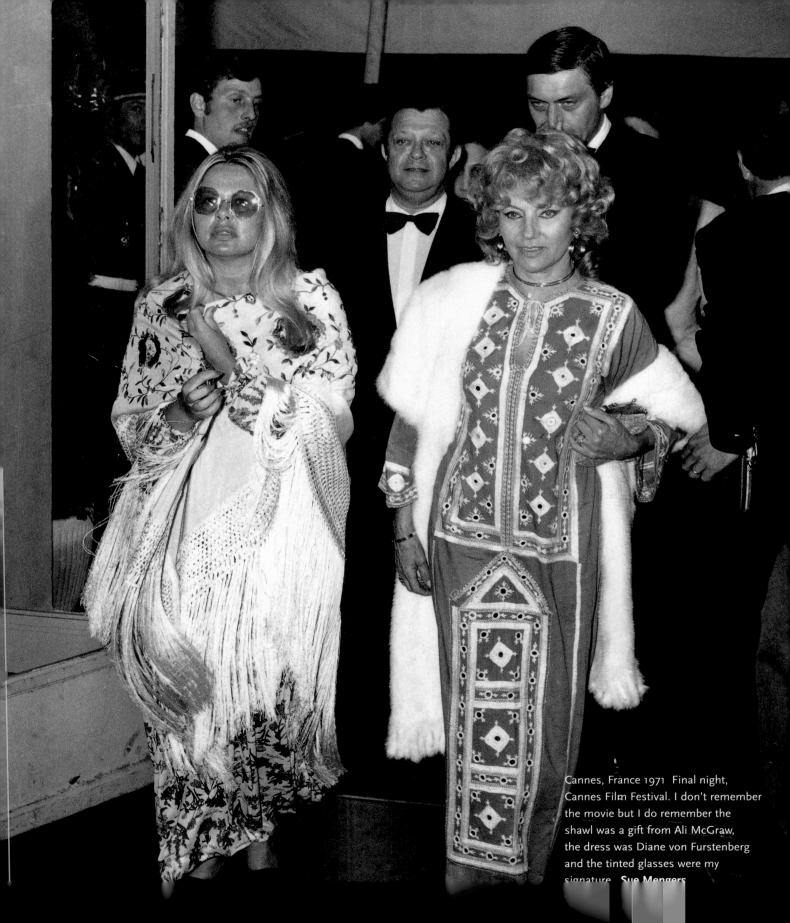

Cannes, France 1971 Final night,
Cannes Film Festival. I don't remember
the movie but I do remember the
shawl was a gift from Ali McGraw,
the dress was Diane von Furstenberg
and the tinted glasses were my
signature. Sue Mengers

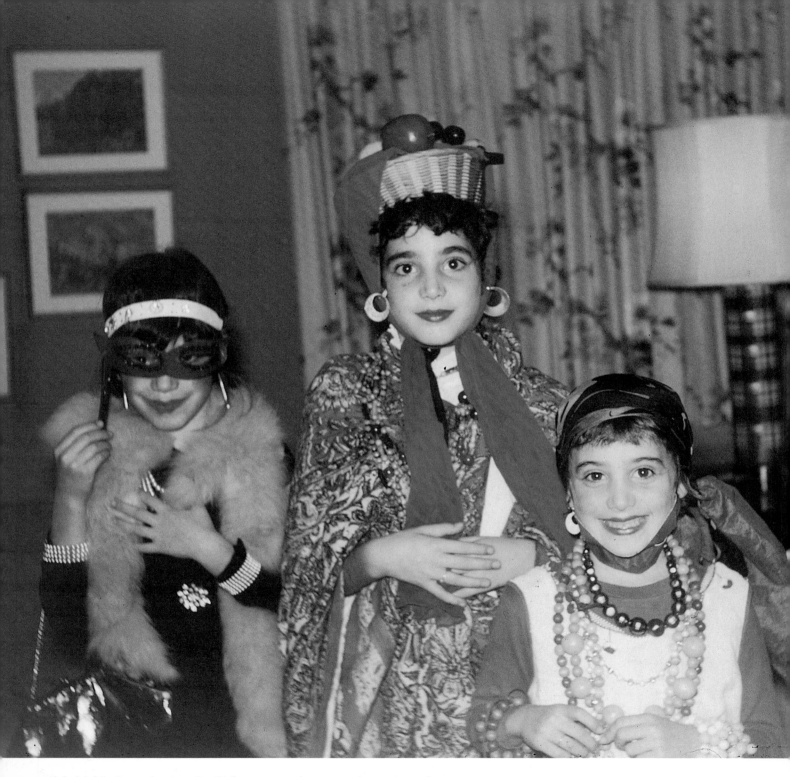

Philadelphia, Pennsylvania 1965 Halloween was always over the top in our house.
We loved all the attention as we went trick-or-treating, but we longed for store-bought costumes like
the other kids in the neighborhood. Little did we know that our mother, Madeline, was actually
priming us for the world of fashion where we all ended up. **Nina Santisi**

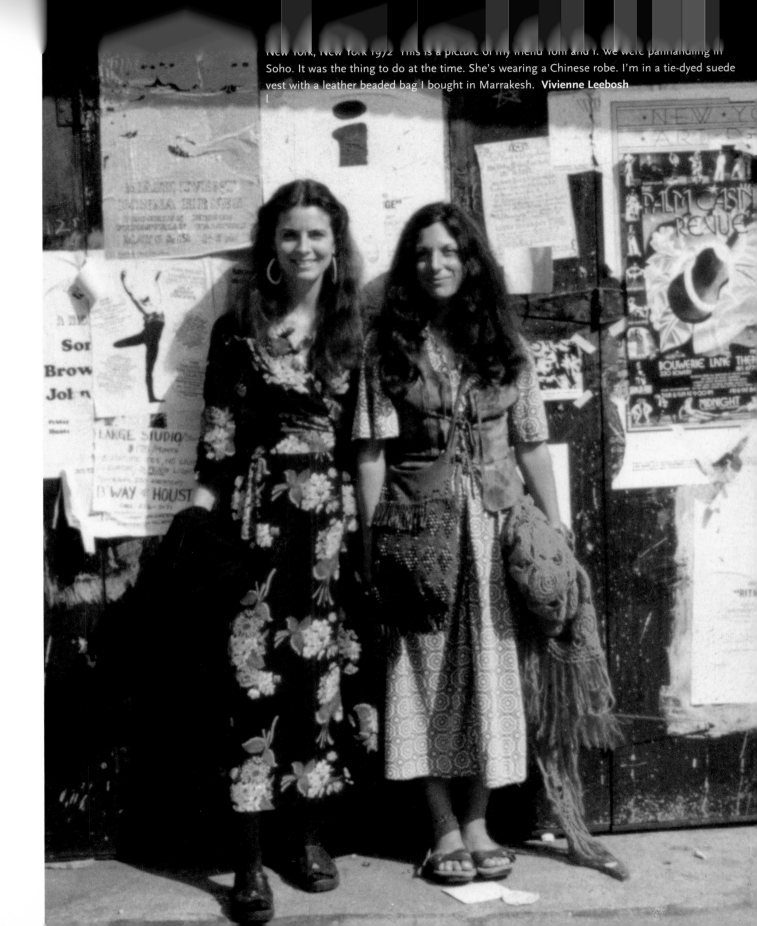

New York, New York 1972 This is a picture of my friend Toni and I. We were panhandling in Soho. It was the thing to do at the time. She's wearing a Chinese robe. I'm in a tie-dyed suede vest with a leather beaded bag I bought in Marrakesh. **Vivienne Leebosh**

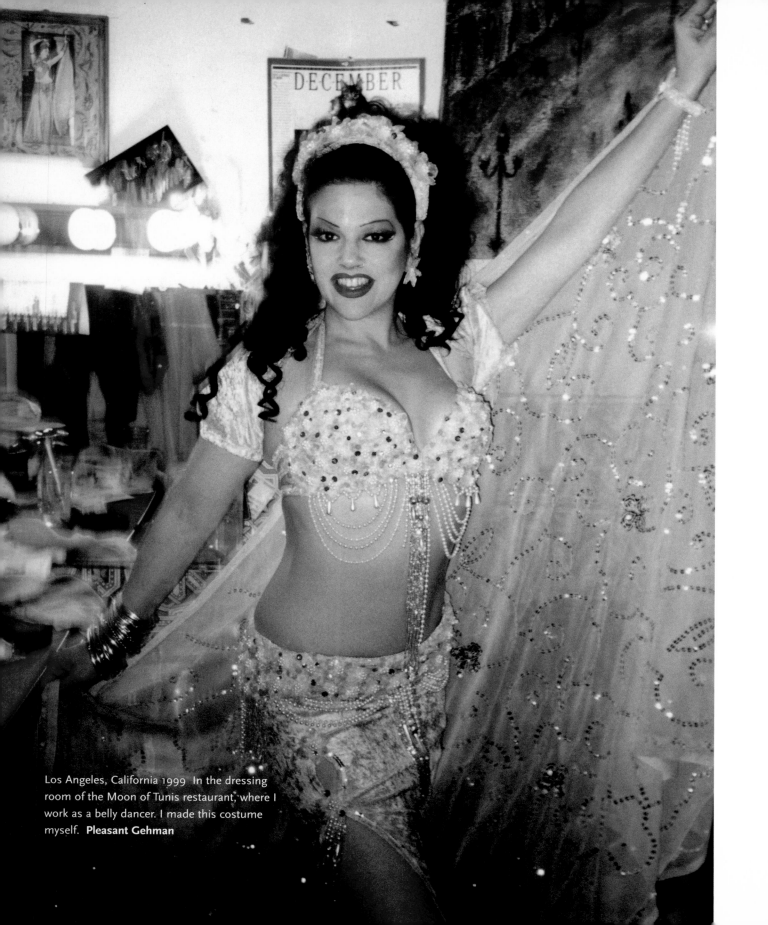

Los Angeles, California 1999 In the dressing room of the Moon of Tunis restaurant, where I work as a belly dancer. I made this costume myself. **Pleasant Gehman**

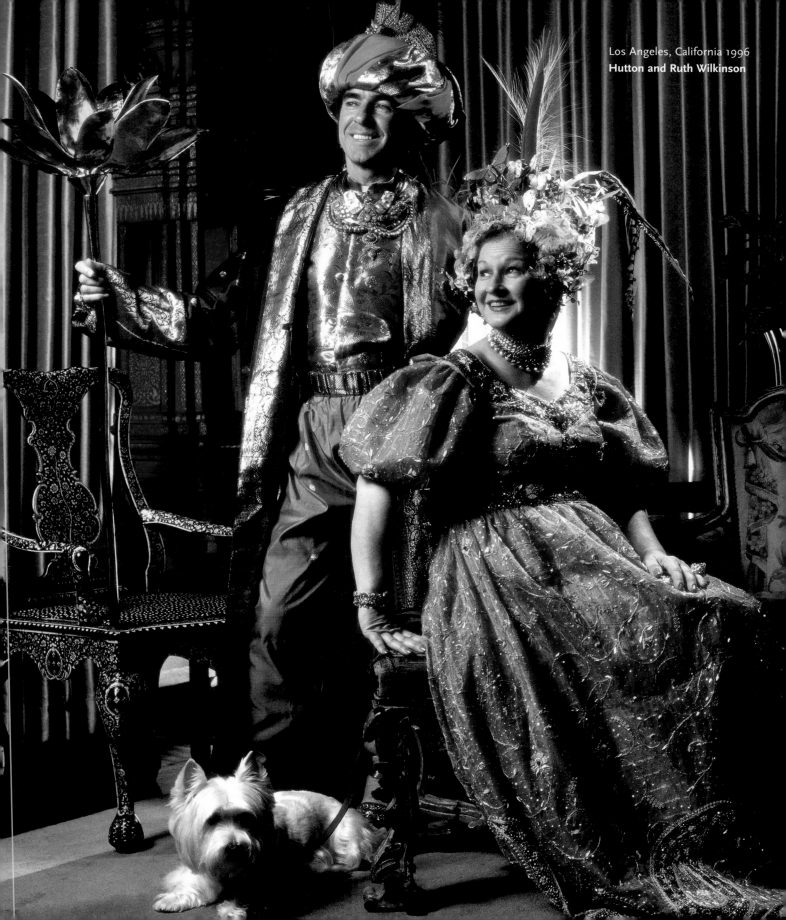

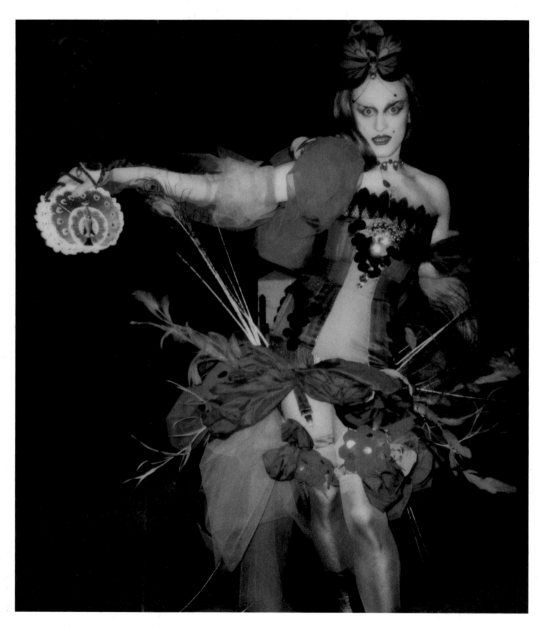

London, England 1986 Mr. Pearl designed this costume for the Pre-Raphaelite Ball
at Leighton House. I was a peacock. **Hamish Bowles**

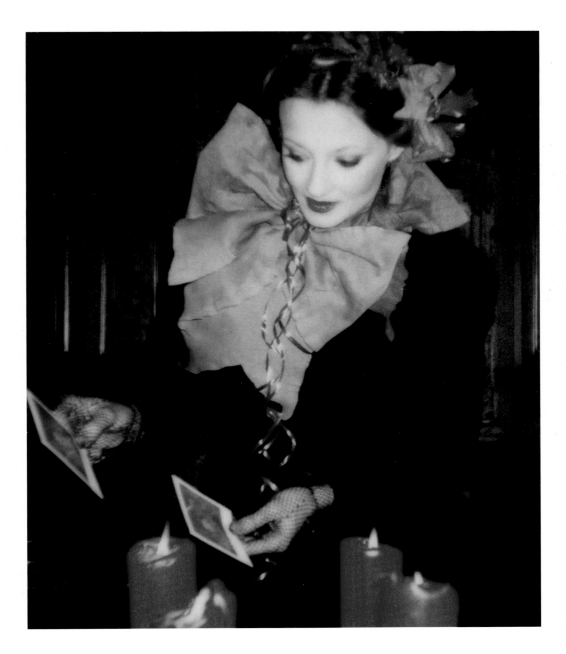

Paris, France 1979 Christmas at Karl Lagerfeld's
Marian McEvoy

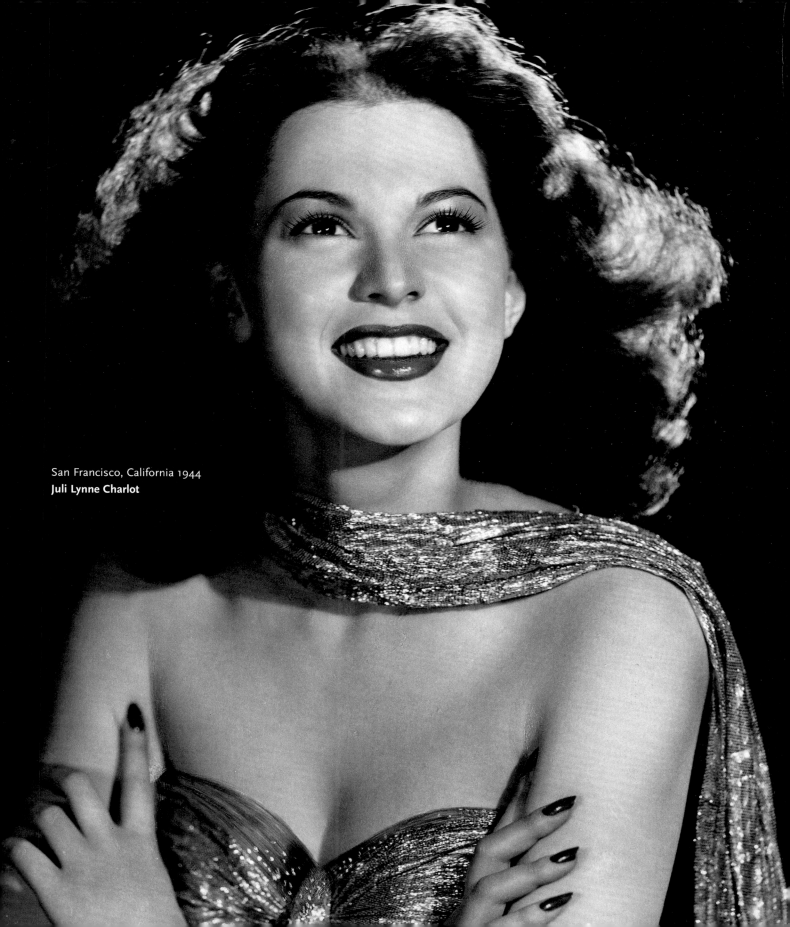

San Francisco, California 1944
Juli Lynne Charlot

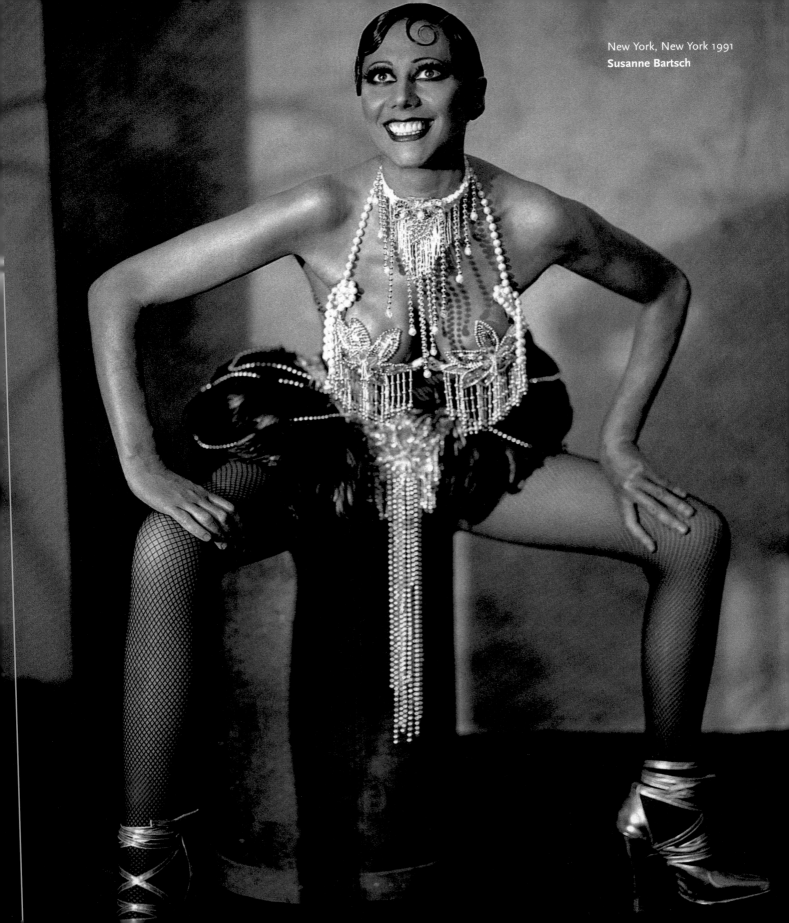

New York, New York 1991
Susanne Bartsch

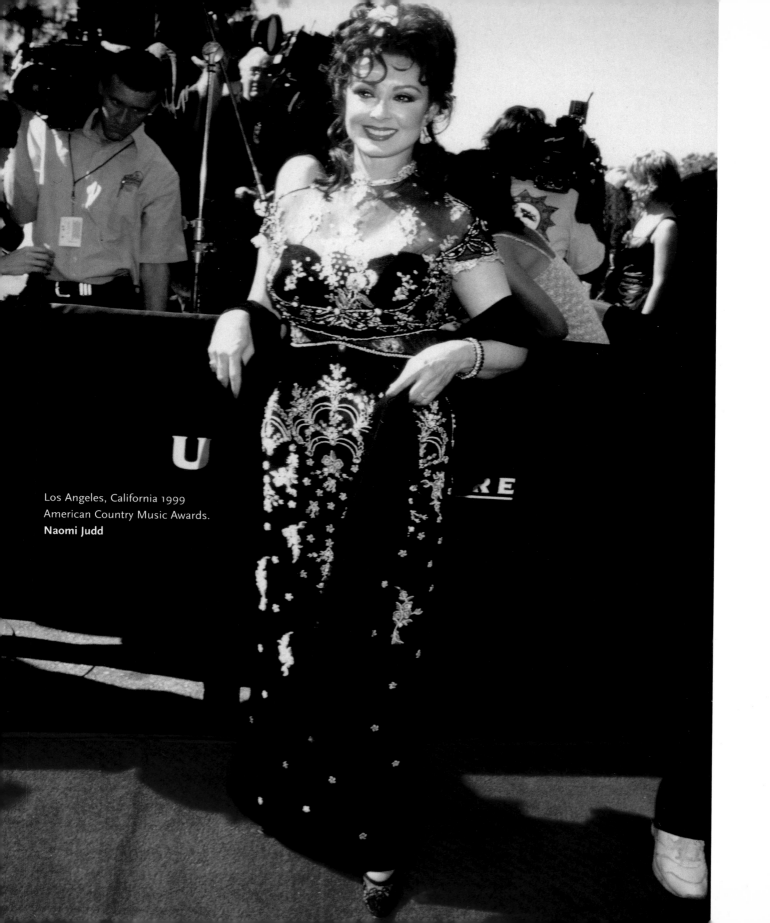

Los Angeles, California 1999
American Country Music Awards.
Naomi Judd

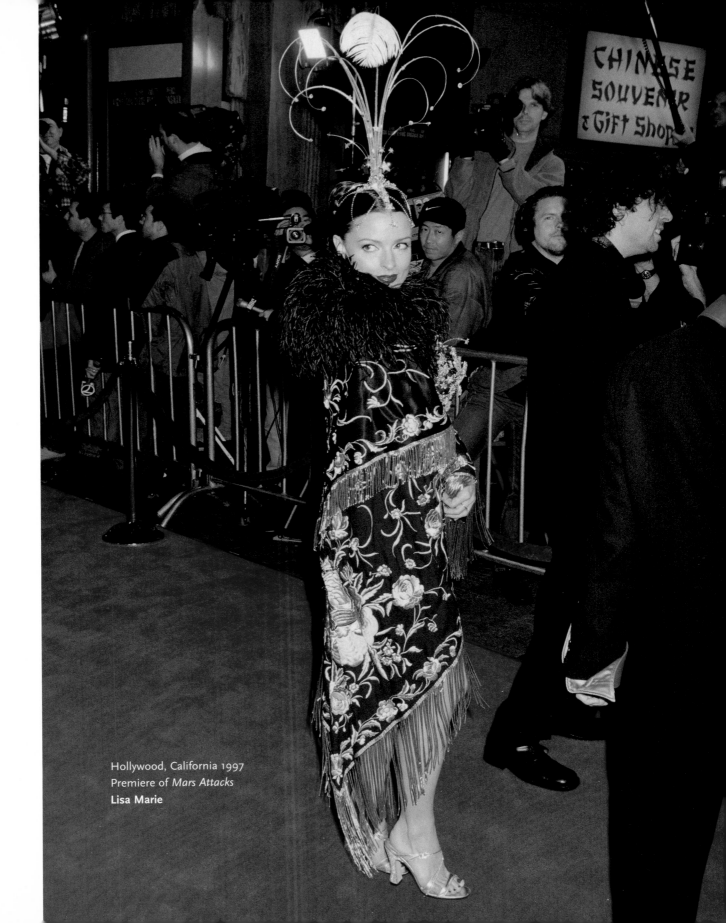

Hollywood, California 1997
Premiere of *Mars Attacks*
Lisa Marie

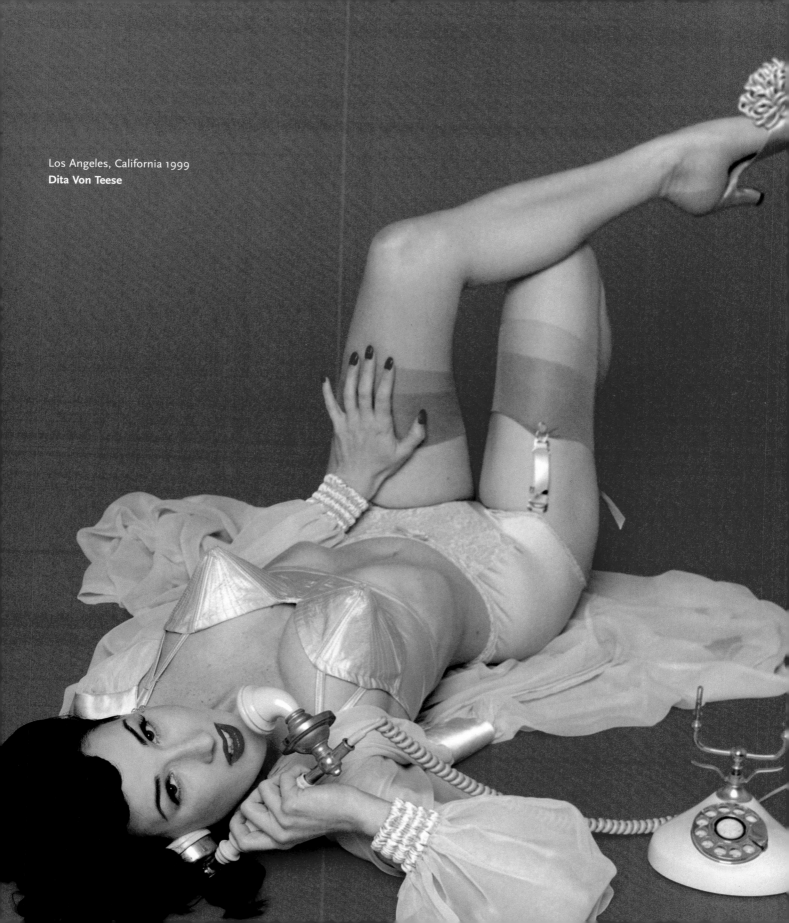

Los Angeles, California 1999
Dita Von Teese

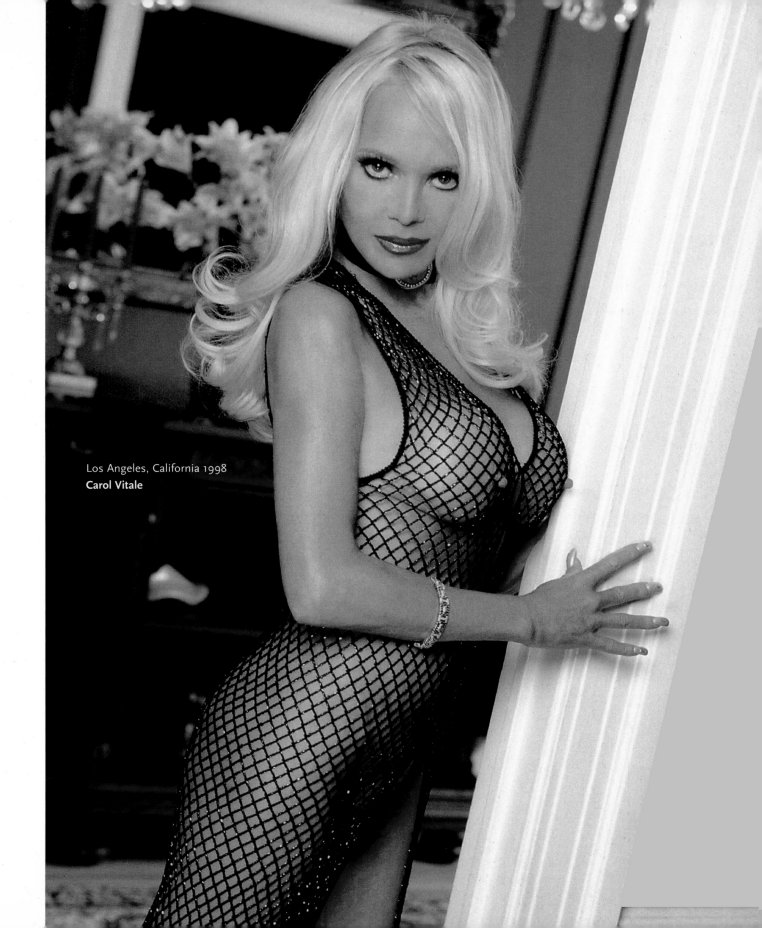

Los Angeles, California 1998
Carol Vitale

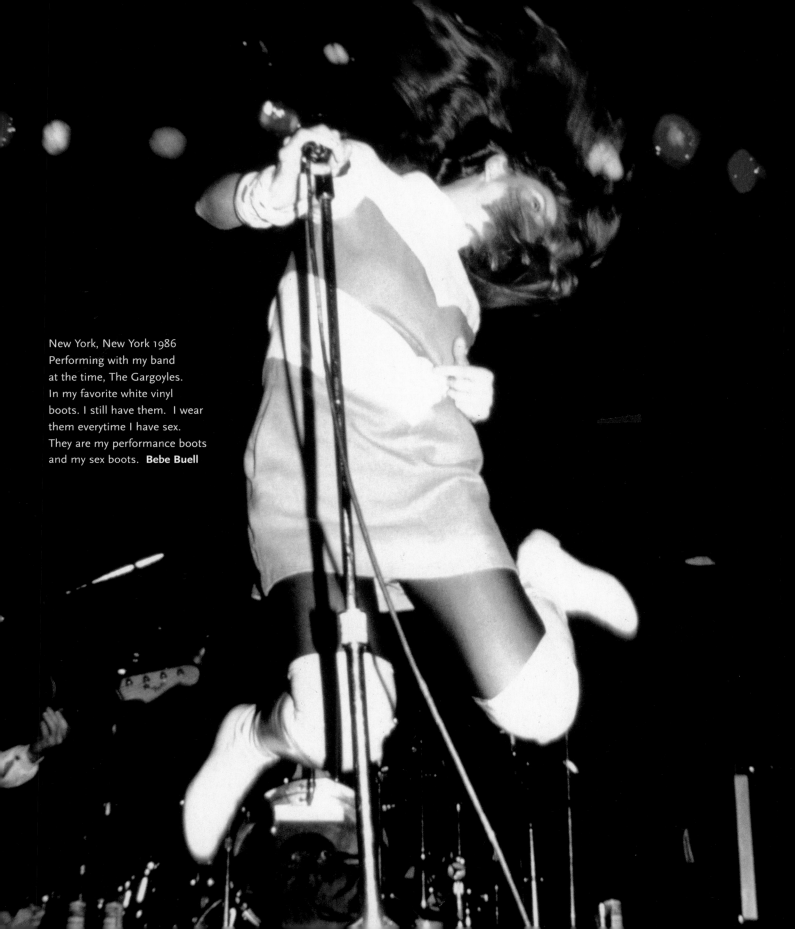

New York, New York 1986
Performing with my band
at the time, The Gargoyles.
In my favorite white vinyl
boots. I still have them. I wear
them everytime I have sex.
They are my performance boots
and my sex boots. **Bebe Buell**

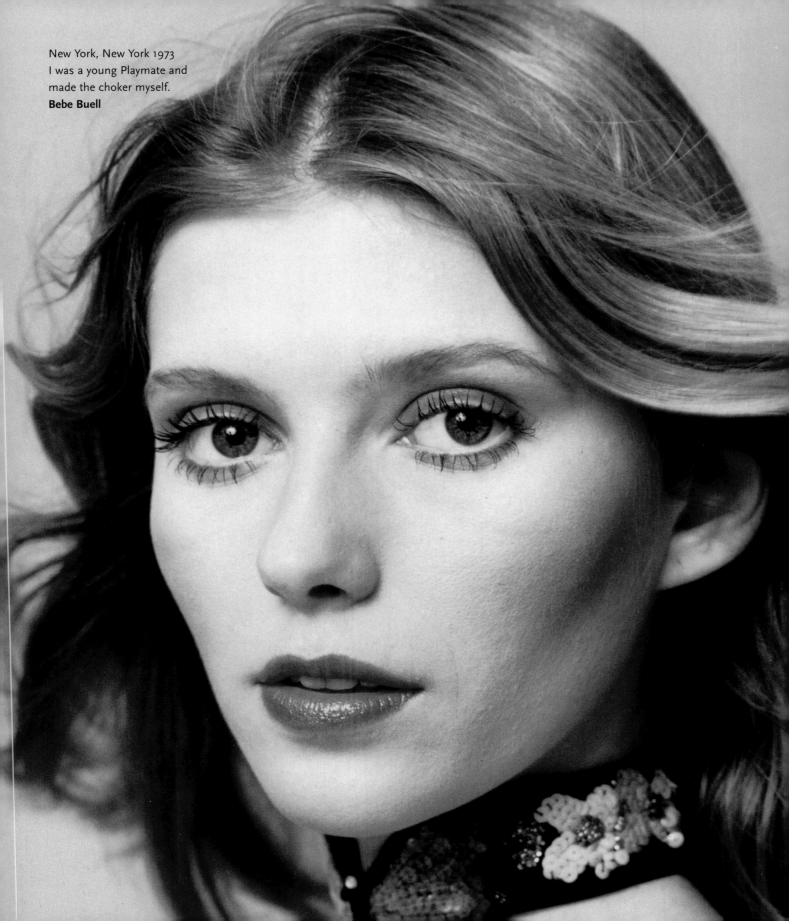

New York, New York 1973
I was a young Playmate and
made the choker myself.
Bebe Buell

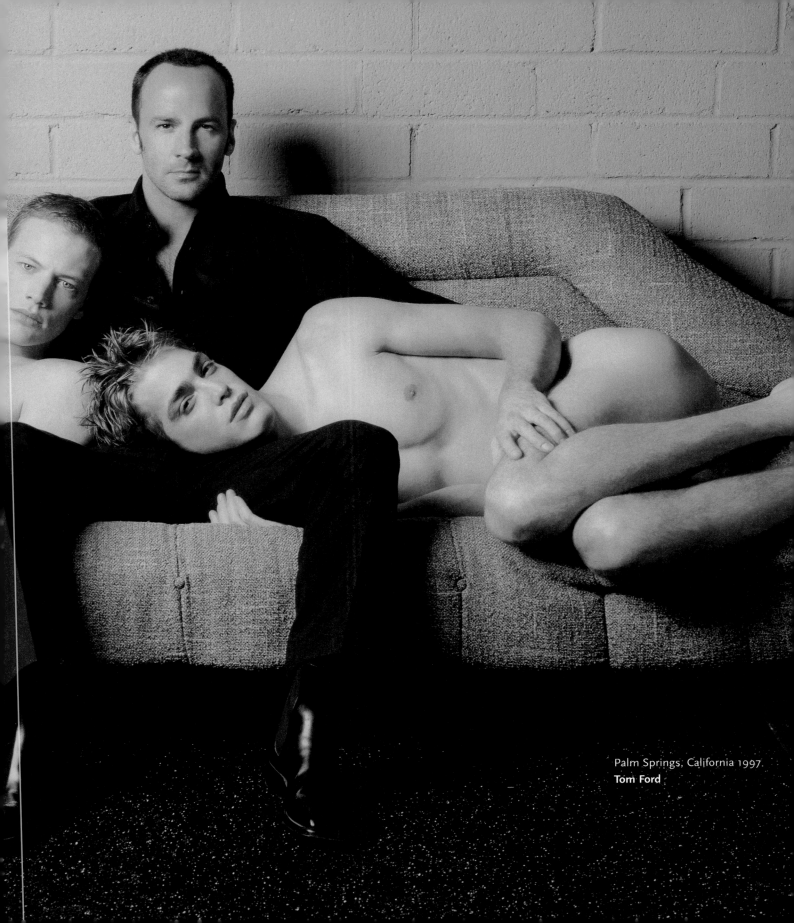

Palm Springs, California 1997.
Tom Ford

Los Angeles, California 1975
James Newton Howard

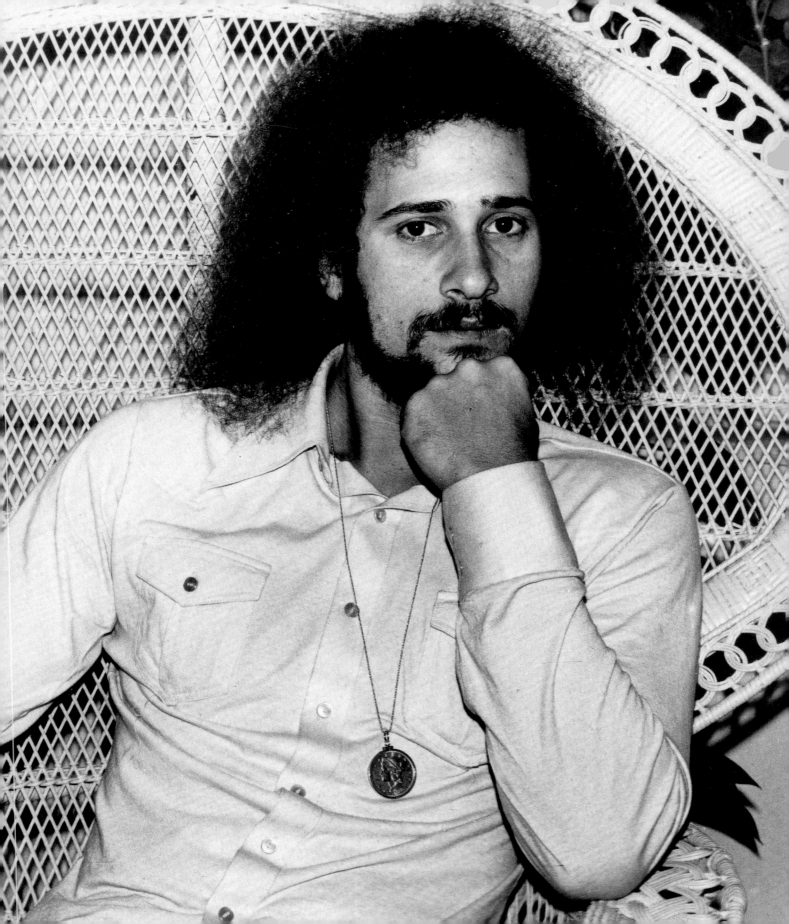

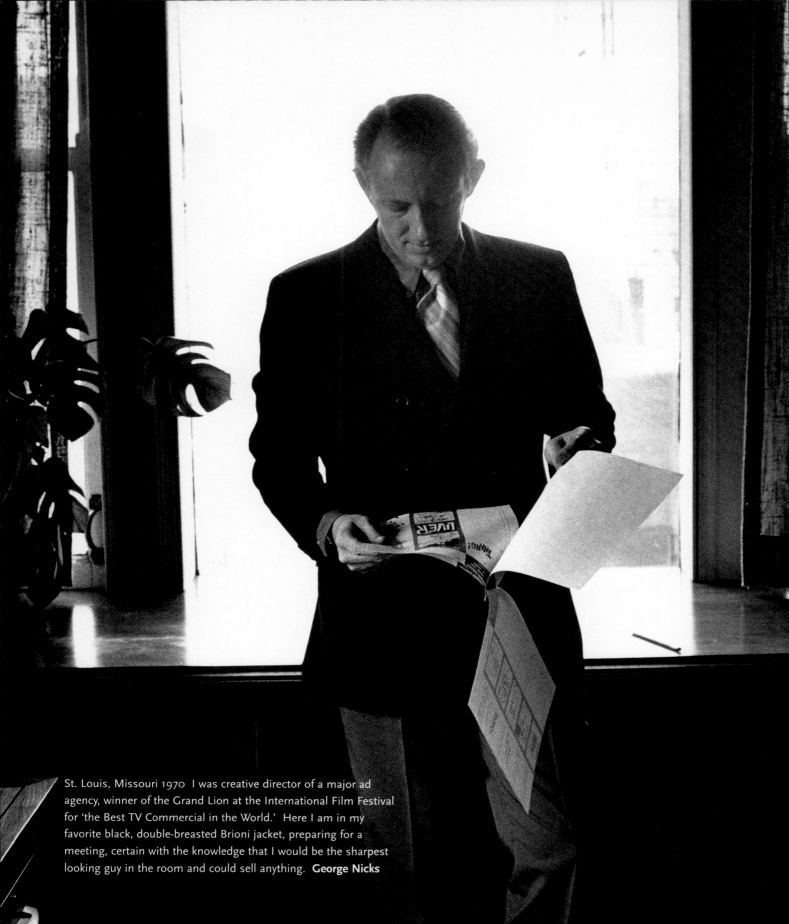

St. Louis, Missouri 1970 I was creative director of a major ad agency, winner of the Grand Lion at the International Film Festival for 'the Best TV Commercial in the World.' Here I am in my favorite black, double-breasted Brioni jacket, preparing for a meeting, certain with the knowledge that I would be the sharpest looking guy in the room and could sell anything. **George Nicks**

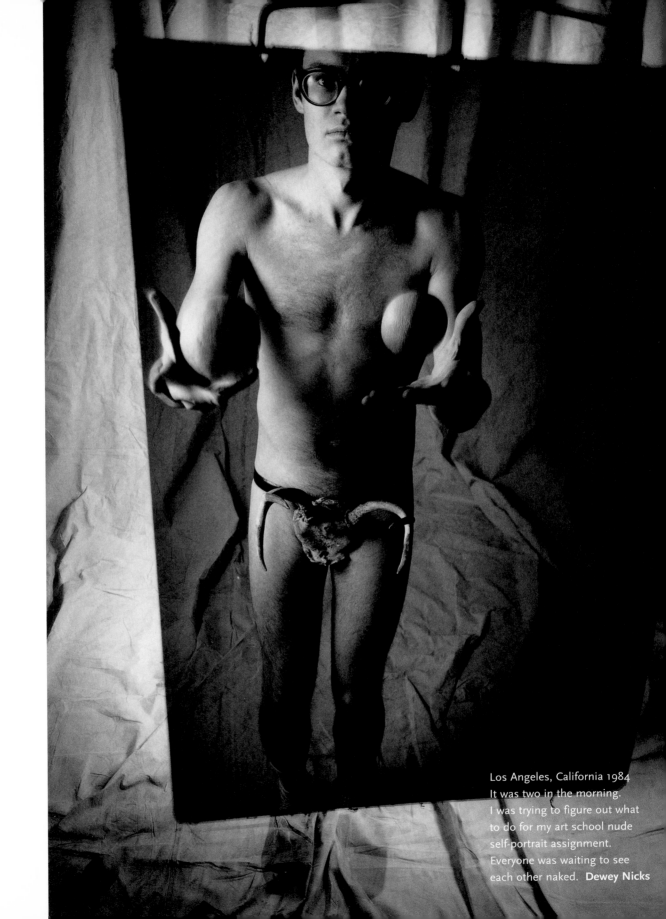

Los Angeles, California 1984
It was two in the morning.
I was trying to figure out what
to do for my art school nude
self-portrait assignment.
Everyone was waiting to see
each other naked. **Dewey Nicks**

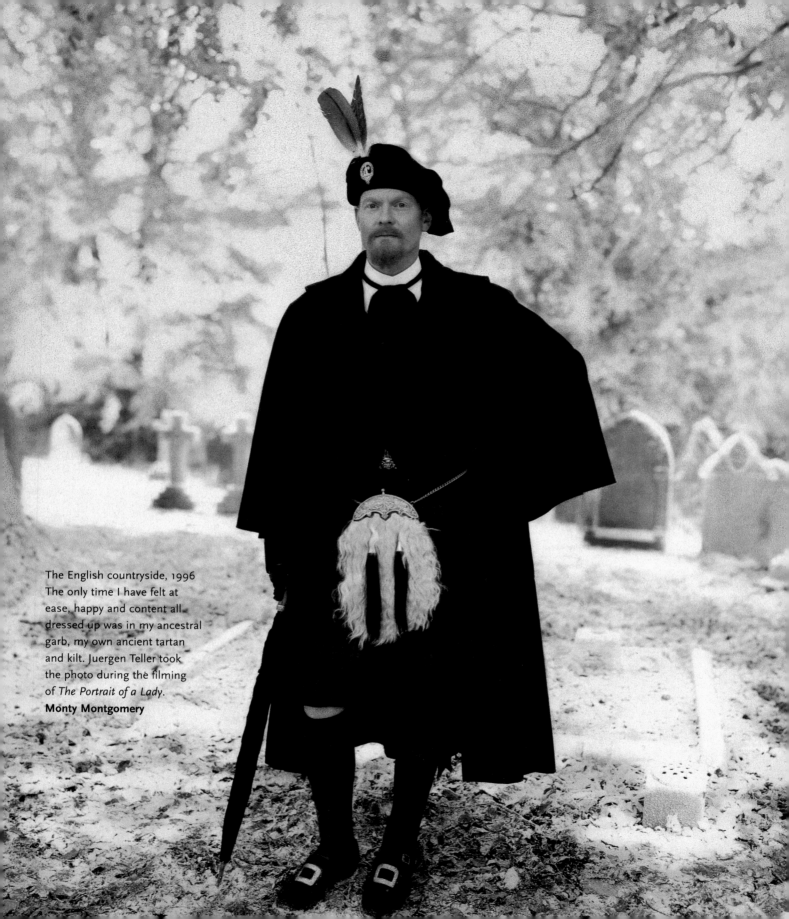

The English countryside, 1996
The only time I have felt at
ease, happy and content all
dressed up was in my ancestral
garb, my own ancient tartan
and kilt. Juergen Teller took
the photo during the filming
of *The Portrait of a Lady*.
Monty Montgomery

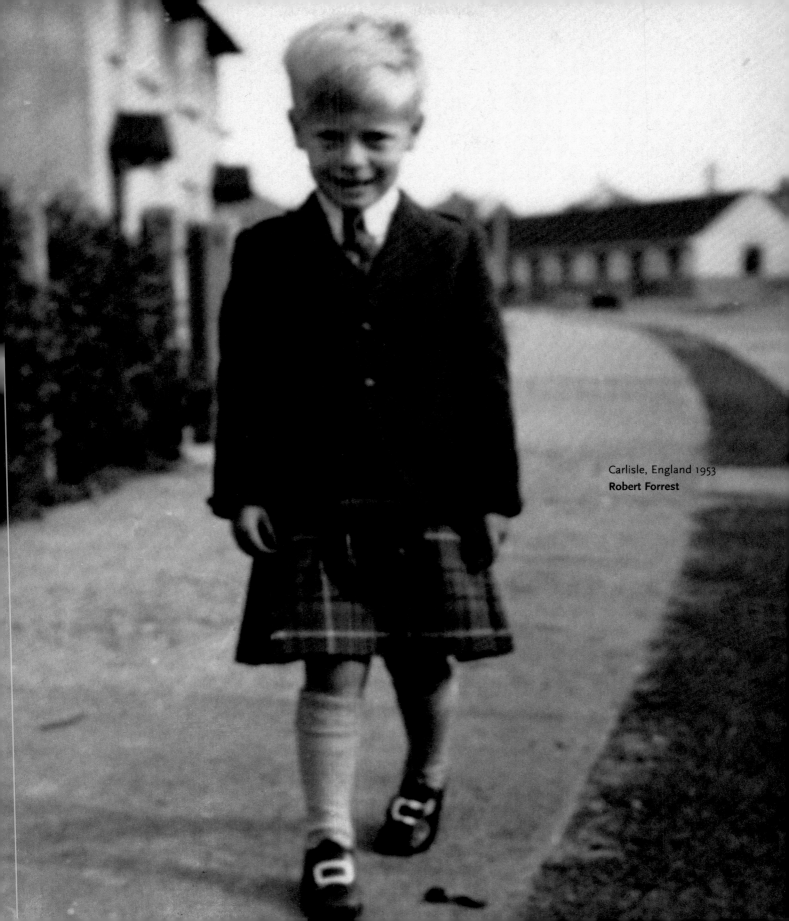

Carlisle, England 1953
Robert Forrest

Marrakesh, Morroco 1989
At the entrance to my villa
with my she-camel, Jamila.
Frederick Vreeland

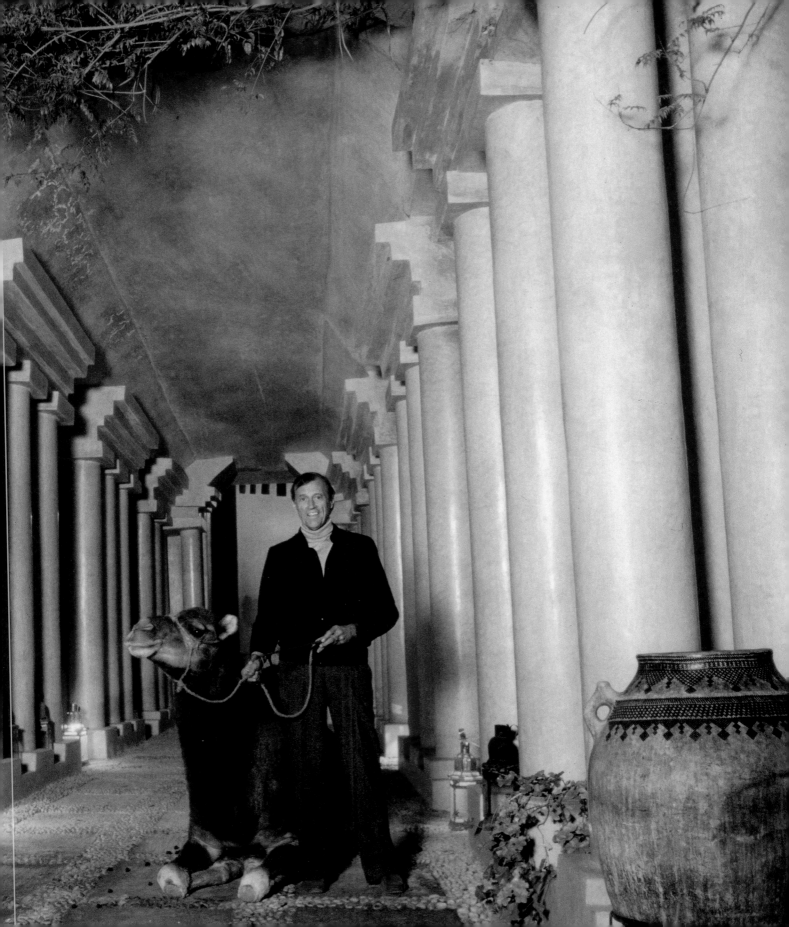

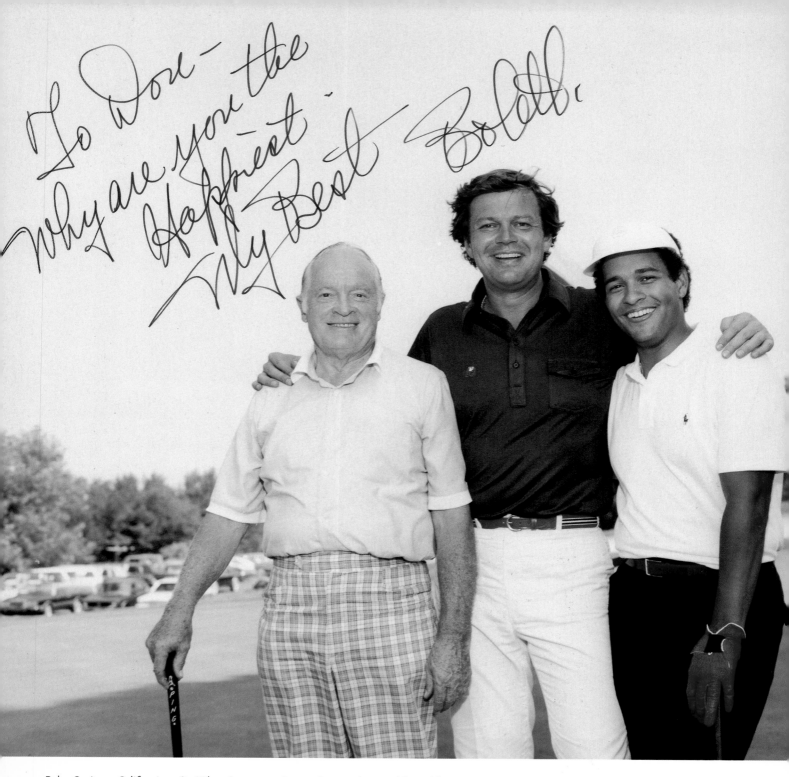

Palm Springs, California 1981 When I was growing up I never dreamed I would ever meet
Bob Hope or a nationally-known TV personality like Bryant Gumbel—let alone play golf with them—
let alone have each of them pay me money to do it! This photo was taken right after I collected
my bets at the Bob Hope Desert Classic. **Don Ohlmeyer**

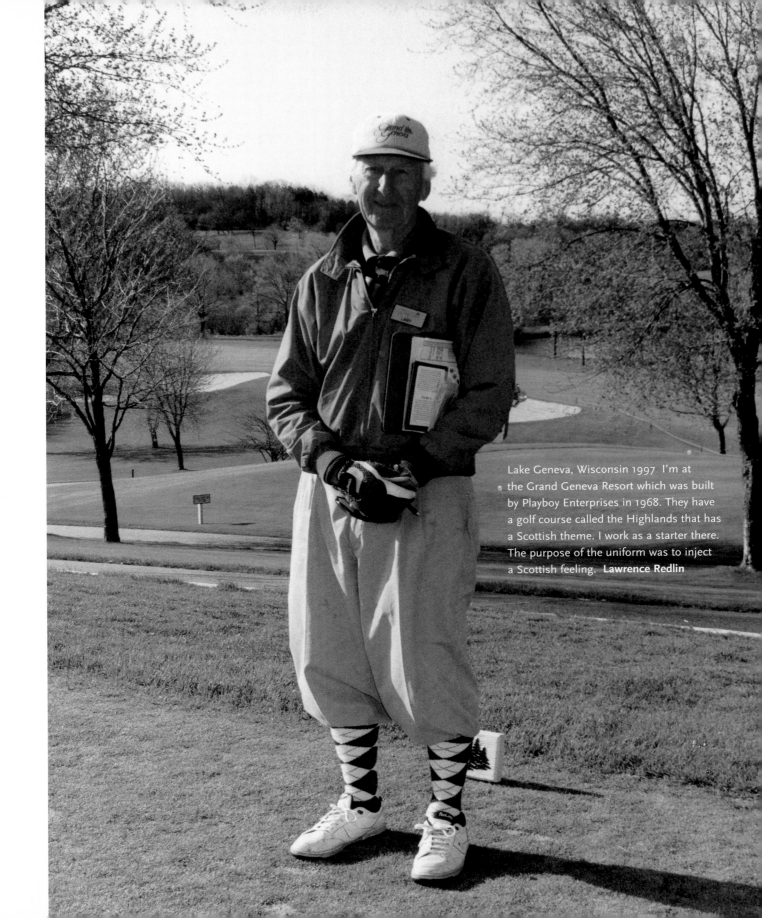

Lake Geneva, Wisconsin 1997 I'm at the Grand Geneva Resort which was built by Playboy Enterprises in 1968. They have a golf course called the Highlands that has a Scottish theme. I work as a starter there. The purpose of the uniform was to inject a Scottish feeling. **Lawrence Redlin**

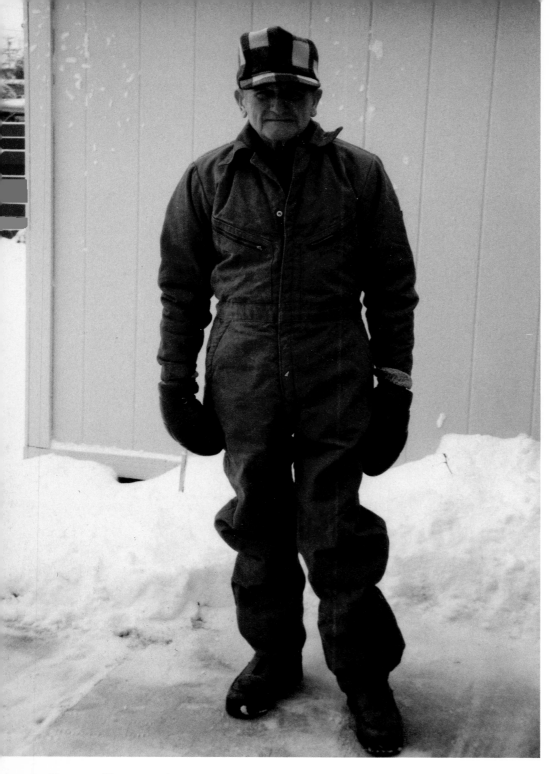

Cheyenne, Wyoming 1983
Mike Finley

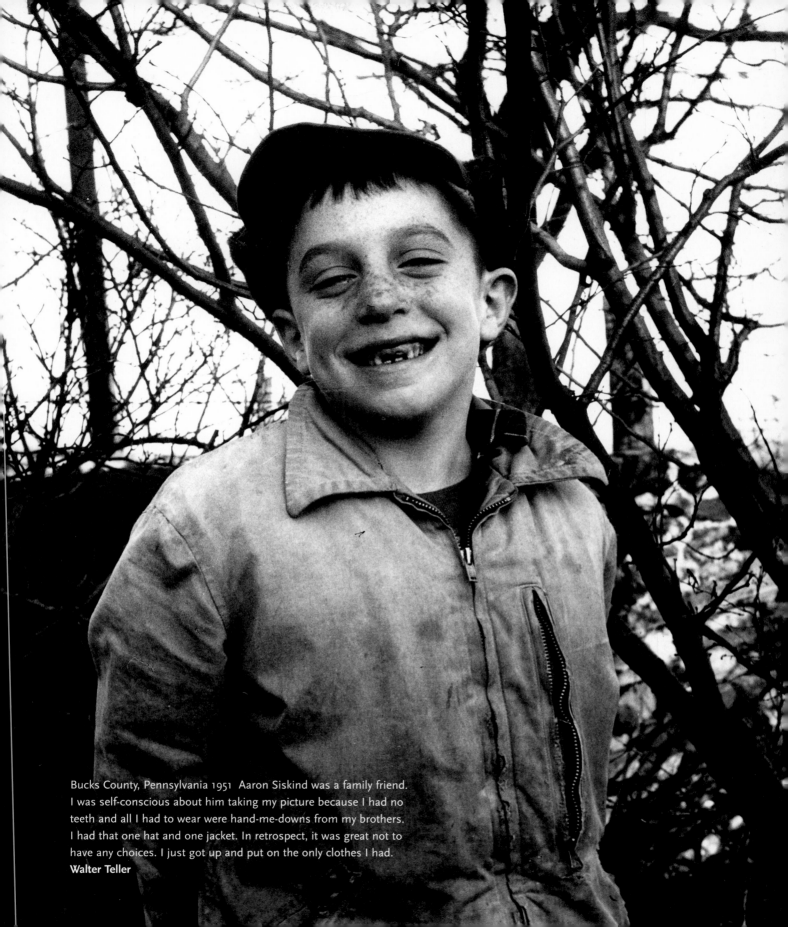

Bucks County, Pennsylvania 1951 Aaron Siskind was a family friend.
I was self-conscious about him taking my picture because I had no
teeth and all I had to wear were hand-me-downs from my brothers.
I had that one hat and one jacket. In retrospect, it was great not to
have any choices. I just got up and put on the only clothes I had.
Walter Teller

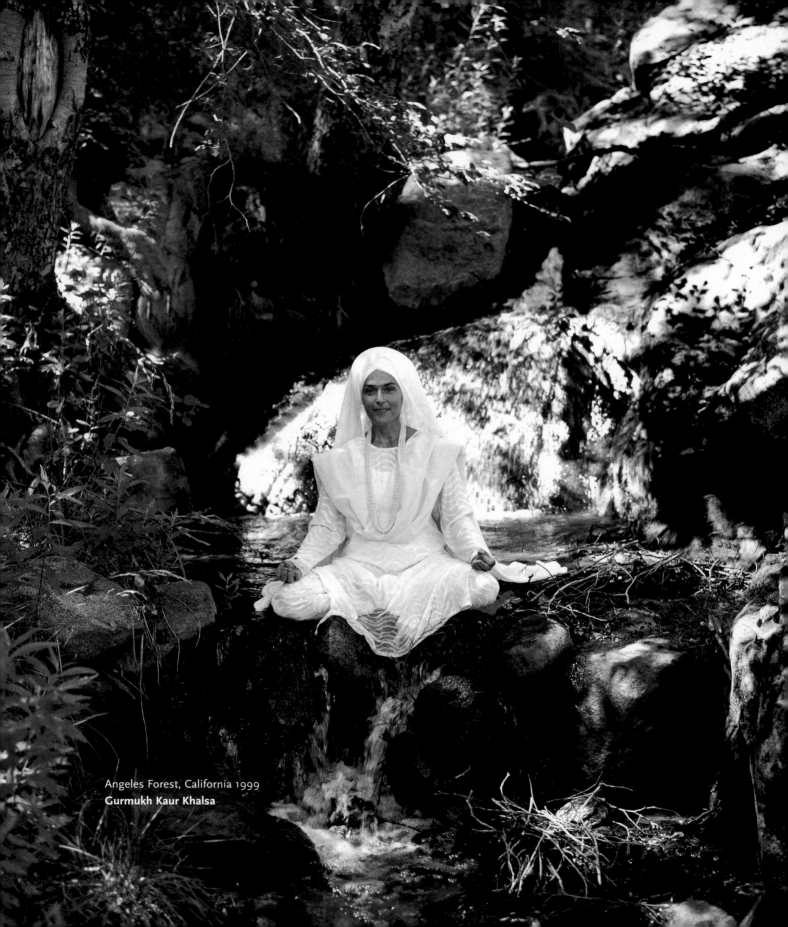

Angeles Forest, California 1999
Gurmukh Kaur Khalsa

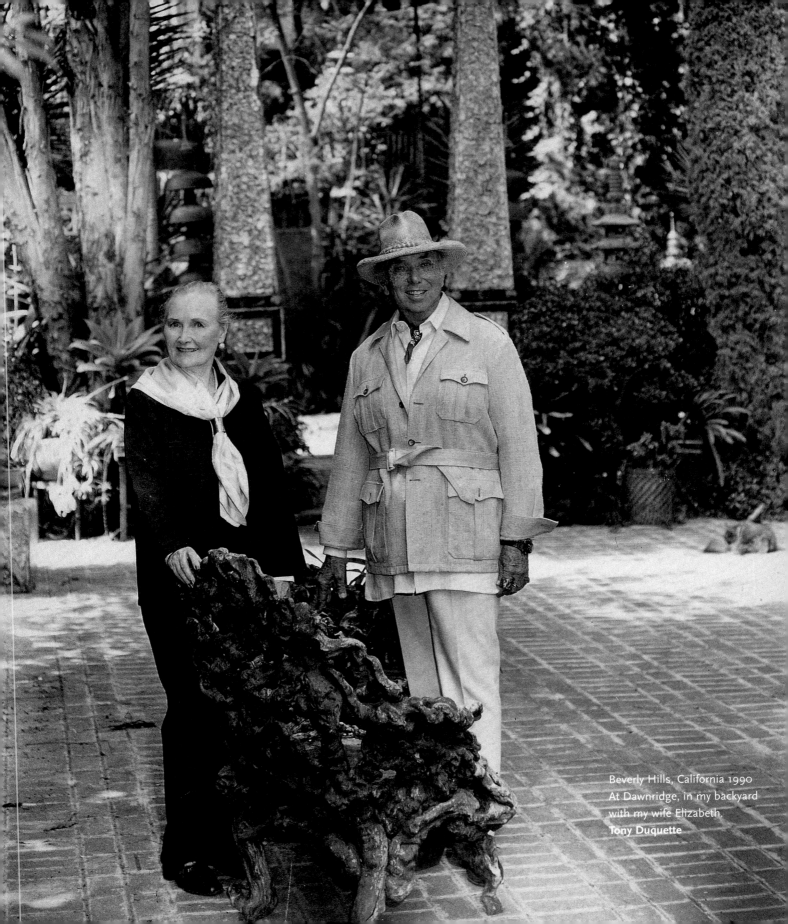

Beverly Hills, California 1990
At Dawnridge, in my backyard
with my wife Elizabeth.
Tony Duquette

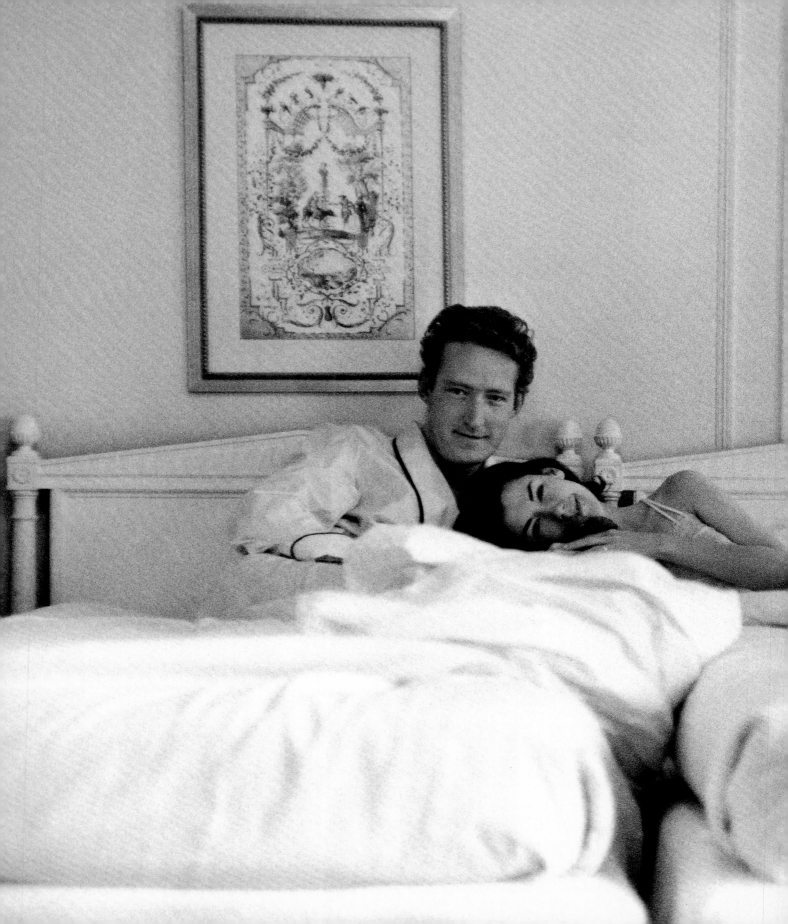

New York, New York 1959 This photo was taken the morning after our wedding, at The Savoy Plaza Hotel. I'm wearing Peggy's wedding present she had given me, a cream Sea Island cotton robe with black piping from Brooks Brothers. Peggy is wearing a lace and pleated chiffon nightgown from her trousseau. The photo was shot by myself using a self-timer. The photo doesn't illustrate some great fashion moment, but it shows our love and happiness. That can have an influence on fashion, too. **William Claxton**

Montreal, Canada 1947
Velma Allain and Rudy Wild

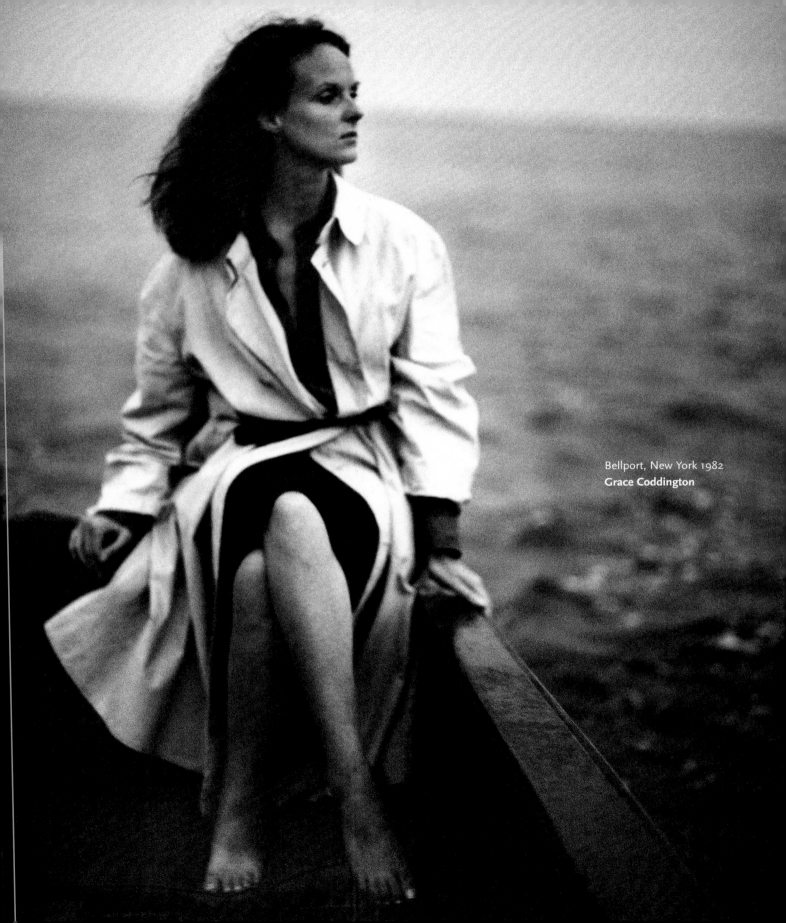

Bellport, New York 1982
Grace Coddington

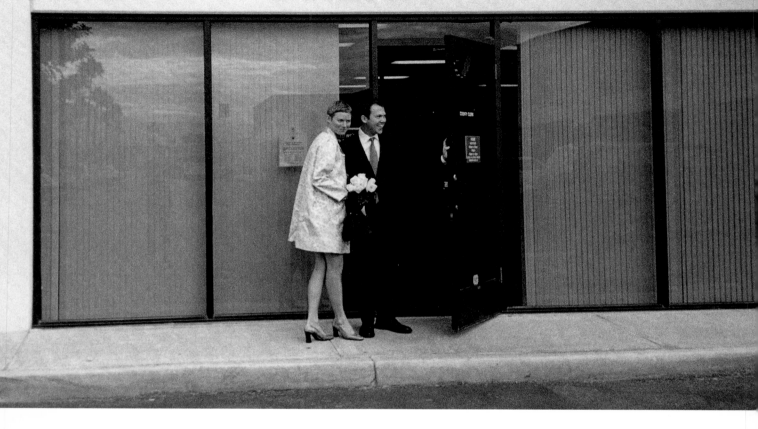

Palm Springs, California 1997 We're eloping. Yolanda is wearing something borrowed:
the ribbon around the flowers. Something old: the vintage satin print jacket that
she got at a flea market in San Francisco. And something blue: her dress is navy blue.
I'm wearing an Agnes B. suit and a Sulka shirt—the first present Yolanda ever gave me.
Matty and Yolanda Hranek

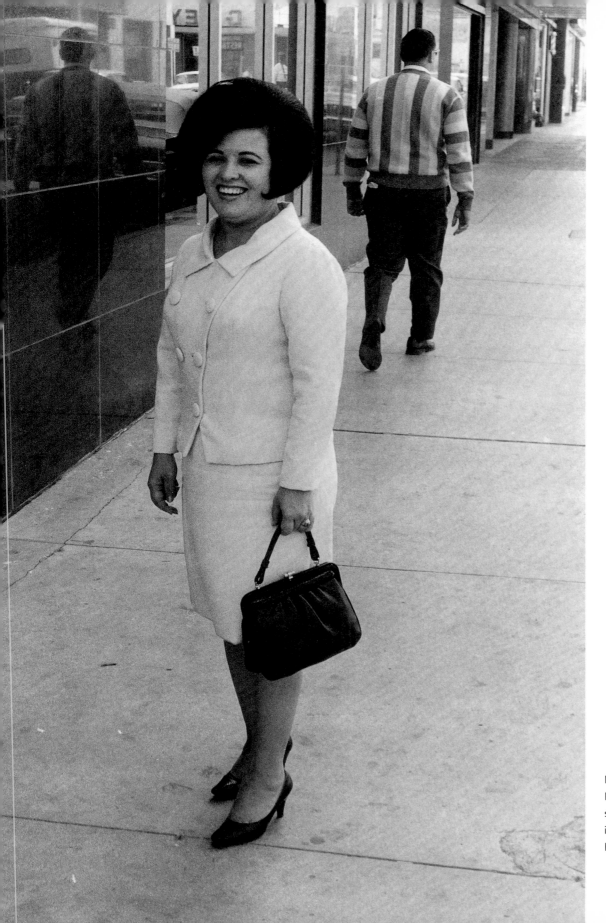

Miami, Florida 1964
It was my wedding day...my
second. I made the suit myself,
inspiration courtesy of Jackie
Kennedy. **Sila Donate**

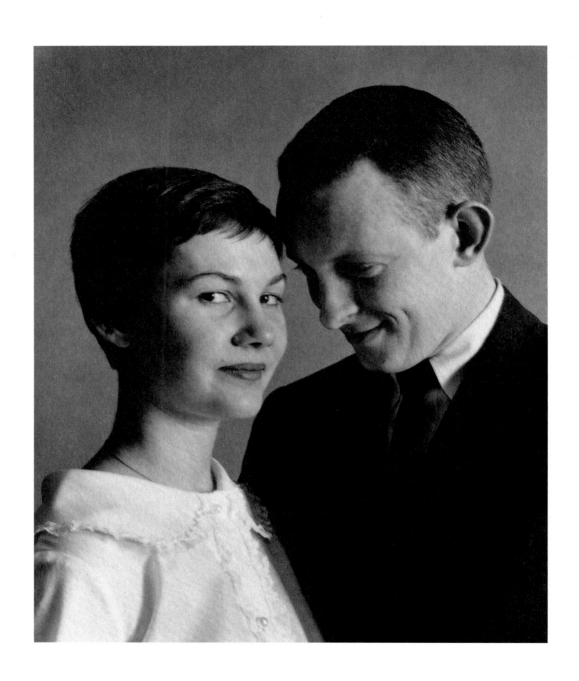

St. Louis, Missouri 1958
Sunny Nicks

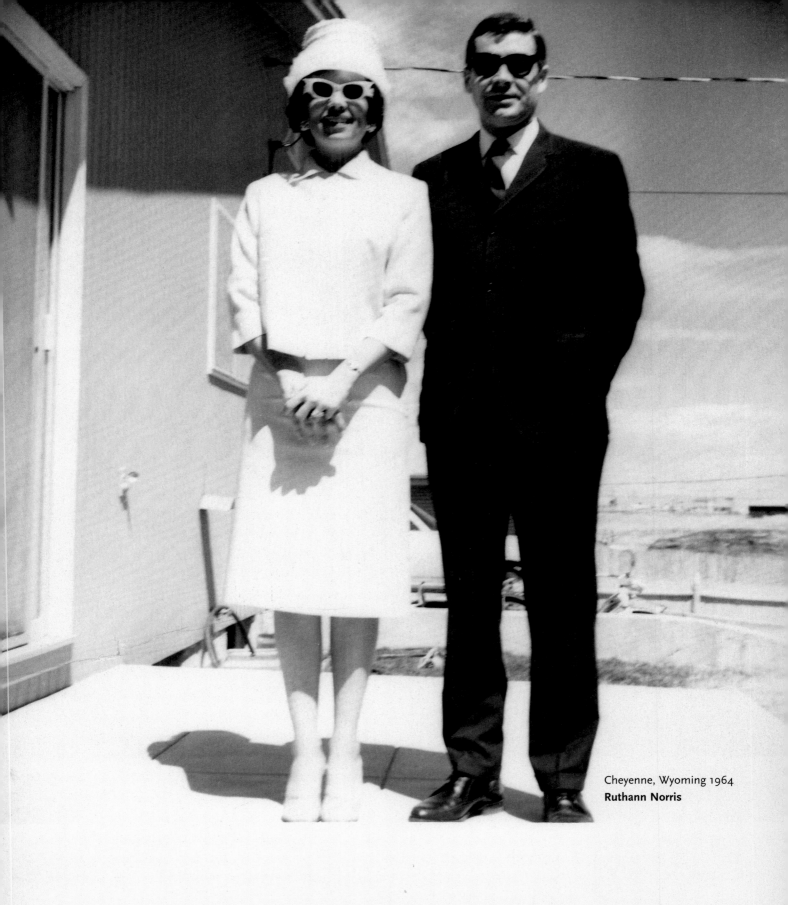

Cheyenne, Wyoming 1964
Ruthann Norris

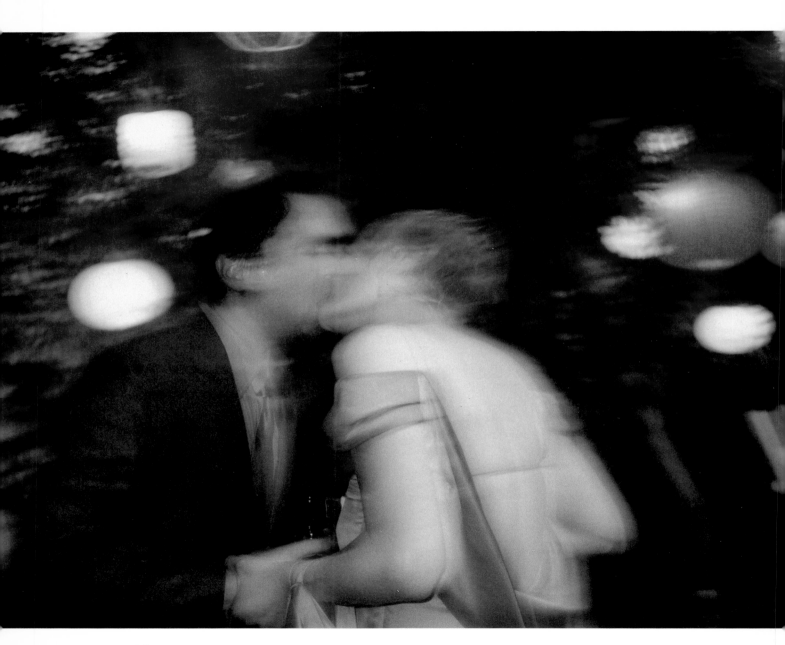

Santa Monica, California 1998
At our wedding in our garden.
Amy Spindler and Roberto Benabib

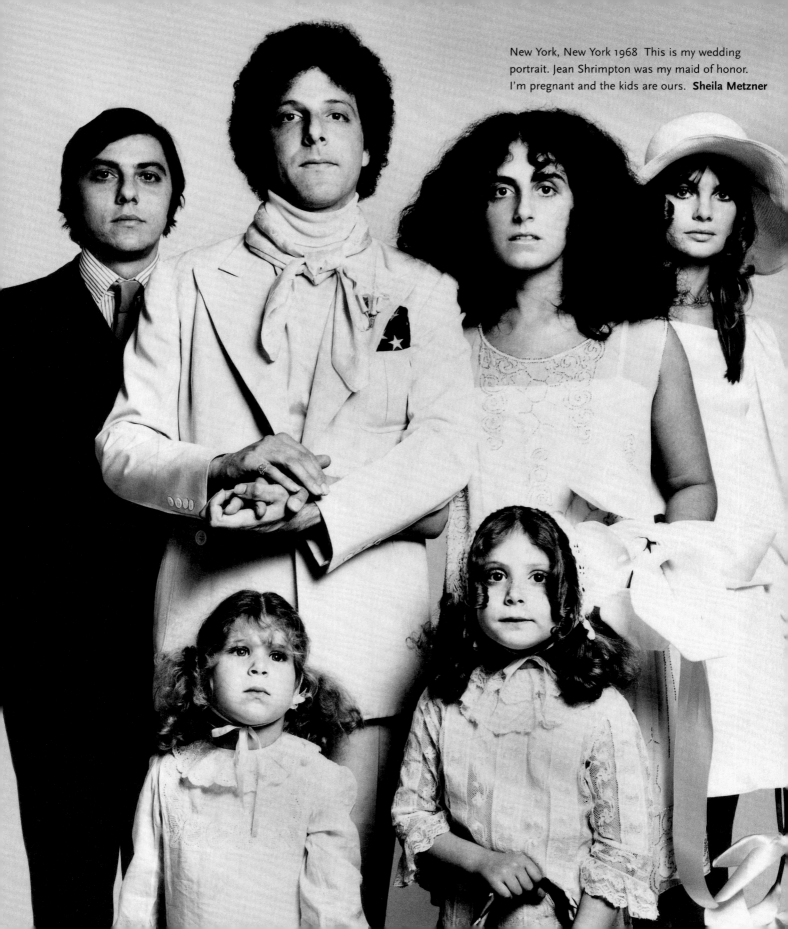

New York, New York 1968 This is my wedding portrait. Jean Shrimpton was my maid of honor. I'm pregnant and the kids are ours. **Sheila Metzner**

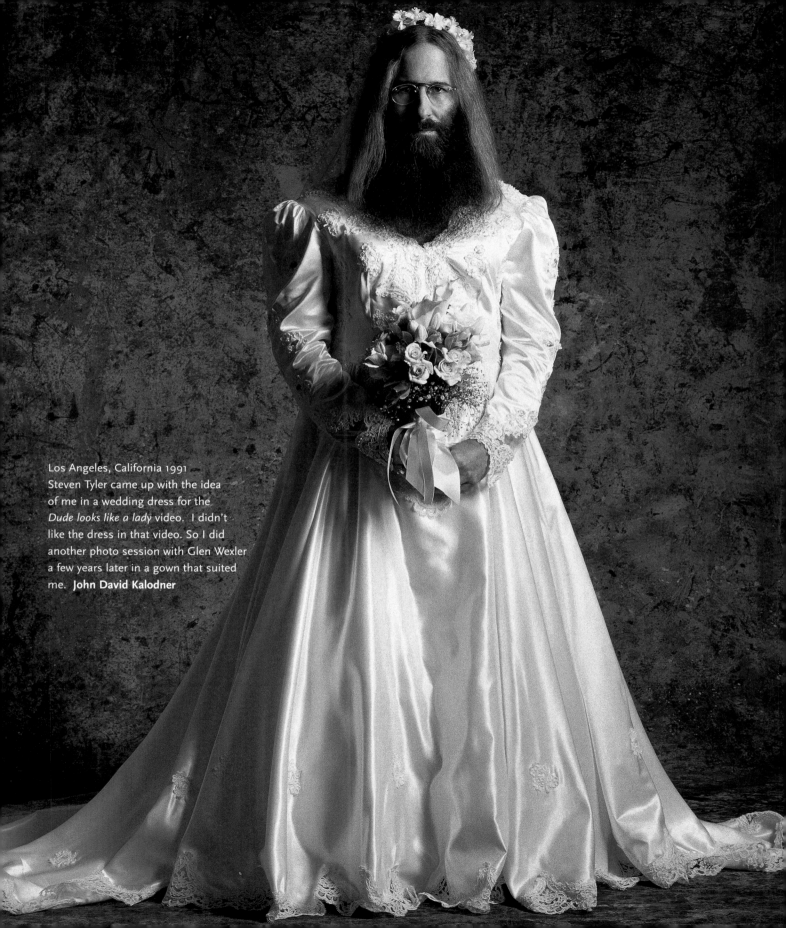

Los Angeles, California 1991
Steven Tyler came up with the idea
of me in a wedding dress for the
Dude looks like a lady video. I didn't
like the dress in that video. So I did
another photo session with Glen Wexler
a few years later in a gown that suited
me. **John David Kalodner**

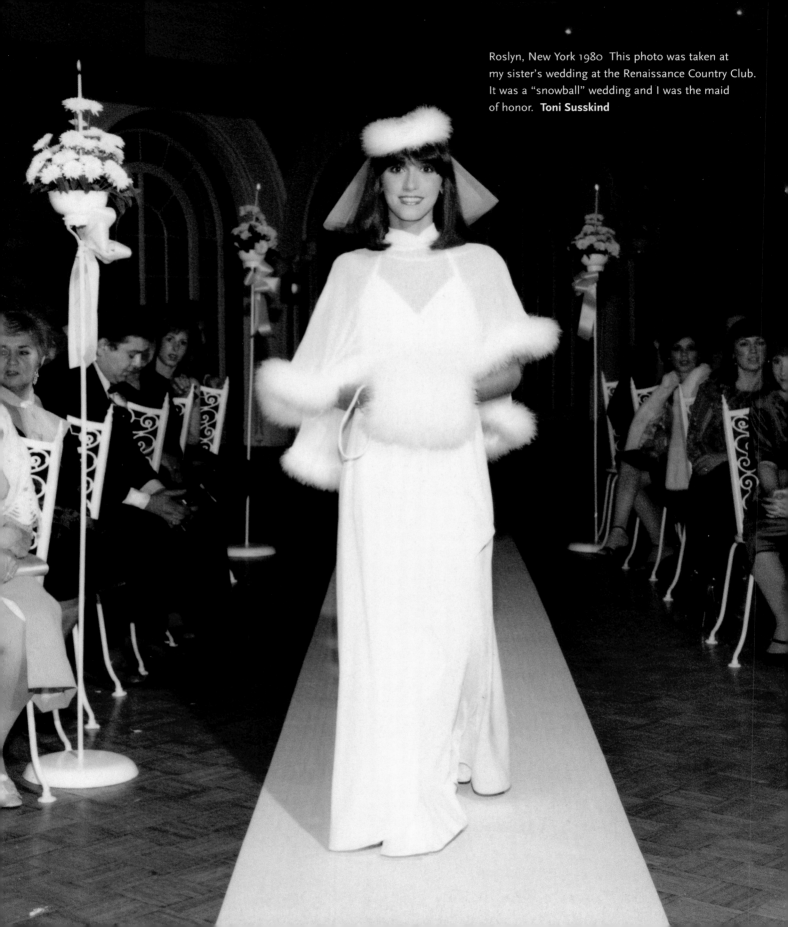

Roslyn, New York 1980 This photo was taken at
my sister's wedding at the Renaissance Country Club.
It was a "snowball" wedding and I was the maid
of honor. **Toni Susskind**

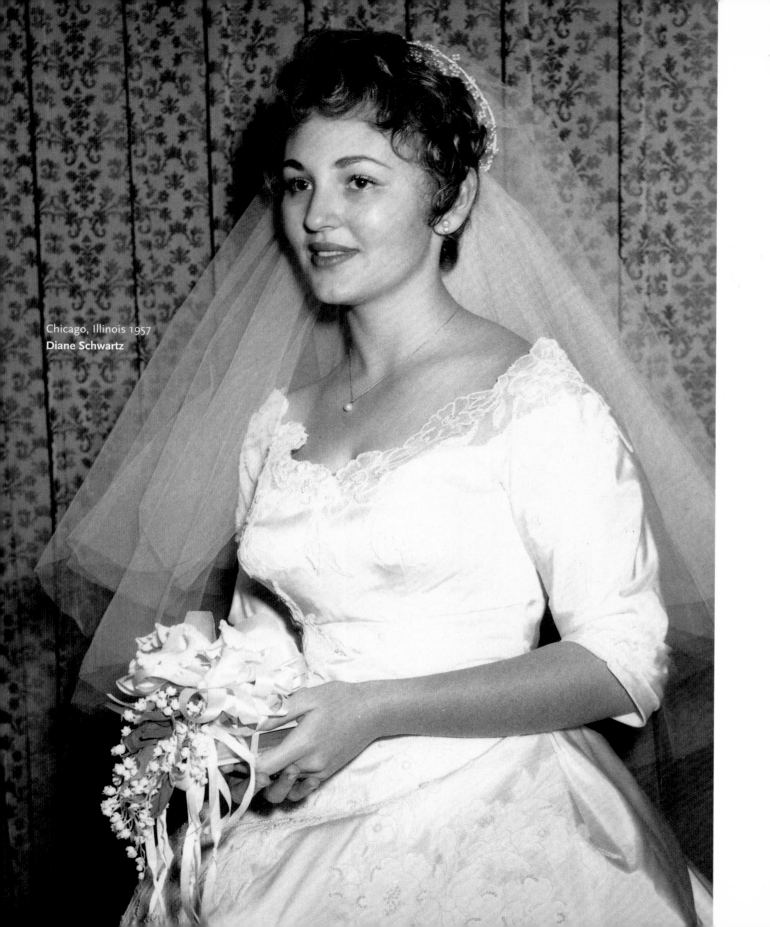

Chicago, Illinois 1957
Diane Schwartz

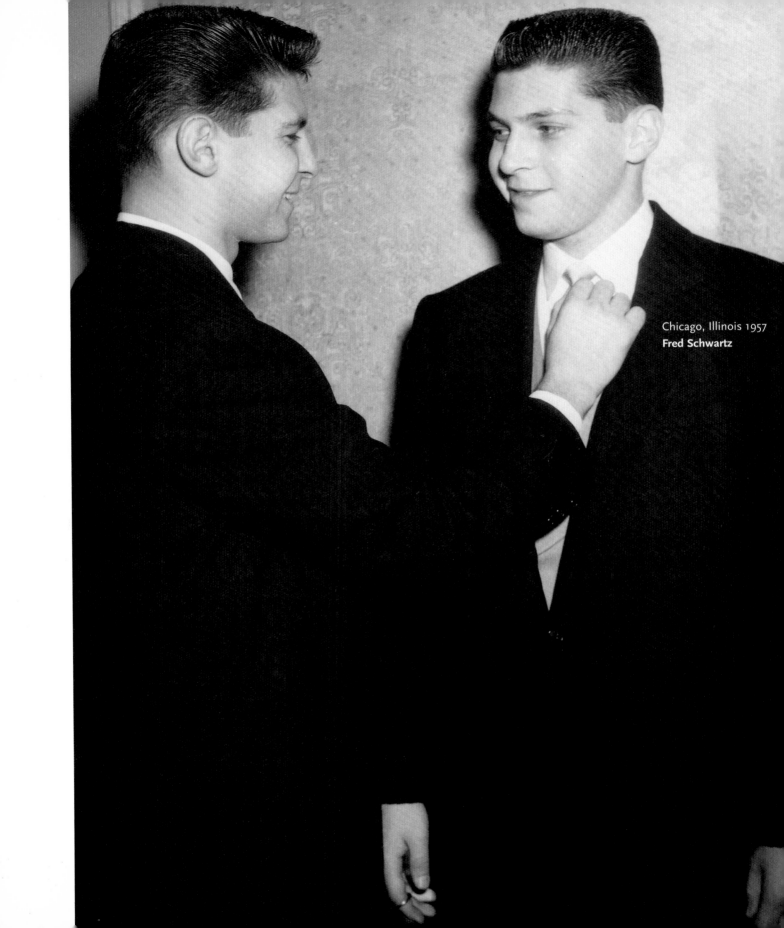

Chicago, Illinois 1957
Fred Schwartz

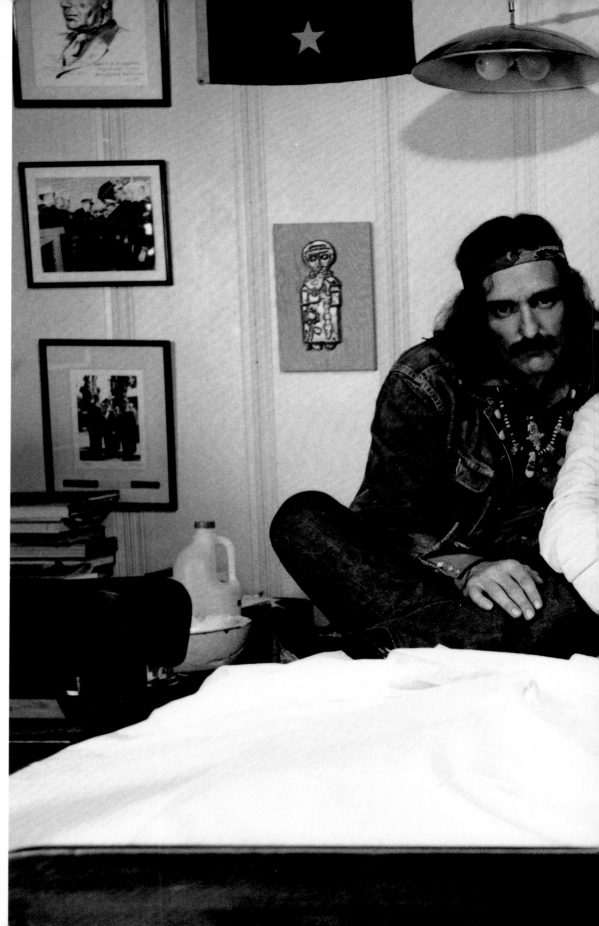

Palm Springs, California 1971
John Houston and I were doing
an ad for whisky with Victor
Skrebneski. I asked Huston when
was the last time he had seen
John Ford. "I haven't seen him
in 20 years" he responded.
So, we decided to visit Mr. Ford
in Palm Springs and take Victor
with us. After talking for a
while, I told Mr. Ford that I had
gotten permission from his wife
to get him into his wheelchair
so we could take a photograph
together. Mr. Ford replied, "Kid,
you know what your problem is?
You've got no sense of drama—
because if you had a sense of
drama you'd get in bed with me."
Dennis Hopper

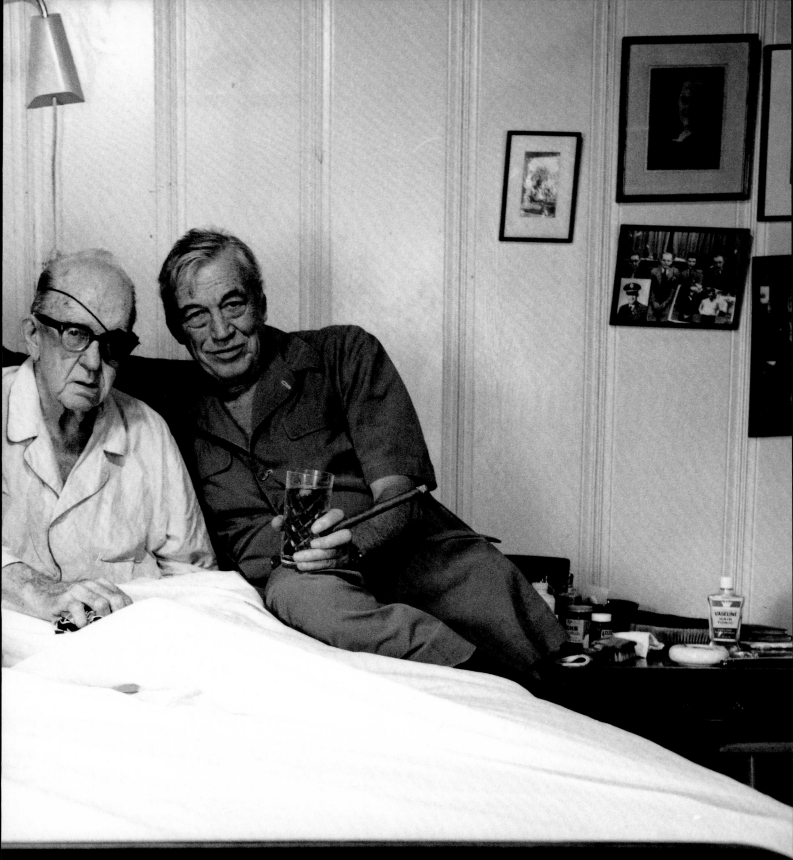

Photo Credits

Acknowledgements: *Special thanks* to Julie Aegerter, Gastón Alonso, Mathu Andersen, Tammie Arroyo, Richard Avedon, Marc Balet, George Barris, Jonathon Beck, Barbara Benedek, Alex Berliner, Norm Bilisko, Laurie Birleffi, Norman Blake, Steven Caras, Ellen Carey, Cecily Carrington, Aaron Chang, Thierry Chomel, Gordon Clark, William Claxton, Richard Courtney, Denise Crisp, Lisa Davis, Adrianna Day, Clara Mirta Donate, Sila Donate, Cat Doran, Bele Ducke, Brad Dunning, Eric Eisner, Louie Eisner, Charlie Eisner, Arthur Elgort, Ramon Estrada, Clare Finley, Sarah Foster, John Fowler, Marisa Gardini, Teri Gelber, Linda Genereux, Billy and Eve Gerber, Gina Gershon, Greg Gorman, John Greenleigh, William Grey Harris, David Harris, Brooke Hayward, Jerry Hoff, Dennis Hopper, Marin Hopper, Lyssa and Linda Horn, Paul Jasmin, Steven Johanknecht, Benton Jordan, Linda Jonsson, Snow Kahn, Lee Kaplan, Larry Kastendiek, Jeffrey Kauch, Suzi Kiefer, Douglas Kirkland, Bobby Klein, Doug Kopinski, Andrew Kromelow, Karl Lagerfeld, Ariana Lambert, Neil Leifer, Chy Lin, Peter Lindbergh, Benjamin Liu, Doug Lloyd, Cristina Malgara, Jill Martin, Dulce and Manuel Mata, Clive McClean, Patrick McMullan, Cindy McMurray, Sue Mengers, Miriam Morales, Keith Morrison, Helmut Newton, Dewey and Stephanie Nicks, George Nicks, Ruthann Norris, Michael James O'Brien, Karen Powelson, Tom Puzzettelli, Rosemary Redlin, Herb Ritts, Rosa Rivera Sol, Tracee Ellis Ross, Pierre Rougier, Joanne Savio, Bonnie Shiffman, Cameron Silver, Kate Simon, Victor Skrebneski, Courtney Small, Steve Small, Paul Smith, Amy Spindler, Michael Stoyla, Lilly Tartikoff, Juergen Teller, Mario Testino, Jay Thompson, Eden Tyler, John Vidol, Alexander Vreeland, Amanda Washburn, Rita Watnick, Bruce Weber and Nan Bush, Glen Wexler, Velma White, Jeanne Williams, Chloe Ziegler, Dick Zimmerman *and all the brave souls who had the shameless vanity and the courage to dig through their memories and send us one. You have our deepest appreciation and our undying admiration for being this cool.* **"Grateful" Press.**

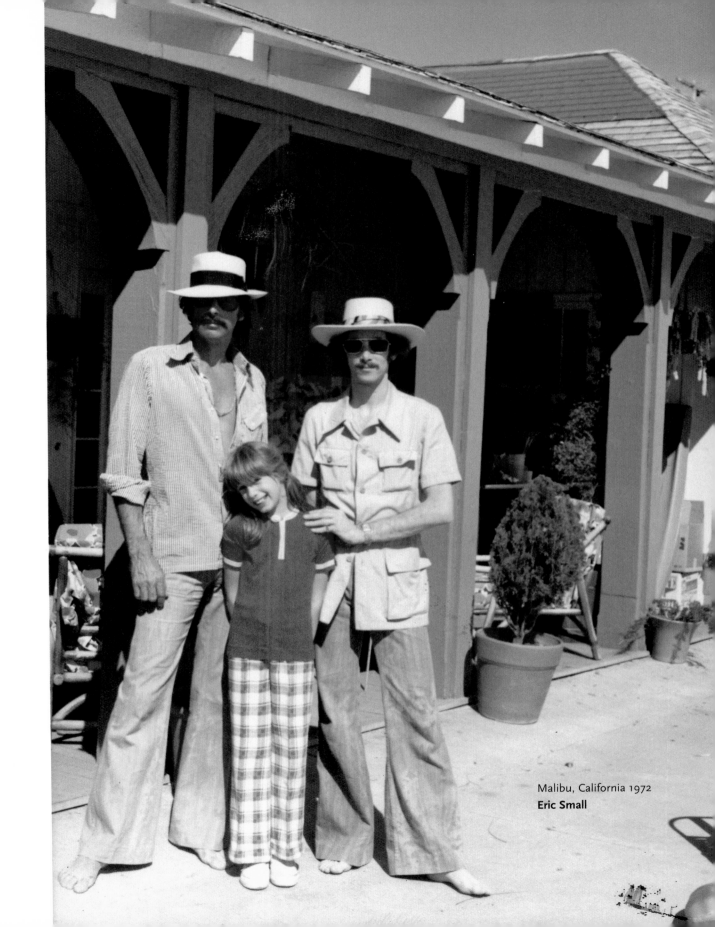

Malibu, California 1972
Eric Small

edited by LISA EISNER & ROMÁN ALONSO
designed by LORRAINE WILD *with* AMANDA WASHBURN & BELE DUCKE

introduction by AMY M. SPINDLER

picture editor LINDA GENEREUX *interviews by* CAT DORAN *endpaper design by* PAE WHITE *editorial assistant* BENTON JORDAN

First Edition published by Greybull Press
Los Angeles, California

Library of Congress Catalog Card Number 00-132162
© Copyright 2000 Greybull Press

Distribution by D. A. P. / Distributed Art Publishers
155 Sixth Avenue, Second Floor
New York, NY 10013

Printed by CS Graphics, Singapore
First Edition 2000
ISBN 0-9672366-1-4
Library of Congress Cataloging in Publication Data

Cover:
East Hampton, New York 1972 Amanda Washburn